The Practical Guide to Photographic Lighting

for Film and Digital Photography

The Practical Guide to Photographic Lighting

for Film and Digital Photography

Jon Tarrant

Focal Press
OXFORD AUCKLAND BOSTON JOHANNESBURG MELBOURNE NEW DELHI

Focal Press
An imprint of Butterworth-Heinemann
Linacre House, Jordan Hill, Oxford OX2 8DP
225 Wildwood Avenue, Woburn, MA 01801-2041
A division of Reed Educational and Professional Publishing Ltd

℞ A member of the Reed Elsevier plc group

First published 2001

© Jon Tarrant 2001

British Library Cataloguing in Publication Data
A catalogue record for this book is available from the British Library

Library of Congress Cataloguing in Publication Data
A catalogue record for this book is available from the Library of Congress

ISBN 0 240 51580 3

Composition by Genesis Typesetting, Laser Quay, Rochester, Kent
Printed and bound in Great Britain

PLANT A TREE

BTCV
British Trust for
Conservation Volunteers

FOR EVERY TITLE THAT WE PUBLISH, BUTTERWORTH-HEINEMANN
WILL PAY FOR BTCV TO PLANT AND CARE FOR A TREE.

CONTENTS

Contents

DEDICATION

This book is dedicated to lighting manufacturers large and small, without whose design and development efforts much of what is discussed on the following pages would probably not exist. On a personal note, the author would like to record special thanks to those manufacturers who have listened to his own suggestions for building or modifying equipment: not all of those suggestions have been sensible or practical, but the author is proud to identify aspects of some items that were, by their manufacturers' own admissions, inspired by his comments.

Subtle example of Hosemaster lighting by Jonathan Knowles, who admits that he was initially uncertain that investment in the specialist (and rather expensive) lighting system had been a wise move because it took much longer to learn how to use the equipment than he originally expected. Today, Knowles is one of the UK's leading Hosemaster experts. In this picture not only light but also colour has been added to the set.

INTRODUCTION

In 1968, Focal Press published the sixteenth edition of Walter Nurnberg's classic work *Lighting for Photography*. In the Foreword, Nurnberg, referring principally to improvements in colour films and the widespread use of electronic flash, noted that 'the last few years have brought many changes to photography'. This author echoes the same sentiment here, but in doing so is alluding to a brand new photographic medium – digital image capture.

If this book had been written a few years ago, it would have been impossible to integrate lighting for digital image capture with lighting for traditional film photography. Today, the two have so much in common that separation would be a folly. That is not surprising, for digital image capture will only become a serious alternative to film photography when the two types of cameras have the same capabilities, including the same compatibilities with different lighting systems. Although that state of affairs does not fully exist yet, it will in the coming years.

It is therefore the intention of this book to explain lighting principles without pandering to the compromises that digital technology demands today. There are pictures in this book that were taken digitally, others that have been scanned and electronically manipulated, and many that are shown as taken on traditional film. All should be viewed equally according to their content, for there is very much more to photographic images than the medium in which they are expressed.

Furthermore, whatever medium is used, photography without deliberate attention to the lighting is at best a matter of luck, and at worst the drab mechanical reproduction of those things that simply happened to be in front of the camera when the shutter button was pressed. Proper lighting is what turns a snapshot into a photograph – regardless of whether it is recorded digitally or on film.

Jon Tarrant

Figure I.1 **A very simple lighting arrangement was used here, with a single softbox camera right, and a second flash head fired into the ceiling to provide fill. A third light was placed behind the frosted glass doors to create a subtle background effect. The picture was taken during a model test session, when flexible lighting is useful in maintaining the flow of the shoot when changing from one pose to another.**

▌ FUNDAMENTAL CONCEPTS

Light is something so obvious that it is taken for granted in most contexts. Photography and science are the two common exceptions. Although the former is the subject of this book, brief mention must be made of certain underlying scientific principles if some of what follows is to make proper sense.

Throughout the millennia, debate has raged over the nature of light. Although there have been conflicting theories, all were based on the common ground of observed effects. Unfortunately, to this day different theories are best suited to different observations, and although the fundamental nature of light is now more roundly described than previously, its explanation is still incomplete. Some of the important landmarks in the science of light are sketched in the Appendix at the back of this book.

It is not essential to have a full understanding of the scientific principles of light in order to master photographic lighting, but those who choose to skip the following outline may fail to appreciate some of the finer points in later chapters. Therefore, even if the technical introduction below is not read now, it should not be ignored for ever.

The properties of light

If light is envisaged similar to a wave on water, then it can be characterized by an amplitude (the height of the wave) and a frequency (the rate at which successive waves break on the shore). An alternative way of measuring frequency is by referring to the distance between successive crests (the wavelength) and the speed with which the waves travel (their velocity). Some of these quantities are illustrated in Figure 1.2.

Figure 1.1 **The blue colour in this photograph is light leakage between two crossed polarizing filters. To see the effect, 1600 J of flash illumination was fired directly towards the camera from behind the filters, between which were placed an assortment of coloured glass blocks. Picture taken on Polaroid Presentation Chrome film using a Nikon FM 35 mm SLR. Metering was by trial and error using 35 mm Polaroid instant film.**

Figure 1.2 Some characteristics of waves on water.

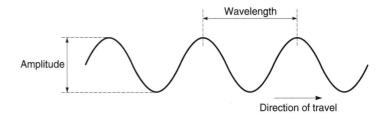

Of these three quantities (frequency, wavelength and velocity), only the frequency is a constant: the wavelength is directly related to the speed of travel of the wave. This fact is formalized by Equation 1.1 – which, when rearranged as Equation 1.2, is directly analogous to the familiar everyday relationship: speed of travel is equal to distance travelled divided by time taken. See also Figure 1.3.

$$\text{Frequency of wave} = \frac{\text{speed of travel}}{\text{wavelength}} \qquad \text{(Eqn 1.1)}$$

$$\text{Rate of passing railings} = \frac{\text{speed of travel}}{\text{distance between railings}} \qquad \text{(Eqn 1.2)}$$

For simplicity, in terms of photographic lighting the amplitude (height) of the wave can be related to the brightness of the light. In strict scientific terms, the brightness is a measure of the number of light particles (photons) arriving at the target, but this is a less meaningful model to use on the scale that applies for photographic lighting.

In addition, although the water wave analogy is very useful in exploring certain aspects of the behaviour of light, as far as photography is concerned the model must be cast aside almost immediately because it fails to acknowledge two essential characteristics. Most

Figure 1.3 Everyday analogy for wave properties.

obviously, there is light's composite nature, with rainbow coloured elements contributing to the overall effect that we call 'white'. This phenomenon is easily seen when sunlight is passed through a prism, or, for that matter, when a simple magnifying glass is used as a lens (when coloured fringes become apparent). It is impossible to imagine such behaviour by watching waves on water!

Colour temperature

Having introduced the term 'white' light, it is necessary to offer qualification by pointing out that 'whiteness' is a subjective term, and that there is an independent scientific measure, known as colour temperature, that quantifies this property. It is based on what is known as an ideal (black body) radiant light source. Fortunately, the explanation is simpler than this technical term might suggest.

Any object that is heated will start to glow as its temperature increases. The radiated light is dull red at first, then brighter red, then orange, then yellow, then white, then blue-white. These, it should be pointed out, are the dominant colours: by nature, a black body radiator is one that emits a broad spectrum of colours with the overall visible hue becoming more 'blue' as the temperature increases. Scientifically, this can be represented by a curve showing the relative intensities of different colours of light for objects heated to different temperatures. In such graphs, the peak intensity is seen to move to shorter wavelengths ('bluer' colours) as the black body temperature increases. See Figure 1.4.

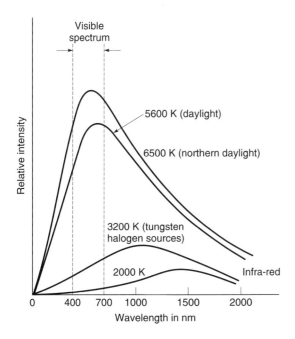

Figure 1.4 Continuous spectra emitted by four typical black bodies. Diagram reproduced courtesy of Brian Fitt and Joe Thornley, *Lighting by Design*, Focal Press 1992.

5

Even at room temperature there is still a 'glow', albeit one that is invisible to the human eye. There is, however, a temperature at which all radiated energy ceases. This temperature is called 'absolute zero' and lies 273.16° below zero Celsius. Nothing can ever be colder than absolute zero: indeed, nothing in the real world can ever get to absolute zero – though specially controlled laboratory conditions do allow scientists to get very close.

Given that nothing can be colder than absolute zero, all negative temperatures can be avoided by numbering the temperature scale from absolute zero upwards. Such a scale was announced in 1848 by Baron Kelvin of Largs. It carries the baron's name – kelvin – and has the virtue of being defined free from the properties of any specific substance. Previous scales used the freezing and boiling points of pure water as fixed reference points. Originally, German physicist Gabriel Fahrenheit, who in 1714 constructed the first mercury thermometer, divided water's liquid range into 180 divisions starting at 32 (in an early attempt to avoid negative temperatures). Later, in 1742, Swedish astronomer Anders Celsius suggested one hundred divisions – hence his scale's alternative name, centigrade – starting from zero. For common usage, degrees Celsius are more convenient, but owing to its scientific significance the colour of light is always equated to the radiation from objects heated to temperatures measured in kelvin (K). Note that there is no 'degree' term: kelvin is a unit that requires no embellishment.

Photographic 'daylight' has the same spectral quality as an ideal black body radiator at 5500 K. Because the temperature scale is constant for all qualifying objects (obviously not those that burst into flames or otherwise decompose) it can be used to specify the spectral quality of light in an absolute manner. In essence, this is nothing more than a way to put numbers to the 'red hot' and 'white hot' terms already mentioned. Apart from its scientific significance, this number scale of colour temperatures provides a way of guarding against the fallibility of subjective judgement by the naked eye.

Human vision tends to be very tolerant of different colour temperatures (types of lighting), but photographic film is not. This fact can be illustrated indoors at night, in a room lit by ordinary light bulbs. Visually, things appear the same as they do during full daylight: clothes, flowers and skin tones all look their usual colours. Yet if a photograph is taken using daylight film, the resulting images will show a strong orange cast. Our eyes are wrong, and the film is right.

The light from a domestic light bulb is proportionally richer in red and poorer in blue than natural daylight. In scientific terms, it has a lower colour temperature because the redder colour would be associated with an ideal radiator of a lower temperature than daylight's 5500 K – typically around 2800–3000 K.

Similarly, when photographic light is filtered, its spectral quality is altered by the selective absorption of some colour components. If the filtration is confined to shifting the blue/red balance across the full spectrum, then it is possible to talk of a new colour temperature, but if other types of adjustment are made there is no equivalent colour temperature rating for the resulting non-white light. Generally speaking, adjusted lighting that maintains a proper colour temperature is classified as 'corrective', whereas filtration that produces non-equivalent coloured lighting is classified as 'creative'. These terms will be discussed in more detail later, so need not cause concern here if the distinction is not immediately apparent.

Sources of light

Of course, not all sources of light use heat to create their illumination. Some of the more exotic alternatives are photo-electronic devices (LEDs) and chemi-luminescence (light given out during a chemical reaction – employed in light sticks that are used by sub-aqua divers, for example). Another possibility is to use the effect known as light amplification by the stimulated emission of radiation (LASER). Laser light is essential to holography, but is not covered in this book as it does not lend itself readily to creative lighting other than within sophisticated 'light painting' techniques of the type that are used in theatres and rock concerts to create visible patterns in clouds of smoke.

Non-incandescent light sources (those that do not produce light as a by-product of being heated) do, however, have some photographic applications. In particular, fluorescent tubes can be used for photography – provided that they are of a sufficiently high quality.

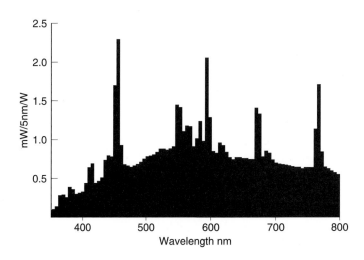

Figure 1.5 Spectral distribution of luminous flux for a CID discharge lamp.

There are also other forms of discharge lighting (of which fluorescent tubes are just one special case) that are even better suited to photographic uses by virtue of their superior quality of illumination.

Sadly, because discharge lighting does not feature an incandescent source it cannot be described using the black body model. The spectrum of a discharge light source is not a smooth curve, but rather contains 'spikes' – as shown in Figure 1.5. If the spikes are 'balanced', the overall lighting effect can get very close to simulating that of a black body radiator, and therefore to being useful in photographic applications.

But because it does not use a hot element to generate its output, the light quality coming from a discharge source cannot be quantified using the colour temperature method. Instead, it is measured using a colour rendering index (CRI) figure that reflects the accuracy with which the light will show a variety of different colours illuminated by it. A high CRI (close to 100) indicates that the source has faithful colour rendering, and therefore offers good potential for photographic uses. At first, fluorescent tubes with high CRI ratings were very expensive, but with time their prices have fallen enormously. However, high prices continue to be an obstacle to the widespread adoption by stills photographers of high intensity discharge lighting, which is commonly used in the motion picture industry.

Figure 1.6 To the naked eye, all lighting looks much the same, but film reveals that the light from ordinary fluorescent tubes commonly has a strong green colour. Picture taken on Kodak Ektachrome E200 using a Nikon FM 35 mm SLR with no filtration.

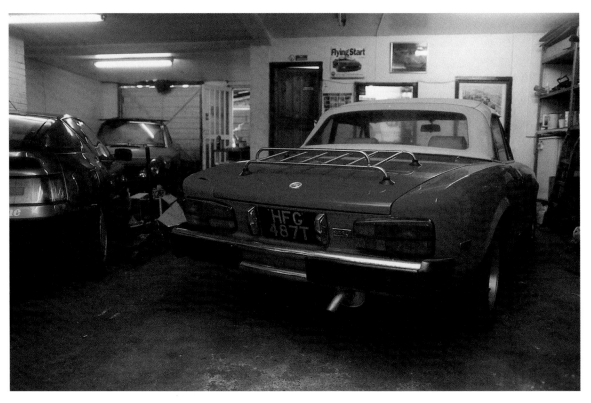

Polarization

Returning to the fundamental properties of light, the second aspect that is not evident from water waves is polarization. Whereas water goes only up and down as its waves travel forwards, light waves can oscillate in any lateral direction as they advance. Polarized light is light that lacks this freedom, having been restrained to a single direction. Water waves are therefore naturally polarized whereas light is generally unpolarized. In photography, polarizing filters are most commonly used not to impart polarization to unpolarized light, but rather to block light that is already polarized. As such, their effectiveness is dependent on the previous history of the light before the filter is encountered.

Prior polarization can be achieved by various means, the most common of which is reflection. Whenever light encounters a surface, part of the light is transmitted (or absorbed) and part is reflected. This fact is common experience, and can be illustrated by viewing the reflection seen in a pane of glass, which shows the same objects as can be seen from the other side of the glass when looking through it. The thing that is not so obvious, unless the viewer is

Figure 1.7 Light is both transmitted through glass and reflected off it (in this case, a car showroom window). The same behaviour applies to many other surfaces, but the eye is unaware of how these encounters affect the light unless the aid of a polarizing medium is enlisted. Picture taken on Fujichrome RMS using a Mamiya 7 medium format rangefinder with no filtration.

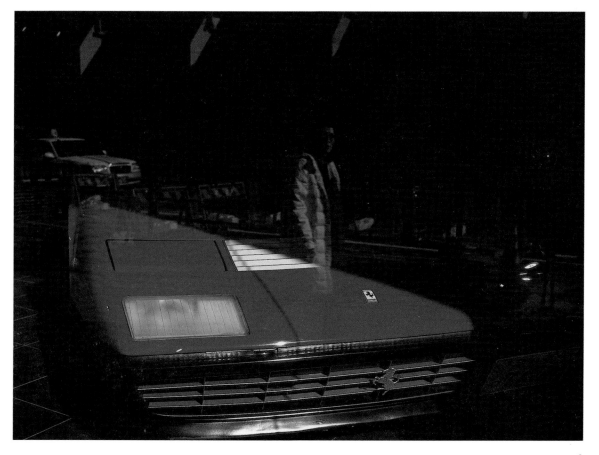

wearing Polaroid sunglasses, is that the reflection disappears when viewed at a certain angle. This angle-dependent behaviour is a simple manifestation of polarization at work.

The degree of polarization varies not only with the angle at which the reflecting surface is viewed, but also with the nature of the surface itself. In particular, conducting surfaces do not polarize light. It therefore follows that photographic polarizing filters cannot be used to quench reflections from the surfaces of bare metal objects.

Although it is usual to fit a polarizing filter over the camera lens to block polarized light after it has been reflected from the surface, it is also possible to pre-filter the light. In this case, the filter is positioned between the light source and the object, and is oriented to block the same direction of oscillation that would otherwise constitute the reflected image. This can be a very useful alternative tactic in photographic lighting – and is one that will be returned to in future pages.

Although photographic polarizing filters were originally all of the 'linear' type, nowadays it is equally common to hear talk of 'circular' polarizers. The distinction is difficult to explain fully without use of a number of concepts that are alien to everyday experience, and therefore it is best to note only that circular polarizers are nothing more than modified linear polarizers. As such, unless a given camera system requires the use of circular polarizers (as many AF cameras do), then linear polarizers should, by virtue of their lower cost, be considered the first choice.

Figure 1.8 Captured from the back of a show at London Fashion Week, this picture reveals the high relative illumination of the catwalk and the orange cast from the tungsten lamps. Picture taken on Fujichrome 100 APS film using a Minolta Vectis 2000 APS compact camera.

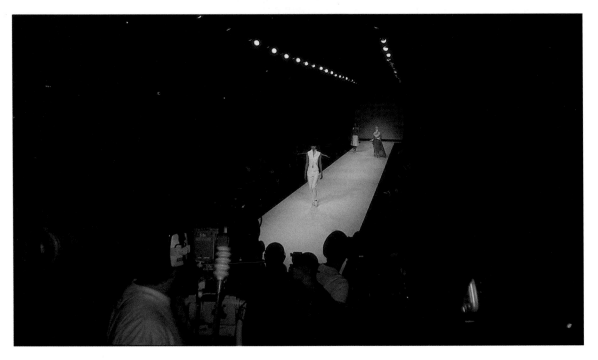

Lighting polarizers are invariably linear, but despite being the cheaper type they are still very expensive on account of their considerable sizes. In view of this, it is important to appreciate that polarizing filters are easily damaged by heat, so great care should be exercised when fitting them to lights (even flash heads that have bright modelling lamps). Whenever possible, lighting polarizers should therefore be mounted on frames that are spaced a short distance in front of the light head to maintain a lower temperature.

Non-visible light

All the previous discussion has talked about light that, by implication, gives rise to a visible effect. But there are other types of non-visible 'light' (in the broad electromagnetic spectrum sense) that cannot be detected directly by the human eye, but are nevertheless important in photography. Strictly speaking, non-visible 'light' is not light at all, and should more correctly be referred to as 'radiation' – with the strict understanding that this term does not, in the lighting sense, have any connection with the same word used in the context of nuclear reactions.

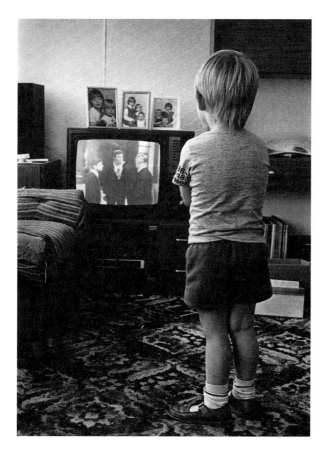

Figure 1.9 Television sets, like most desktop computer monitors, generate their light by bombarding a phosphorescent screen with electrons. The image takes time to build up – something that our eyes do not notice but a fast camera shutter speed would betray. This picture was therefore taken at 1/30 s: strictly speaking this is 'too slow' for the 50 mm lens used (if camera movement blur is to be avoided), but the situation forced a variation from normal practice. Picture taken on Kodak Tri-X using a Nikon FM 35 mm SLR.

An extreme example of non-visible illumination is provided by beams of electrons that are used to image the surfaces of ultra-small objects within electron microscopes. To convert the electron image into one that can be seen by eye and recorded on photographic film, circuitry is employed that writes the information onto a small phosphor screen. A common analogy is the way in which television sets convert transmitted signals into visible pictures. Other non-visible signals can be converted in similar ways, and low lighting levels that are too dim for normal vision can also be boosted electronically using image-intensifier devices such as those that are used for some types of night vision systems.

Another sort of night vision system uses active illumination from an infrared emitter. Goggles fitted with infrared sources and photon converters are worn by photographic technicians who work

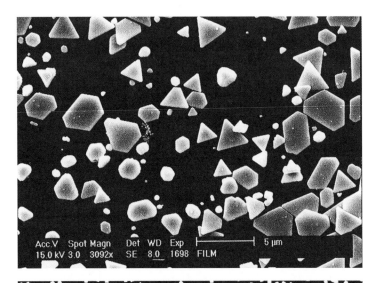

Figure 1.10 Two pictures taken using a scanning electron microscope (SEM). The images were photographed from a phosphorescent screen – not unlike a small television screen. Shown here are the grain structures of a typical camera film emulsion (variable triangular morphology) and a typical b&w printing paper emulsion (uniform cubic morphology). Photographs courtesy of Ilford Ltd.

in 'dark' rooms, or who have to tend large-scale processing equipment that has developed a fault with film still loaded on its racks. Active infrared illumination is also used by some compact cameras as a means of achieving accurate automatic focusing under both normal and dark conditions.

In picture taking situations, it is more common to think of infrared radiation as a route to dramatic photographs that can feature black skies, white foliage and ghostly skin tones. Photography with infrared sensitive films will be covered in more detail later.

To the other side of the visible spectrum there is ultraviolet radiation. Because films are often more sensitive than the human eye to blue and far-blue (ultraviolet) light, the latter can cause unforeseen problems. On the simplest level, this increased sensitivity explains why blue skies come out a very light shade of grey in many b&w photographs. More seriously, mountain photography, even at modest altitudes, can be ruined by a haze that obscures the view in pictures when the day appeared clear to the naked eye. This effect arises from the scattering of ultraviolet light by atmospheric water molecules – an effect that the eye simply cannot see. The answer is to fit a corrective filter to the lens: for black and white photography a yellow filter is best, but for colour work a nearly colourless (vaguely pink) type 1A or 'skylight' filter is the usual answer.

Finally, as with infrared there are interesting special effects that can be obtained when working with ultraviolet 'light' under deliberate conditions. But, unlike the case with infrared, rather than using a special ultraviolet sensitive film, effects arising from this sort of non-visible radiation are normally exploited through the visible responses that they provoke. The most common response is a type of photo-luminescence that causes, for example, white shirts to glow purple under nightclub lighting. By experimenting with substances that exhibit this response (including 'day-glow' paints and make-ups), some weird and wonderful results can be recorded on ordinary colour film.

In summary

This chapter started with highly theoretical issues regarding light in general, and has ended with specific mentions of particular photographic possibilities. That is the way it should be, for photographic lighting is always underwritten by theory, but exploited in practice. If the theory that has been covered here has sometimes been hard work, then all that need be remembered is that the science of light is quantitative whereas photography is qualitative. Although photography requires a numerical assessment of the light level in order to determine an appropriate exposure, the most important aspects of photographic lighting are the mood and atmosphere that it conveys.

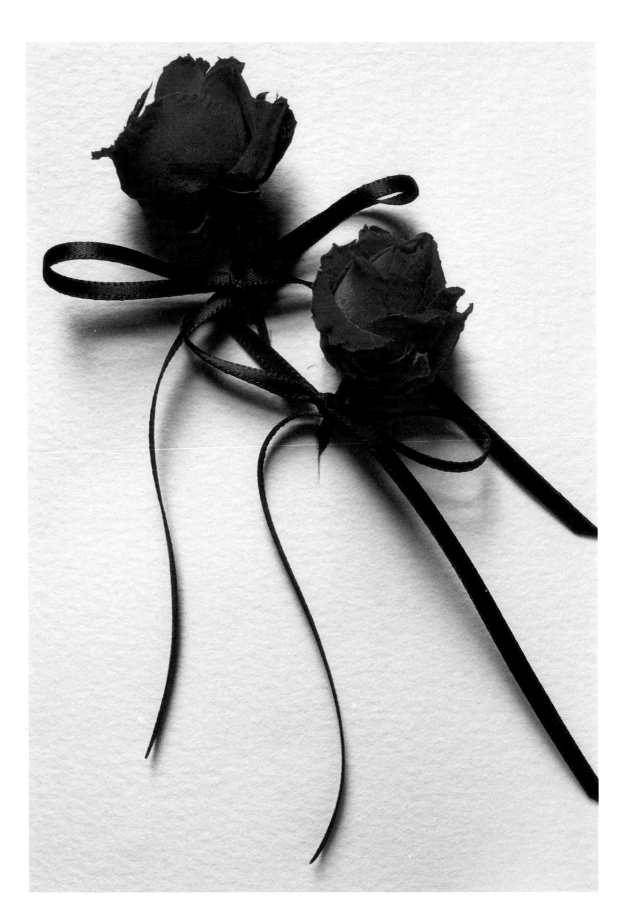

2 LIGHT SOURCES

By far the most common light source is natural daylight. Unsurprisingly, therefore, daylight – in a precisely specified form – is the photographic standard to which many artificial light sources are matched. In particular, and as mentioned previously, the colour temperature of a light source has an obvious affect on the appearance of colour images. Human visual perception is adaptable and interprets virtually all scenes, regardless of how they are actually lit, as if they were illuminated with natural daylight. Film, by contrast, records the scene as it really is, revealing, for example, orange or green casts if pictures are taken under domestic tungsten or fluorescent lighting. To get a 'natural' result, the film must be matched to the light source: the reason why colour casts appear is because the two do not properly complement each other.

The criterion that determines how well photographed colours match those seen by the eye is the degree of matching between the light's spectral quality and the film's lighting calibration (spectral balance). Mostly, films are 'tuned' to the photographic daylight standard, though some are matched to a standard artificial (tungsten) light source.

If a daylight film is exposed under tungsten illumination, the resulting pictures will show an orange cast; if a tungsten film is exposed under daylight illumination, the resulting pictures will show a blue cast. But even between these two extremes, and staying just with daylight for a moment, there exists a host of variations that arise from changes in colour temperature throughout the day. These changes are most evident during the twilight of early dawn and the sunsets of late dusk. Similar colour shifts are found when using tungsten lighting, which is not the true absolute standard that some people imagine. In fact, different lamps (and even the same lamp as it ages) can have slightly different colours.

Figure 2.1 Lit by window light and exposed using in-camera metering, this is the best exposure from a bracketed sequence of images. The critical factor was the need to record texture on the watercolour paper that forms the background, while at the same time getting as much brightness as possible into the rose buds. Picture taken on Kodak Ektachrome E200 using a Contax Aria 35 mm SLR.

Figure 2.2 Exposing tungsten film under twilight conditions is a great way of making the sky appear more blue while at the same time taming the colour cast of incandescent lights that start to come on at this time. Picture taken on Kodak Ektachrome EPT using a Lubitel medium format TLR camera.

In short, whilst there exist two common photographic lighting standards, real-world lighting can have almost any colour. And although there are colour temperature meters that measure the exact colour of any light, such details are not a high priority at this stage. For now, the important point is to appreciate that all lighting has an intrinsic colour: measuring and controlling that colour (with meters and corrective filters) is best left until other, more fundamental aspects of lighting have been fully mastered.

Figure 2.3 This pair of images, exposed just a few minutes apart, illustrates how the colour of sunlight varies when the sun shines directly in comparison with its effect when obscured by clouds. Pictures taken on Kodak Ektachrome E200 using a Mamiya 645 Pro medium format SLR.

Basic properties

In addition to colour temperature, another three properties can be used to define any light source: power, size and prevailing direction. The term 'power' is applied here loosely, not in its strict scientific meaning, and is related to brightness. In terms of daylight, it can be typified according to the prevailing weather conditions and the time of year. The fact that daylight is usually predictable is what allows general exposure recommendations – such as f/16 in bright sunlight with the shutter speed set to the nearest reciprocal of the ISO film speed (i.e. 1/125 s for an ISO125 film, and 1/500 s for an ISO400 film).

Similar consistency in typical domestic lighting levels means that an exposure of 1/30 s at f/2.8 will almost certainly give acceptable (if rather yellow) indoor pictures on ISO400 or ISO800 film.

Readers who have been brought up in an age of sophisticated automatic 35 mm SLRs may be surprised that such sweeping generalizations work – but they do. Provided that exposures are made on negative films, which are relatively tolerant of slight exposure errors, a good result will be obtained most times. The advantages of sophisticated automatic metering systems only become truly apparent under more tricky conditions, though even then there are often rules of thumb that can be remarkably effective. The moral of this brief interlude is that exposure is not difficult, despite the best efforts of modern SLRs to make it appear that way. At the same time, it is more complex than these generalizations might suggest, and exposure issues are therefore the subject of their own separate chapter later in this book.

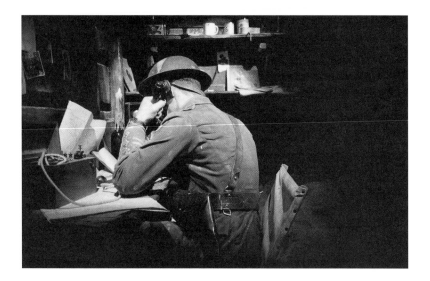

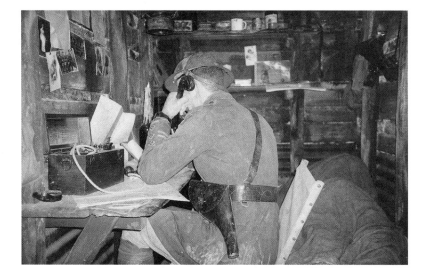

Figure 2.4 This tableau, at the Imperial War Museum in London, was photographed by available light and using the camera's integral flashgun. It is clear that although the latter shows more detail, the former is far more atmospheric. Picture taken on Ilford HP5 Plus using an Olympus LT-1 35 mm compact camera.

Having made a comment about the relative consistency of interior lighting levels, it must be admitted that the more common tactic is to employ a small on-camera flashgun in such situations. This being the case, in order for flash pictures to be recorded indoors using the same film that is otherwise used under daylight illumination outdoors, it follows that flash must have a similar spectral quality to natural daylight. Clearly, however, the ways in which the two sources generate their light are very different, so to expect an exact match would be unreasonable. Some older flashguns have a colour balance that is slightly too blue, but newer flashguns tend to be very much better (though they can still show colour shifts at different power levels). Nevertheless, once again fine detail such as this is jumping the gun at this early stage. It is far more important to concentrate on the issues of power, size and direction already mentioned.

Power and brightness

Power can be quantified relative to either the lighting's cause or its effect: the former characterizes the light source itself whereas the latter is related to the appropriate photographic exposure. The first is an absolute, the second depends on the result that the photographer wants to obtain (how light or dark the final image should be). The guidelines already given for bright daylight and domestic interior exposures assume that an 'average' result is wanted. For early lighting work, average results are normally appropriate, but as experience grows almost all photographers tend to customize their exposures to suit particular styles. Such methods will be covered in more detail later.

To quantify the power of a light, different measures are used depending on the source type. Small on-camera flashguns are characterized by a guide number (GN), which often forms part of the flashgun's model number. The Metz 40CT4, for example, has a guide number of 40, and the Sunpak AutoZoom 3600 has a guide number of 36. Exceptions to this rule include Nikon, whose flashguns are numbered in model sequence prefixed by the initials SB (e.g. SB28). The meaning of guide numbers is explained below. Studio flash units can be specified in the same way, but are more commonly described by their ratings in joules (J) or watt-seconds (Ws). These two expressions are equivalent. The definition of one watt of power is the expenditure of one joule of energy in one second of time. It therefore follows that watt-seconds are joules divided by seconds, multiplied by seconds – or simply joules for short. Nevertheless, the UK seems particularly reluctant to use joules – despite the expression's superior linguistic and technical elegance. One theory is that engineer James Watt was British

whereas joule sounds like a French name: in fact, physicist James Joule was another Briton whose only misfortune appears to be the timing of his birth within a few months of Watt's death.

No such problem exists for continuous sources, which are all defined by the power consumption of the 'bulb' fitted, measured in watts (W). The word 'bulb' is used here reluctantly, and will in future be supplanted by the more correct term 'lamp'. A bulb, as its name suggests, is something bulbous in shape – which older lamps often were for reasons of strength – but modern lamps frequently are not because they can now be made more compactly using stronger materials than plain glass. The fact that it is illogical to call a linear light a 'bulb' is the reason why fluorescent lights are referred to as 'tubes' – though even here a tube is nothing more than a particular kind of lamp. So throughout the rest of this book the word lamp will be used to denote a general artificial (continuous) light source, and more specific terms will be applied only where appropriate.

Of the various terms used to express light output, only the guide number has any immediate practical significance. The other two (joules and watts) are useful when comparing one light source with another, but are not generally used directly to determine photo-graphic exposures nowadays. Indeed, to a considerable extent even flashgun guide numbers have been relegated to comparison purposes thanks to the advent of fully automatic flash exposure systems.

The definition of a flashgun's guide number is as given in Equation 2.1.

$$\text{Guide Number (GN)} = \text{Aperture (F)} \times \text{Distance (d)} \quad \text{(Eqn 2.1)}$$

In this expression, the aperture is the F-stop that gives correct exposure when the flashgun is fired at the subject from the specified distance. The distance may be measured in any units, but the guide number figure will change with the scale used. Therefore the guide number must be specified for particular units – and for a specific film speed. In Europe, guide numbers refer to metre distances whereas the US specifications often use distances measured in feet: in both cases, the film standard is ISO100. Although it may not be obvious immediately, Equation 2.1 is an expression of the inverse square law of lighting, which is discussed in greater detail later. For now, it is only necessary to note that for the inverse square law to work, the light source must be very small – and that this observation leads neatly on to the issue of light source sizes in general.

Light source size

Outdoors, natural illumination normally comes from the sun, which is a truly massive light source that is located far distant from the earth. In effect, therefore, it behaves as if it were a small light

source. From the surface of planets closer to the sun, the sun would appear much bigger, while more remote planets see the sun even smaller in their skies. As such, it should be evident that the effective size of a light source is related both to its physical size and to its distance from the illuminated object. Allied with this change in apparent size is a variation in illumination intensity. Planets very close to the sun experience brilliantly bright daylight hours, while the surfaces of more distant planets are more dimly illuminated.

Returning to earth, a further complication arises outdoors on a cloudy or hazy day when the sun cannot be seen, and its light is heavily diffused by cloud. In photographic terms, this type of lighting can be likened to that from a huge overhead softbox. As such, the effect in this case is related to the size of the diffuser (area of cloud cover or softbox screen), and is largely independent of the physical size and location of the source itself.

The effective size of any light, whether it is natural outdoor lighting or an artificial source in the studio, governs the effect produced. Small light sources are called 'hard' because they produce hard-edged shadows that tend to be very dark. The word 'hard' therefore applies both to the severity of the shadow edge, and to something analogous to high image contrast. Large light sources are called 'soft' because they have the opposite properties: their shadows

Figure 2.5 An exhibit, photographed at the National Museum of Photography, Film and Television in Bradford, showing the type of lighting arrangement that was used for some 'Hollywood style' portraits. Picture taken on Kodak Tri-X using an Olympus XA 35 mm compact camera (no flash).

are poorly defined and less dark – equating to low contrast. Any hard light source can be made soft simply by placing a diffusing screen between the source and the illuminated object (as is the case when even cloud cover obscures the sun). It is very much more difficult to make a soft light source into a hard one.

Although hard and soft lighting have been discussed as two extremes, there is in fact a wide range of intermediates. Different sizes of dish reflectors fitted to the same light source give different amounts of hardness and softness, as do semi-opaque screens that are placed between the light source and the subject.

Hard lighting is often lighting that is more localized than soft lighting, but this is not always the case. In particular, grid-like baffles ('honeycombs' for studio flash heads, or 'egg-crates' for large tungsten lights) are very effective in reducing the scattering of light into unwanted areas without increasing the hardness of the lighting. More details about different light sources and their accessories appear further on in this book.

Lighting direction

Natural daylight comes from a source that is usually overhead, and never significantly below eye level. As such, naturally lit pictures,

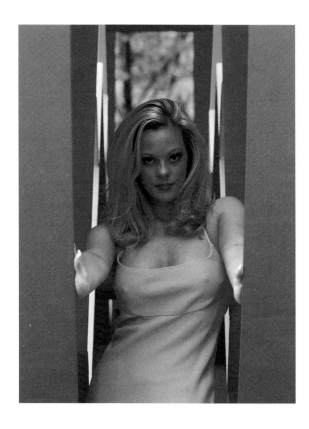

Figure 2.6 In b&w photography, colour casts are not apparent. It would therefore not be guessed – though the accompanying colour image shows – that the environment used for this portrait is in fact very strongly coloured, and gives an objectionable cast on transparency film. Both pictures taken using a Mamiya 645 medium format SLR.

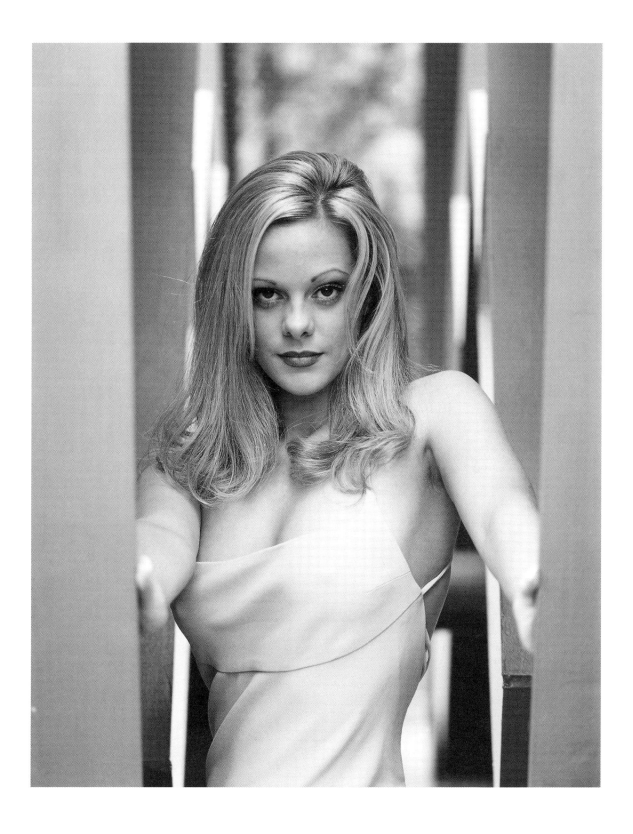

whether taken by daylight or artificial light, look best when the light source is above the subject. On-camera flash, where the light source often faces the subject head-on, tends to look harsh and unflattering by comparison. Similarly, in the studio it is best to have lights angled down from on high, though there is also a good case for a large, soft light source placed more or less at eye level. Such a source mimics the light from a north-facing window, providing gently graduated illumination that looks natural for an indoor setting. These two possibilities (lighting from above and lighting from the side) are formalized for portrait photography by the so-called butterfly lighting and Rembrandt lighting arrangements respectively – details of which are given later.

In product and still-life photography, unobtrusive lighting often comes by virtue of a large, diffused overhead light source. The bigger the source, the less shadow there will be, and also the less there will be fall-off of illumination with increasing distance from the source. This last point is important in avoiding 'hot spots' on those parts of objects that naturally lie closer to the source, and which would otherwise, according to the inverse square law, be over-lit. The fact that the problem doesn't arise – or at least can be minimized – demonstrates that the inverse square law does not apply in close proximity to large light sources. This in turn helps to promote a softer, more homogeneous lighting effect than would be obtained otherwise.

In other cases, especially when photographing artistic still-life studies, the direction of the light is often chosen to emphasize certain aspects of the chosen objects. Light that comes in steeply from one side, and grazes across a surface, shows very much more texture than would a light placed in front. The same light also helps to reveal overall shape – especially 'roundness' – by creating shadows on unlit surfaces. Equally, it follows that when texture and shape are not required, side lighting should be avoided.

The direction and size of the light source additionally influence surface colours. Smaller, front-on light sources tend to give the brightest results, which is one reason why ring lights (sources that surround the camera lens – see later) are much favoured for some types of fashion photography. The drawback of frontal lighting is that it increases the risk of 'hot spot' reflections of the lights being seen on the surface of the object by the camera. Obviously, smaller light sources give smaller reflections, and vice versa.

When photographing curved surfaces, it is all but impossible to locate the lights anywhere where they will not create a reflection. Sometimes, such reflections can be reduced using polarizers, but even these filters may not always be enough to hide the unsightly blemishes of reflected light sources. Unsurprisingly, this is an area where retouching (either traditional or digital) can come to the rescue.

Copy lighting

The least textured, least shapely form of lighting is that used for copying applications, wherein two identical light sources are placed in equivalent positions on opposite sides of the lens-to-subject axis. A dedicated copy stand with integral lights normally has either strip sources or multiple compact lamps arranged under hoods to each side of the baseboard. For a temporary set-up, it can be sufficient to use two tungsten or flash heads, one positioned to each side of the subject, both located at approximately 45° to the line between the centre of the subject and the camera. A specific example of copy lighting in action is given later.

The same arrangement can also be used to create a very soft portrait lighting effect that is easy to work with, but which risks producing very bland results. To a degree, this is the nature of all photographic lighting: either it can be arranged for maximum ease of use, or for maximum effect. Rarely will the two coexist at the same time. Therefore, there is a case for saying that if the lighting is versatile, suiting a variety of different subjects (whether different people or different types of still-life arrangements), then the resulting pictures will not be of the highest quality because the lighting has not been properly optimized for the individual job in hand. Sometimes – when doing portraits en masse, for example – ease of working is more important than outstanding results, and on these occasions versatile lighting arrangements are the correct choice. But when time permits, and perfection demands, bespoke lighting is the better choice.

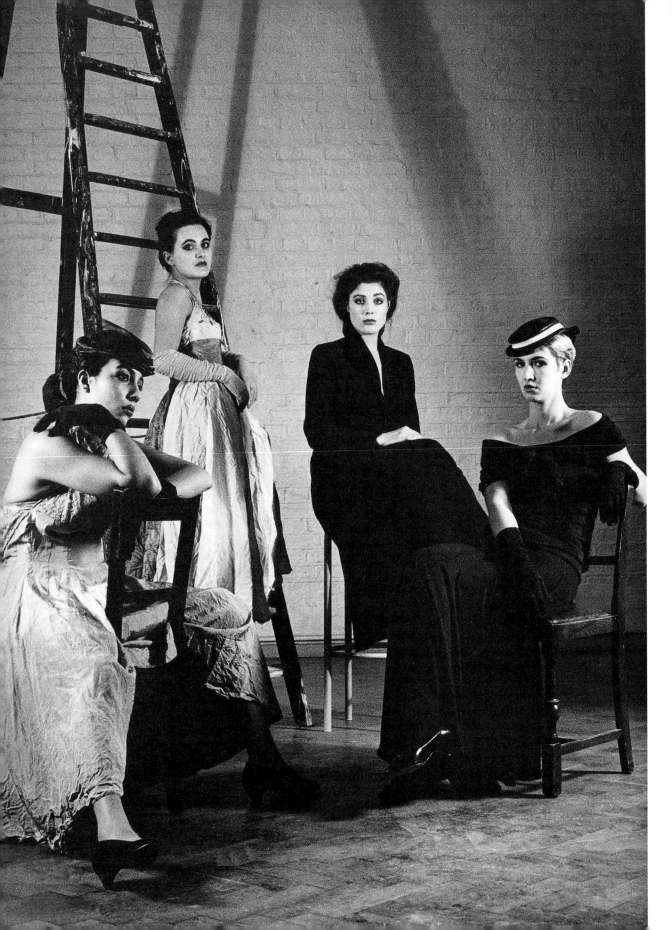

3 CONTINUOUS SOURCES

Whereas the previous chapter covered mostly broad considerations and the properties of light sources in general, attention here turns to the effect of specific lighting units.

In order for any lighting unit to perform a particular task, its light source must be of an appropriate design. It follows that if a light is required to illuminate, say, a person standing full height, then the best source will probably be one that illuminates evenly over a 2 m length. This effect could be achieved either by using a uniform source (an array of photographic quality fluorescent tubes, for example) or by arranging a number of discrete sources behind a homogenizing diffuser that results in virtually even illumination. Although the former is neater, the latter is more versatile in that it allows gradation of the lighting if required.

In the same way that a large light source provides even illumination for large objects, so a small source is ideal when the light will be modified using optical devices. This is because light-source lenses (and even many reflectors) are designed on the assumption that they will be affecting light that originates from a very small (point) source. Sadly, few lighting units fit this description: older tungsten lamps are particularly serious offenders, as are most flash heads. More modern tungsten lamps and those used in high intensity discharge lighting feature more compact sources, but even the latest flash heads almost invariably employ ring-shaped flash tubes.

Before looking in more detail at different light source designs, it is worth restating an underlying problem that was first identified when discussing copy lighting: any versatile lighting arrangement is

Figure 3.1 Cast picture for the play *Blue Angel*, taken in a rehearsal studio using portable tungsten lighting. The ladder was added to the set with the deliberate intention of creating an interesting shadow pattern. A very slow shutter speed was required, so the camera was tripod mounted and the actresses were asked to hold still. The final picture is so sharp that it looks as if it could have been taken by flash!

likely to be inferior for a particular task compared with one that has been devised uniquely for the job in hand. In the current context, it should now be noted that a general purpose lighting unit is also likely to represent a compromise in almost every situation, and can invariably be improved upon for specific uses. Tempting though it is to imagine that a core lighting system can be adapted for most purposes, the truth is that it is generally better to use equipment that is best suited to your most common application, and to work harder to adapt it for other uses when necessary.

Design philosophies

The biggest divide that exists between different types of light sources is the underlying design philosophy gulf between the manufacturers of continuous light sources and the majority of flash heads. Continuous lights, especially those that were conceived for theatre or motion picture use, tend to be built with particular applications in mind: flash heads are often universal cores onto which a variety of modifiers can be mounted to give different lighting effects. As just observed, the former approach tends to give better quality, whereas the latter can be more cost effective for users of the equipment. So although most people, when asked what advantage tungsten lighting offers over flash, will normally cite the former's 'what you see is what you get' quality, in fact the more correct answer is that tungsten units are more likely to be properly designed for a specific use.

It must be pointed out, however, that there are exceptions to this rule on both sides of the fence. In the tungsten arena, portable tungsten lighting kits, such as are used for news gathering and lightweight location filming work (brands such as Photon Beard and Lowell), are promoted partly with their general purpose heads and various ranges of add-on adaptors in mind. When portability is paramount, optimum lighting configurations become a secondary issue.

Similarly, there are high-end electronic flash manufacturers, principally the Swiss company Broncolor and Strobex in the UK, that make a range of dedicated studio flash units for particular professional applications. Users of these systems would not dream of fixing, for example, a fabric softbox on the front of a general purpose head when it is possible to buy instead a rigid softbox with a bespoke array of flash tubes arranged inside.

Nevertheless, many photographers cannot afford custom-built lighting units, and manage to work very successfully using the general purpose approach. Even so, it is still important to understand the characteristics of different light head designs, for only by doing so do the relative merits of different manufacturers' decisions become apparent.

Tungsten lamps

The term 'tungsten' is applied to hot lights generally. The fact is that very few tungsten lights today use old-fashioned tungsten lamps. Those that do are easily identified by their bulbous fittings (legitimately referred to as 'bulbs') that resemble oversized domestic lights. There are both 'Photoflood' and 'Photolamp' types, each with its own unique characteristics.

Photoflood lamps come in 275 W (P1/1) and 500 W (P1/2) versions, though the ratings specified do not reflect the amount of light given out. This is because the lamps are 'over-run' and therefore burn brighter than their wattage would ordinarily suggest. By the same token, their operating life is severely reduced. The trade-off is a dramatic one, as Figure 3.2 shows. This graph indicates that if a lamp is run at a voltage that is 20 per cent higher than its normal rating, then the light output goes up by around 75 per cent but the expected lifetime is only around one-sixth of what it would normally be. In addition, as would be expected from last chapter's discussions, an over-run lamp operates at a higher colour temperature. In the case of Photoflood lamps, this temperature is about 6–7 per cent higher – at about 3400 K compared to 3200 K for normal tungstens.

Conversely, although Photolamps are more expensive than Photofloods they also last longer in use. They are not over-run, but gain extra output from higher ratings: 500 W (P2/1) and 1000 W (P2/2). The effective outputs of the two Photolamps are actually higher than those of the two Photofloods – but that does not mean

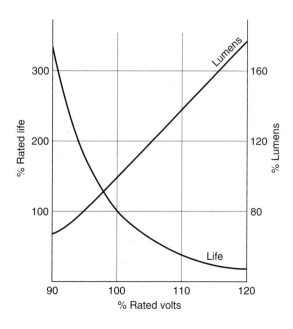

Figure 3.2 Typical variation of lamp life and light output against operating voltage.

that the higher rated lamps suit shorter photographic exposures. The subject of exposure is covered in Chapter 7; even so, before going on here to look at modern tungsten-halogen lamps, a brief diversion is required to comment on the 'actinic' quality of any illumination.

Actinic light

Although little talked about today, 'actinism' is the ability of light to cause a photographic change. Early photographers discovered that it was not enough to have a bright light; rather, they needed a light that had the correct quality – the ability to cause darkening on a photographic plate. They discovered, for example, that the light of a fire, whilst bright to the eye, was not an effective photographic illuminant. The reason was that their films (unlike modern emulsions) had no sensitivity to reddish firelight. But even though this particular failing has long since been addressed, issues do still remain that can cause slight differences in film speed when using b&w film with daylight and tungsten illumination. Such differences become even more significant when colour filtration is used, or when an infrared-sensitive emulsion is employed, and can also arise when colour film is shot under lighting for which it is not correctly balanced. These aspects will all be covered in more detail later: for now, suffice it to say that with tungsten lamps – as with flash heads – power rating comparisons alone are not firm indicators of actual photographic performances.

With that fact in mind, attention turns to modern tungsten-halogen lamps that provide the dominant continuous lighting source in photographic use today. Although the name suggests that a 'halogen' material is what separates the old and new types, this is an over-simplification. In a tungsten lamp, a very thin tungsten wire filament is contained within a glass envelope filled with inert gas. During use, tungsten metal inevitably evaporates from the filament and condenses on the inside surface of the glass envelope. From the outside, this causes blackening on the glass; inside, the filament is thinned where evaporation occurs. Eventually the filament thins to such an extent that it breaks, ending the life of the lamp. Between this rather crude type of lamp – which is actually little more than a very bright domestic light – and a modern tungsten-halogen type there sits a halfway model. This version has the named qualities of a tungsten-halogen lamp (a tungsten filament and a halogen gas), but is otherwise the same as a plain tungsten type. The only advantage of the in-between lamp is that it does not suffer from blackening on the inside of its glass envelope and therefore enjoys a more consistent light output.

Modern tungsten-halogen lamps feature further refinements that not only improve lighting efficiency but also extend their service lives. Most importantly, in addition to a gaseous filling that features both nitrogen and halogens (chemical elements that include chlorine, bromine and iodine), the envelope material is changed from glass to quartz, and the overall design of the lamp is made more compact (see Figure 3.3). As a consequence of this last factor, the envelope can be filled with gas to a higher pressure, and this in turn further reduces tungsten evaporation. It is also the case that the envelope of a modern tungsten-halogen lamp runs hotter than that of a plain tungsten type: indeed, if ordinary glass were used in a high-technology tungsten-halogen lamp it would simply melt away.

Failure of a tungsten-halogen lamp arises either from degradation of the quartz envelope (especially if the outside of the lamp has been handled with bare hands), or by crystallization or thinning of the filament. The last of these is, of course, the same cause as that most common amongst plain tungsten lamps, but appears only after a much longer service life – typically double that of a less sophisticated type. It is therefore not surprising that quartz

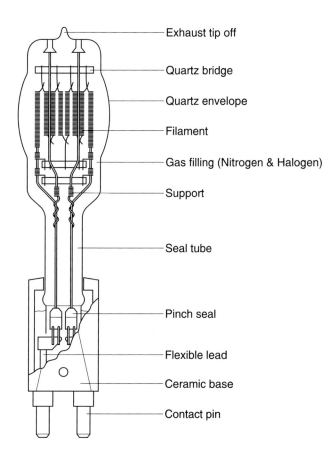

Exhaust tip off

Quartz bridge

Quartz envelope

Filament

Gas filling (Nitrogen & Halogen)

Support

Seal tube

Pinch seal

Flexible lead

Ceramic base

Contact pin

Figure 3.3 Construction of a typical high-wattage studio lamp.

tungsten-halogen lamps have largely displaced plain tungsten and glass-enveloped tungsten-halogen lamps.

Admittedly, modern tungsten-halogens are more expensive, but this is offset by the convenience of not having to change lamps so often. In any case, by buying lamps from specialist suppliers (rather than general photographic outlets) considerable cost savings can be enjoyed. Certainly, anybody who shoots regularly under tungsten-halogen lighting really should research lamp prices from different suppliers as it is the author's experience that prices can vary by a factor of three – or sometimes even more.

Tungsten heads

Surrounding the light source is the head (or 'luminaire') – and it is therefore the head that is seen when any tungsten light is first viewed. Sadly, not all tungsten heads that look the same, or even are called the same, actually have the same lamps inside. And therefore, given that it is the lamp design that is the foundation on which the best uses for any light rest, it follows that some lights will be better in certain applications than others. A warning has already been issued about judging lights by wattage power ratings alone: now a second warning is given here advising caution over the inter-pretation of the names given to lights by different manufacturers. Readers are urged to look carefully at each individual brand to discover its design philosophy rather than taking the use of similar names at face value.

The most common compact tungsten lights are 'redheads' and 'blondes' – both so named in recognition of their original outer

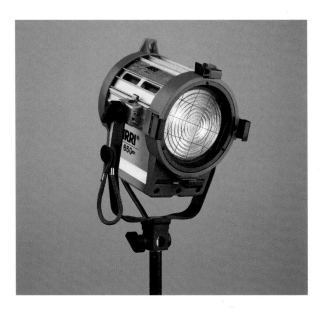

Figure 3.4 Arri 650 W Junior, the smallest in a family of Fresnel lights. Picture courtesy of Arri GB.

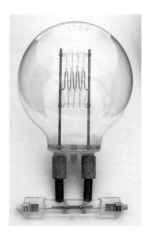

Figure 3.5 Old-fashioned 2000 W single-ended 'bulb' and modern 2000 W double-ended tungsten-halogen linear source (type FEX). Picture taken using a Fujifilm FinePix S1 Pro digital camera set to monochrome mode.

casing colours (orange and yellow respectively). Current designs differ from one manufacturer to another, but in all cases the maximum power lamps that can be fitted are consistently 800 W for redheads and 2000 W for blondes. In Photon Beard lights the lamps are linear, whereas Arri lights are fitted with compact filament (projector-like) types. In view of such differences, it should be clear that this is a case where specific terms (redhead and blonde) are indicative only of general species of small tungsten lights. In the case of Arri, the outer housings are not even coloured as expected, but this does not, of course, make the company's lights any less effective.

To a degree, modest tungsten lights of the type that find use in stills photography all divide along the same lines as the Photon Beard/Arri lamp difference: some employ linear tubes whereas others use more compact designs. Lights that are intended for lighting broad areas, such as backgrounds, tend to use linear tubes. Lights that exploit circular symmetry, either in their reflectors or through optical focusing attachments, tend to use compact lamps. Wise buyers will keep this guideline in mind when choosing which units to purchase.

Fluorescent lighting

When photographs are taken under domestic or industrial fluorescent tube lighting, a nasty green cast frequently results. This arises from a big green 'spike' in the output spectrum of tubes that are designed with low cost as their highest priority. However, by combining an optimized mixture of gases with a carefully tailored phosphorescent coating, it is possible to manufacture fluorescent lights that are almost as good as daylight in their overall photographic effect. As has already been explained, the light quality of a fluorescent tube is expressed using the colour rendering index

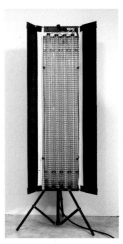

Figure 3.6 Photographic quality fluorescent lights are available from several different manufacturers, one of the best known of which is KinoFlo: this is the 4 ft FourBank. Picture taken using an Epson PhotoPC-850Z digital compact.

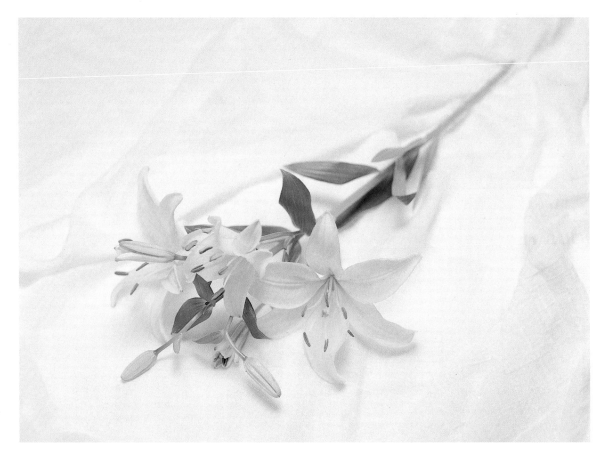

Figure 3.7 This high-key flower image was lit using only a single overhead fluorescent softbox. There is just the slightest hint of a green cast in the picture caused by an untamed 'spike' in the emission spectrum of the phosphor inside the fluorescent tubes. Picture taken on Kodak Ektachrome EPP100 using a Mamiya RB67 Pro medium format SLR.

(CRI), where 100 is a perfect score and anything above about 90 is considered good. Modern photographic fluorescent lights typically score between 95 and 98.

There is a complication here in that different photographic films react differently to the same fluorescent source. This fact arises from different specific spectral sensitivities in the emulsions, and the way in which these sensitivities align with the 'peaks' of the source's spectrum. Therefore, although the CRI is a good general indicator of lighting quality, only individual tests using a particular brand of lights and a specific type of film can reveal the results that will be obtained by individual photographers.

The attraction of fluorescent lighting is its softness, which comes from the large arrays in which the tubes are normally assembled, and its freedom from excessive heat. Other advantages include compact design (banks are typically less than 20 cm deep), good compatibility with the shape of the human body, and low

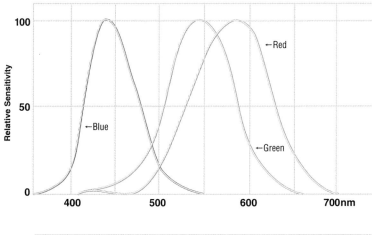

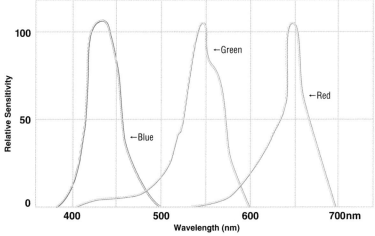

Figure 3.8 Differences between how the eye sees colour (wider curves) and how a typical photographic emulsion sees colour (narrower curves). Diagram taken from the Rosco CalColor brochure *New Ideas for Filters in Film*, reproduced courtesy of Rosco.

power consumption. The few disadvantages are relatively high purchase prices – leading most photographers to hire what they need when they need it – and occasional colour irregularities caused by interactions between the light and the subject being photographed. It should be realized, however, that this last effect is not confined to fluorescent lighting, and can be due as much to the film as to the light source. It therefore follows that the eye alone cannot possibly judge how a scene will record on film (see Figure 3.8), and neither can a Polaroid print provide a critical colour check. It is a sad but true fact that only film tests can give an accurate answer, and this is why many photographers like to stick with one chosen emulsion once they have mastered its behaviour.

Daylight discharge lighting

Whereas banks of fluorescent tubes are best viewed as dedicated soft lights, compact source discharge lighting is the exact opposite.

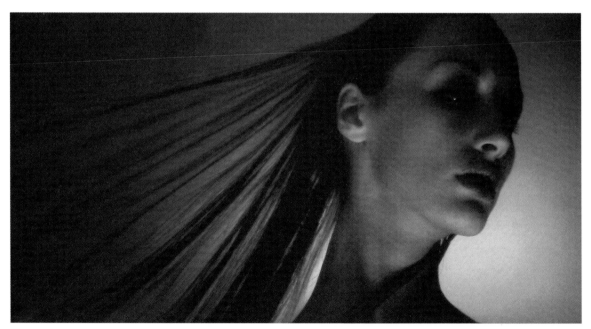

Figure 3.9 In the words of fashion photographer Sean Ellis: 'KinoFlo is actually quite a harsh light.' That comment comes despite the relatively large size of the source, and is an indicator of the difference that exists between the way in which a light source is viewed theoretically, and the way it is viewed and used in practice. To illustrate the point, the example image here was lit using one light on the background with a KinoFlo on the floor aiming upwards in a manner that many people think lighting should never be arranged. More generally, Ellis recommends positioning a KinoFlo above, and quite close to, the model, pointing down at an angle of about 45° to get a soft top-light effect with the hint of a linear catchlight. The disadvantage of what Ellis otherwise describes as the 'beautiful' KinoFlo quality is the lighting's relatively low output, which severely limits its use when shooting large format. In such situations, Ellis turns to the flash near-equivalent of KinoFlo lights – Ellistrip flash heads. 'That is the only way to get the depth-of-field you need: on eight-ten with a 600 mm lens, depth-of-field is minimal, even at f/45,' he explains. Photograph by Sean Ellis.

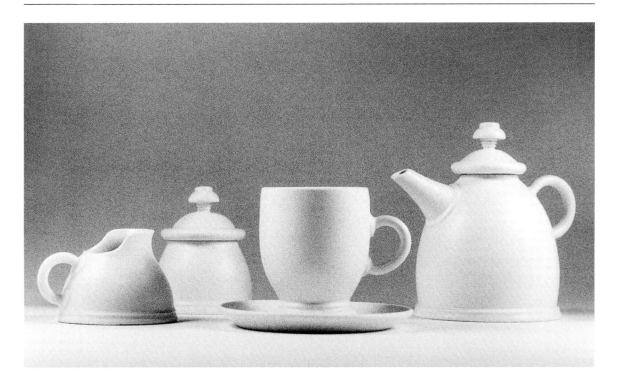

Both exploit the phenomenon of light being emitted when electricity flows through a gas, but do so in totally different ways. In the case of the fluorescent tube, a phosphorescent coating produces visible light over an extended length, but in a compact source lamp the electrodes are very close together and produce light directly. Not only is this light intense, but also it is of near daylight quality.

As has been the case in several instances already, compact source discharge lighting is another arena where different names are used by different suppliers: HMI, MSR and CID are three such labels. Lamp designs do differ, most obviously between single-ended and double-ended types, but the essential characteristics are much the same. Lighting efficiency is very high indeed, making a compact source discharge light 'equivalent' to a tungsten-halogen rated between three and four times higher. A 575 W CID, for example, gives out almost as much light as a 2000 W tungsten-halogen – and does so whilst at the same time matching the spectral requirements for daylight balanced colour film.

This last point is one reason why motion picture filming, which often runs between outdoor and indoor locations, tends to favour these lights. The alternative (using tungsten lights with daylight correction filters) is both inconvenient and less efficient. The main disadvantages of daylight discharge lighting (high capital and replacement lamp costs) are less significant in the context of

Figure 3.10 Emma Grove teaset, lit with two 800 W Photon Beard tungsten redheads. One light was placed to each side of the set, just out of camera view; both were shone through diffusing screens to give a softened effect. The film used was Ilford SFX200, filtered for a near infrared exposure to get increased grain (because smaller grains are almost unaffected by longer-wavelength infrared light).

large motion picture production budgets than they are for individual stills photographers. Once again, therefore, the sensible approach is to hire these lights as and when they are needed.

The attraction of compact discharge lighting is its small light source – almost a point source – that is perfect for hard-edge effects. Pictures taken under compact discharge lighting can actually look sharper than those taken under soft illumination. Compact discharge lighting is also invaluable when taking pictures using a high-end scanning digital back. This is because such cameras require a lot of light, and need their lighting to be absolutely consistent for the period during which the image is captured. Any continuous light that is powered from an alternating current (AC) mains supply flickers to some degree with the cycling of the voltage, but discharge lighting can be made to flicker so fast that it effectively becomes 'flicker-free'. This is done by fitting a high frequency ballast, which is very expensive under normal circumstances, but less so in relative terms when allied with already costly compact discharge lighting equipment.

In the early days of digital photography, when high-end cameras all used scanning systems, compact discharge lighting was very much in vogue: today, it tends to be confined to users of older digital cameras and fashion photographers in search of different lighting qualities.

Safety

It is generally the case that continuous light sources are bigger, heavier and more power-hungry than studio flash units. Therefore, great care must be exercised when transporting and using such lighting systems. The size and weight of continuous lights pose obvious handling problems, but power consumption can easily be overlooked. The loading of every lighting unit on the mains supply needs to be known, together with any power factors that apply. The latter refer to differences between the voltage and current phases caused by reactive components in the circuit: these components are coils and capacitors, and this consideration applies particularly to discharge lighting. It should go without saying that all lights must be correctly wired and fused, and that maintenance must be done only by those people who are suitably qualified.

When in use, lights must be supported on stands that are rated for the loads applied. Suspended lights must always have safety chains to prevent them from falling to the ground if their mountings work loose. Floor standing lights must be equally secure, and must never be mounted in any way that could allow them to fall.

Always be aware that the outer housings of tungsten-halogen lights can become very hot in use, and never attempt to move any light while it is still switched on: if nothing else, the vibrations caused will significantly reduce the lamp's life. Always allow lights to cool fully before packing them away for transportation – and never, ever let water come into contact with lighting equipment.

4 FLASH SOURCES

The origins of flash lighting were coincident with the beginnings of photography itself – but in a different context. In 1839, the same year that William Henry Fox Talbot demonstrated 'photogenic drawings' at the Royal Institution, Michael Faraday published details of his 'Electric Egg'. This was a device that could be evacuated then back-filled with samples of different gases. Inside the 'egg' were two electrodes that could be connected to an external power supply in order to observe the effect of passing electricity through the chosen gas. On the one hand, this line of investigation could be connected with discharge sources, but given that Faraday's power supply was instantaneous – a spark – the connection is more readily made with flash lighting.

Sparks were themselves the first means by which high-speed flash photography was conducted, and again it is Fox Talbot who is credited with the first such photograph. But sparks are of relatively low intensity, and for general photography chemical flash lighting was the route taken by the early photographers. It is generally recognized that J. Traill Taylor, a past editor of the *British Journal of Photography* (the oldest photographic magazine in the world), brought chemical flash lighting to the masses. This he did by devising a mixture of substances to use in place of magnesium alone. The latter had been employed for its bright, rapid-burning flame – but reluctantly so on account of its extreme expense. Traill Taylor proposed powdered magnesium in combination with potassium chlorate (a source of chemical oxygen) and antimony sulphide and sulphur. This was, in essence, a sort of gunpowder!

Apart from the explosive dangers arising from misuse of the mixture – such as accidental employment in lamps designed for plain magnesium (an easy mistake to make) – there was the very

Figure 4.1 To get bright colours, such as are seen here, it is usually necessary to throw a lot of light onto a set. That is most easily done using electronic flash. Here there are two lights on the blue background, two lighting the yellow floor, one on the red rubber curtain, a focusing spot on the model's face and a low angle light illuminating her hands and filling in on the face. The picture was taken on Kodak Ektachrome EPZ100, pushed one stop during processing.

serious disadvantage of copious amounts of white smoke coupled with unpleasant odours. One answer was to contain the light source within a sealed jar, and so the 'flashbulb' was born. Although the first commercial flashbulbs contained magnesium, it was aluminium foil (rather than ribbon) that was used in Osram's pioneering Vacublitz bulbs of 1932. Interestingly, foil had been suggested previously in the context of multiple sparking systems by none other than William Henry Fox Talbot (writing to Michael Faraday in June 1851) for spark-illuminated photography, and it may be that this is where the idea for Osram's design originated.

Flashbulbs continue to be manufactured and used for some applications today, but the vast majority of modern flash lighting equipment employs what could be described as an instantaneous discharge tube. Building on the work of Faraday and Heinrich Geissler (who designed a very substantially improved vacuum pump and also perfected the embedding of wires in sealed glass tubes), it was Marcel Laporte who discovered that a spark transmitted through xenon gas, under the appropriate conditions, could produce a brief burst of artificial daylight.

Electronic flash units had existed before Laporte's work of the 1930s, but items such as the Seguin brothers' Stroborama and Harold Edgerton's Stroboscope initially used neon or argon gas, or mercury vapour – none of which is truly suitable for photographic work (though pictures indeed were taken). Nevertheless, Edgerton is the man that history credits with the invention of the first proper photographic flash unit, a device that Kodak developed to produce the Kodatron flash pack of 1940. Costing a then very substantial $225, the first Kodatrons were 200 J heads that featured a xenon flash tube, a 50 W modelling lamp, interchangeable reflectors and a photocell to trigger additional units. In short, they were the clear ancestors of all studio flash systems today.

Studio flash systems

Initially, all studio flash systems were in two parts: a power supply unit connected to a separate head by cable. This design persists today, and is known as the generator pack configuration. Subsequently, a different arrangement – the monobloc – was devised. This combined the power supply unit and the head in a single housing, an idea that was first realized by the Surrey company, Langham Photographic Instruments, in the early 1950s. Not surprisingly, this more compact configuration proved very popular, and almost every flash manufacturer today offers either this design alone, or this design as an alternative to generator packs.

While reduced size is the obvious advantage of the monobloc design, it is not the only one. Monoblocs are more portable by

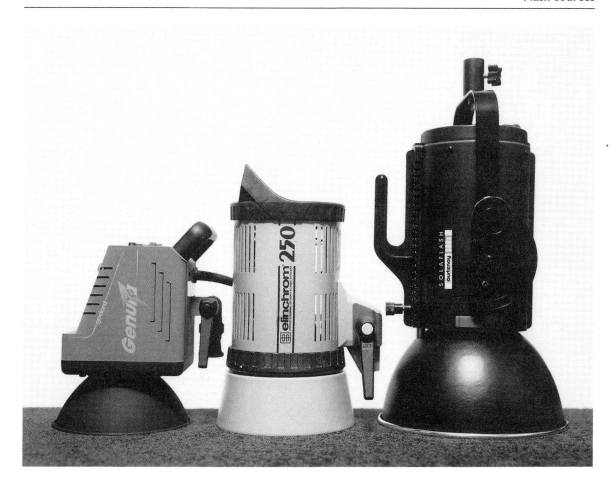

virtue of being lighter, and generally start at lower prices. In addition, they can be purchased individually, whereas because a modern power pack has the capacity to drive multiple heads it is best bought as a complete set. Not only that, but if a generator pack develops a fault it blights all the attached heads: by contrast, the failure of one monobloc has no effect on any others. Therefore, monoblocs can be considered a 'safer' option – especially when working on location.

Against these plus points is one huge disadvantage – monoblocs are almost always constructed using a general purpose flash tube. This means that compromise is an inevitable partner of monobloc lighting. When softboxes are fitted, this fact is of little consequence (though perfectionist photographers will still prefer a dedicated soft light with bespoke flash tubes inside). But when hard lighting is required, or specialist accessories are to be fitted, monoblocs quickly reveal their weaknesses.

Countering this attitude of compromise are the myriad heads offered by those companies who specialize in generator packs.

Figure 4.2 Trio of modern flash monoblocs revealing a considerable difference in overall size. Significantly, the Courtenay Solaflash (far right) is both the largest and the most sophisticated of the three, while the Godard Genura is both the smallest and the simplest.

Foremost amongst these are Broncolor in Switzerland, and Strobex in England. It is no coincidence that the studios of professional photographers for whom lighting quality is paramount, and money no object, are frequently equipped with one of these two brands.

Battery flash systems

Portable flash lighting systems are almost as old as studio-bound units. Edward Farber had a working design as early as 1939 but this, like all of the first models, used valve circuitry contained within an over-the-shoulder power pack. Separate batteries and heads continued for many years, right up until the advent of transistors that allowed the low voltage from a direct current (DC) battery to be converted into simulated 'AC' and thereby transformed up to a much higher voltage. It is important to appreciate that whereas chemical flash is possible with just modest DC voltages, electronic flash is not. Transistors, and subsequently thyristors (for conserving power), are what made portable electronic flash truly viable for the mass market. Interestingly, over-the-shoulder portable flash packs do still exist today. The reason for this is one of power. By employing a substantial battery, not only can the flashgun be made more powerful (or faster in recycling), but also it is possible to add a modelling light to the system. Some of the latest all-in-one camera flashguns also have a modest 'modelling' facility that is provided by a rapid stroboscopic flash effect that appears continuous to the human eye, but the duration of this is brief, and such systems are not as user-friendly as those with proper modelling lamps when working under difficult conditions.

Figure 4.3 'Hammerhead' style professional flashgun. This Sunpak G4500DX has, as its name suggests, a standard metric guide number of 45.

Some all-in-one flashguns have two separate flash tubes of different power. The theory here is that the main tube can be angled to reflect its light off a white ceiling, for example, in order to create a softer, more natural lighting effect than would be obtained with direct flash. The second tube then provides fill-in illumination that lightens shadows created by the high-angle 'bounced' light. This can be a useful feature, but because it is usually necessary to use the twin-flash system in automatic mode, users are at the mercy of their cameras. As far as controlled lighting goes, this is clearly not an ideal situation. It is also a fact that different cameras use different algorithms when assessing lighting levels for automatic exposures – and therefore produce different results even in the hands of the same user. This is a very unhealthy situation for any purist photographer, though it must be admitted that when time is tight a fully automated system will often perform well enough.

If conditions are more favourable, an experienced photographer should be able to achieve better results than even the most sophisticated automatic flashgun. This fact is true for the very simple reason that the flashgun has no knowledge of the subject

Figure 4.4 Classic on-camera flash picture of the 'grip and grin' type – in this case a presentation to Greg Forte of London processing lab Joe's Basement by the late Terence Donovan. Picture taken on Ilford XP2 using a Mamiya 645 Pro medium format SLR and a Metz CT40 flashgun.

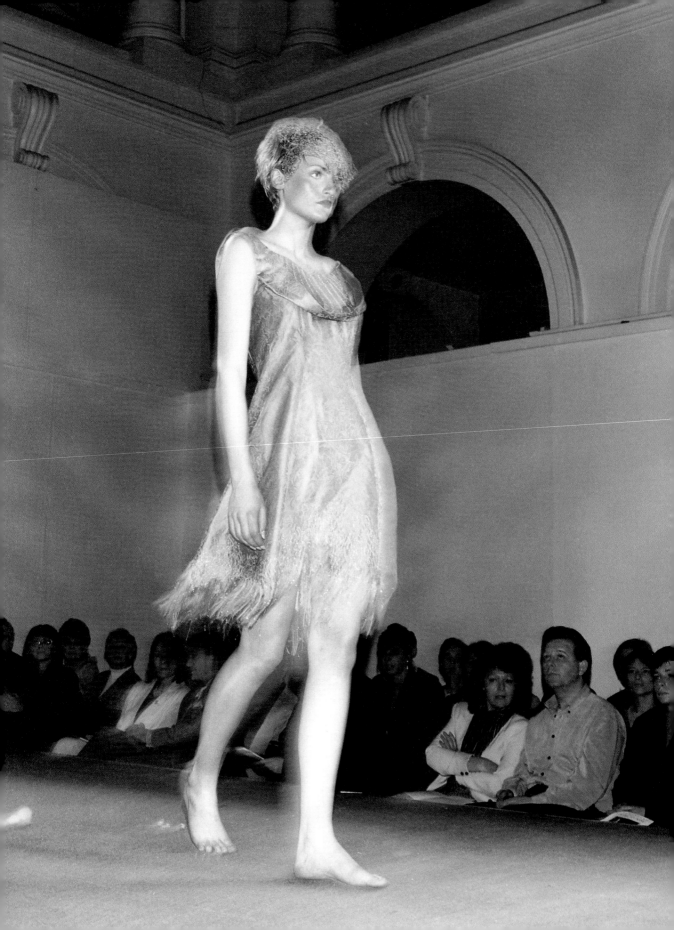

being photographed other than its overall brightness and (in some cameras) its distance away. The photographer, on the other hand, knows both of these things, and also knows not only why the subject reflects with its measured brightness but also how this brightness should be interpreted to get the desired picture. Such interpretations are central to a successful marriage between lighting and exposure – and are covered in detail later.

As far as versatility is concerned, flashguns are even more limited than studio monoblocs. Their tubes are very small so their lighting is very hard. Bouncing the light, or diffusing it through a small softbox attached to the head of the flashgun, can help, but by far the biggest improvement to flash-lit pictures can be obtained by balancing the flashgun's output against the ambient light level. If the flashgun is well balanced, the background will be visible (albeit rather dimly lit) and shadows cast by the flash tube will be reduced. If the output is not balanced, either the background or the flashgun's shadows will be almost black. In the very worst cases, it is even possible to see both failings in the same picture! Fortunately, modern automated flash exposure systems have considerably reduced occurrences of the second type – and have generally also improved the quality of pictures taken under mixed daylight and flash lighting.

To a degree, therefore, the answer to many flash lighting problems is simply to set everything on automatic. That will work well, but it will teach you nothing about lighting. Worse still, it will limit your lighting to those conditions that the flashgun and camera can handle. In many cases, that will mean keeping the flashgun mounted in the camera hotshoe – which is just about the worst place for it to be. Sacrificing the convenience of automation, and learning to do things manually, will open up many more possibilities. Indeed, unless you take that simple step you will be unable to benefit fully from this book.

Flash characteristics

The principal property of flash lighting, whether it originates from a chemical or an electronic source, is that it is transitional. It is therefore necessary to ensure that the camera exposure coincides with the flash burst. The human eye is misleading in this context, for it appears that a flash burst might last for the best part of a second. In fact, an electronic flash lasts at most around 1/250 s, and can be

Figure 4.5 Balancing fill-flash with ambient lighting is easy to do manually (as here) with careful metering, but is even easier with modern fully automatic systems. Picture taken on Fujicolor NPH colour negative film using a Mamiya 7 medium format rangefinder camera with a Sunpak 3075G flashgun.

as much as one hundred times faster (these figures refer to typical studio and flashgun units respectively). Even a flashbulb lasts for only about 1/50 s, though this period of peak brightness comes only after an approximately equal initialization time. That is why some older cameras have both 'X' and 'M' flash synchronization settings: the former suits electronic flash whereas the latter is for M-class flashbulbs with an initialization time of around 1/40 s. Modern cameras have only 'X-sync' and are therefore only compatible with electronic flash, but do offer synchronization relative to either the first or the second curtain of a focal plane shutter.

This last development arises from the fact that a focal plane shutter (the type found in 35 mm SLR cameras) exposes the film by running two curtains across in front of it. The size of the 'slit' between the curtains determines the exposure time. However, in order for the very brief burst from an electronic flashgun to make an exposure over the whole of the film, it stands to reason that the 'slit' must be wide enough to reveal the entire area of the film frame at once. This situation always introduces a slight delay between the first curtain becoming fully open and the second one starting to close, and it is this delay that the first/second curtain synchronization option exploits.

The effect on the image is that second curtain synchronization minimizes the effect of ambient light blurring after the flash has fired, so in the case of moving objects it forces any movement blur to exist mostly behind the object. This is very much more realistic than the in-front blur caused by first curtain synchronization. (The same issue does not arise in cameras that have lens shutters because here the exposure is always evenly imposed over the entire film area.)

In a thyristor-based flashgun, the flash duration reduces as the power level is decreased. This means that if a flashgun is to be used for stopping high-speed action (using a suitable high-speed trigger), it should be set close to minimum power. On the other hand, studio flash units tend to give their shortest durations at maximum power, because this corresponds to the highest electrode voltage. In any case, the flash duration of studio flash units is invariably longer than that of most flashguns for reasons that are intrinsic to the two designs (see box panel).

Figure 4.6 The top picture shows how moving car headlights can 'streak' in a picture, obscuring the subject. It was taken using 'first curtain' synchronization, so the streaks appear in front of the car, almost as if it was moving away from the camera: using 'rear curtain' synchronization would have given a more natural appearance. The bottom picture is fully sharp except for light streaks in the background, which come from the camera being 'panned' to follow the action as the picture was taken. In this case, the streaks are small and distant, so do not cause any great distraction.

When comparing flash durations between different brands of equipment, it is important to make sure that the same figures are being quoted. Generally, flash durations are measured as the time period for which the flash burst's brightness is above one-half of its peak value – designated t(0.5). The theory is that the bulk of the light is emitted within this period. But some manufacturers recognize that even outside this time the remaining light can affect the exposure (particularly in respect of critical image sharpness) and therefore choose to specify the time for which the flash brightness is above just one-tenth of its peak intensity – designated t(0.1). These two values are shown graphically in Figure 4.7.

Figure 4.7 Definition of flash duration on the time–intensity light output curve. Diagram taken from *The Photographic Flash – A Concise Illustrated History*, reproduced courtesy of Bron Elektronik AG.

In terms of relating the times quoted to other values, the t(0.1) figure can be compared to an equivalent shutter speed. Unfortunately, the more commonly quoted t(0.5) time has no such direct connection, but needs instead to be multiplied by some factor to get the same equivalence. The factor is variable depending on the design of the flash tube and its circuitry, but typically has a value around three. So in terms of arresting movement, a t(0.5) flash duration of 1/750 s commonly equates to a daylight shutter speed of about 1/250 s. This consideration aside, it matters little which value is quoted provided that the same specification is used for all units whenever comparisons are made between brands.

The range of power levels offered by any flash source, be it a flashgun or a studio unit, is the single factor that most determines its usefulness. So when looking to buy a unit, consider not only the maximum power level, but also the minimum. Often, cheaper units have respectable maximum levels but are found to be lacking at the lower end. In the studio, one solution is to buy monoblocs with different maximum power levels – and therefore, by association, a range of different minimum power levels too.

Allied with the power rating is the unit's recycling time, which corresponds to the delay that must be experienced between successive flashes at the same power level. Manufacturers of rapidly recycling equipment tend to make much of this property, but the

truth is that for most applications it is not really an issue. All modern flash sources recycle with acceptable speed most of the time. Studio generator packs are sometimes fitted with fast/slow recycling selector switches: the primary purpose is to allow slower recycling if the capacity of the mains supply is in any way doubtful, but this setting is actually kinder to the equipment's components in that it stresses them less. In general, the slower the recycling that can be tolerated, the better will be the long-term performance of the equipment.

Principles of flash

Despite mechanical improvements and the presence of some complex electronics, modern studio flash units and portable flashguns are still remarkably similar to models of old in their fundamental operation. The essential component is a tube filled with gas that, when an electronic pulse is applied, emits a burst of light as a transient current flows between its two electrodes. The triggering pulse is quite separate from the voltage that exists across the electrodes, and is applied via thin wire that is wrapped around the outside of the tube. At one time, the triggering pulse was transmitted through the camera's contacts to provide direct synchronization between the shutter and the flash, but nowadays a lower voltage 'relay' signal is all that the camera experiences.

In an on-camera flashgun, the tube length is very short, and as a consequence of this the duration of the flash can be very brief. Also, because battery power is precious, excess energy is re-routed back into the capacitors when only low brightness flashes are required. This is done using a high-speed semiconductor switch (called a thyristor, or silicon controlled rectifier), and results in shorter flash durations as the light output is reduced. Studio flash units work differently in that they do not generally reuse excess energy, and nor do they curtail their light output to the same degree. Instead, studio units are set to charge up to different power levels at the outset. Some older studio flash units do not allow any variations other than those provided by the selected power level: this can be a harsh limitation when working with packs that can be set only in whole F-stop steps. Newer units allow continuous (or virtually continuous) variations in output, but tend to do so over more confined power ranges. To get the best of both worlds, some modern units divide a wide power range into a number of smaller bands and offer continuous adjustment

within each separate range individually. An example of this approach is provided by the Bowens Esprit 1500 monobloc, which has three power ranges of 500 J each.

Flash colour variations (changes in the effective colour temperature) arise from the fact that electronically generated light comprises a mixture of different colours, and that different colours dominate at different stages during the flash burst. Initially, blue colours are the strongest, with oranges prevailing in the later stages. Therefore it follows that if the flash burst is curtailed, its light will be bluer than if it had run its full course. Differences are most likely to be seen when using high saturation colour transparency films to photograph subjects that contain neutral mid-tones: the problem is rarely evident with portraits and other more common subjects. Even so, by employing very sophisticated control circuitry, it is possible to influence flash duration, colour temperature and flash output simultaneously. That said, at the time of writing only Broncolor has incorporated such circuitry into commercially available studio flash packs.

Expanding slightly on the subject of tube length and flash duration, there is also the allied matter of applied voltage. In order to have a long arc length (flash tube), it is necessary to apply a higher voltage across the ends of the tube. This in turn requires appropriately high-voltage controlling circuitry – something that carries cost and safety implications. Therefore, the majority of mid-range studio flash heads feature only modest-length flash tubes. Those manufacturers who seek the briefest flash durations to render the sharpest pictures, do so either with very short flash tubes, or by using multiple arc paths within the tube. Short tubes do not naturally lend themselves to soft lighting effects, and multiple arcs can give inconsistent outputs. Therefore, as with so much else in photography, it should be accepted that there are no universal answers in flash lighting systems. The designer's art lies in knowing which compromises to make – and when. The knack for the photographer is to know what effect the various compromises will have on the intended lighting scheme.

Table 4.1 Characteristics of selected flash monoblocs

Make & model	Rating (J)	t(0.5) (s)	Recycle (s)	Lowest ratio
Bowens				
Esprit 250	250	1/1100	1.4 (max)	1/4 (step)
Esprit 500	500	1/500	1.4 (max)	1/32 (cont)
Esprit 1000	1000	1/1300	2.6 (max)	1/32 (cont)
Broncolor				
Minipuls C40	300	1/1000	1.4–0.6	1/8 (cont)
Minipuls C80	600	1/600	1.9–0.7	1/8 (cont)
Minipuls C200	1500	1/1000	2.4–0.6	1/16 (cont)
Courtenay				
Solaflash 300×	300	1/2300	1.5–0.6	1/16 (cont)
Solaflash 600×	600	1/1500	3.0–0.8	1/16 (cont)
Solaflash 1200×	1200	1/1000	3.5–1.2	1/16 (cont)
Elinchrom				
EL250	250	1/2500	0.6–0.25	1/4 (cont)
EL250R	250	1/6200	0.6–0.25	1/4 (cont)
EL500	500	1/1700	1.0–0.3	1/4 (cont)
EL500R	500	1/4000	1.0–0.3	1/4 (cont)
EL750S	750	1/2100	0.8–0.2	1/16 (cont)
EL1000	1000	1/1000	2.5–0.5	1/4 (cont)
Multiblitz				
Varilux 250	250	1/850	1.3–0.4	1/16 (cont)
Varilux 500	500	1/2100	1.4–0.4	1/16 (cont)
Varilux 1000	1000	1/1200	1.4–0.4	1/16 (cont)
Systems Imaging				
S300	300	1/1600	0.5–0.25	1/4 (step)
S600	600	1/950	0.9–0.25	1/16 (step)
S900	900	1/1050	1.2–0.3	1/16 (step)

Note: Flash durations are quoted at full power; recycling times are given for the complete power range where possible; lowest power – expressed as a fraction of maximum output – also distinguishes between output adjustment in discrete steps and output adjustment that is effectively continuous in nature.

5 LIGHTING ACCESSORIES

The previous two chapters considered the characteristics of continuous and flash artificial lighting sources in the context of general purpose heads. In the first instance, the general purpose heads are complemented by other more specialized designs: in the second, there are fewer specialized units but a greater variety of accessory attachments. This chapter looks at all of those extras.

Fundamental to almost every lighting unit is a reflector of some sort. Sometimes the reflector appears to be there only because it is expected, and does not perform its function particularly well. This may be because the designer has tried to make the reflector small, and therefore very portable, rather than accepting a larger size with the optimum profile. On other occasions, the reflector is the heart of the unit: the Optex Aurasoft light is an excellent example, featuring a unique spheroidal mirrored reflector that can accept tungsten-halogen, HMI or flash sources. The Aurasoft is widely used in motion picture filming, and also finds application in stills studios. But rather than analysing this particular design in detail, it makes more sense to step back and consider some of the considerations that apply when trying to devise the perfect reflector in general.

Reflector design

What is the primary purpose of the reflector? Mostly, the answer is to direct light onto the subject as efficiently as possible whilst also creating the desired lighting effect. As has been stressed previously, the reflector design that will achieve these ambitions is influenced by the shape of the lamp. That said, for the purpose of the following discussion it is assumed that the lamp is an ideal light source – effectively, a single point. Such a source would radiate light equally

Figure 5.1 The only light used for this fashion-style portrait was a single Aurasoft head fitted with tungsten lamps. Because the Aurasoft reflector gives such soft illumination, there is no need for a separate fill light. A slightly slower than normal shutter speed was employed here to give a subtle feeling of movement. Picture taken on Fujifilm Neopan 400 using a Mamiya RB67 Pro medium format SLR.

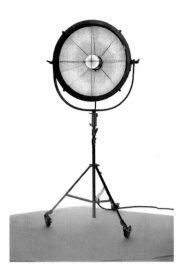

Figure 5.2 The Optex
Aurasoft light, with its large
'dimpled' reflector. The
lighting used here was
electronic flash, with a slow
shutter speed set on the
camera in order to record a
warm glow from the
Aurasoft's own tungsten
lamps. Picture taken on
Kodak Ektachrome EPP100
using a Mamiya RB67 Pro.

in all directions, and two of the simplest reflectors that might be thought of are a hemisphere and a flat sheet. As it happens, neither of these reflector types is of any great use in improving the forward lighting effect.

It should be pointed out, however, that 'bare bulb' lighting – light that radiates in virtually all directions from a source that is fitted with no reflector whatsoever – can itself prove very useful. To improve the effect even more, a diffusing dome can be fitted over the source to create something that looks rather like an illuminated balloon. Indeed, Broncolor offers just such a fitting for its flash

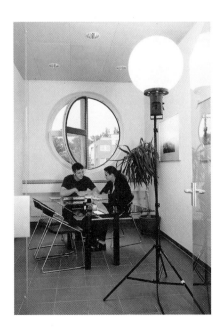

Figure 5.3 Broncolor
Balloon flash head, which
creates natural, all-round
illumination. Picture courtesy
of Bron Elektronik AG.

56

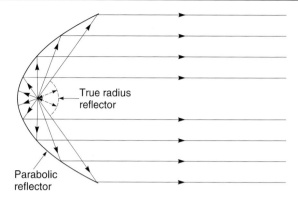

True radius
reflector

Parabolic
reflector

Figure 5.4 Parabolic reflector profile, as used in a beam light. Diagram reproduced courtesy of Brian Fitt and Joe Thornley, *Lighting by Design*, **Focal Press 1992.**

heads. Details of how bare-bulb lighting can be used to great effect with a minimum of fuss are given in Chapter 9.

Returning to reflector design, given that the circular arc cross-section of a hemisphere does not make a useful reflector, the two obvious options would be to stretch such a shape either forwards or out to the sides. Technically, these two profiles are elliptic and parabolic. When those profiles are rotated about their centre axes, the three-dimensional shapes described are ones known as ellipsoid and paraboloid. Ellipsoid reflectors are used inside focusing spotlights (see below) whereas paraboloid reflectors are the bedrock upon which all general purpose flash lighting systems are built. That is not to say that paraboloid reflectors are common, for actually they are exceptionally rare, but rather that most flash reflectors are variations on the parabolic profile.

When properly designed and used, a paraboloid reflector (coupled with a small, backward-facing, part-spherical reflector) generates a parallel beam of light that can be projected a considerable distance. The diameter of the light beam is the same as the diameter of the reflector face (see Figure 5.4). Although this feature is useful in applications such as searchlights, in photographic situations it is more common to light a broader area. Increased coverage is achieved in a fixed geometry luminaire by using a reflector that has been 'opened up' beyond a parabolic profile to produce a diverging beam of light (see Figure 5.5). The precise profile used, and the presence or otherwise of a part-spherical supplementary (backward-facing) reflector, are the principal factors that determine the final lighting effect. In luminaries with variable geometry, moving the source away from the focus of the paraboloid allows a degree of control over the spread of the beam without any need to change the shape of the reflector itself.

Allied with a reflector's profile is its surface finish. If the source were a very small lamp, and the reflector were large by comparison, with a parabolic profile to generate a hard beam of light, then the

Figure 5.5 Softlight reflector profile, with backward-facing centre reflector to prevent the creation of a 'hot-spot' within the illuminated area. Diagram reproduced courtesy of Brian Fitt and Joe Thornley, *Lighting by Design*, Focal Press 1992.

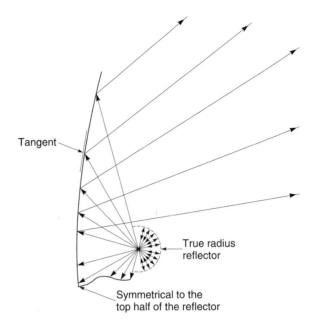

ideal surface would be a highly polished mirror. But photographic lights are not like that: in photography the intention is normally to provide subtle, often soft-edged illumination – and for this it is better to have a rougher textured reflector surface. Different manufacturers use different types of roughness, varying from a fine satin to a coarse bumpy texture. Larger diameter, broad area reflectors have also been made in the past with a white matt painted surface, but yellowing was a problem, and it is more usual now to stick with a semi-matt sand-blasted effect on bare metal.

Finally, there is the matter of the mechanical strength of the reflector. Some flash manufacturers use relatively thin metal to make

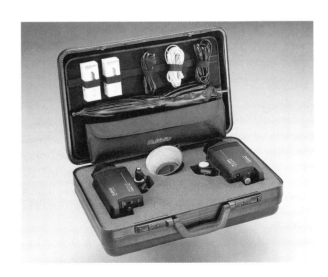

Figure 5.6 Complete portable flash lighting outfit in a case, here based on two Multiblitz Profilite Compact 200 monoblocs. Picture courtesy of Multiblitz and Hasselblad UK.

their reflectors, and simply cut slots to provide mounting points. Other manufacturers use heavier grade metal, and attach reinforced lugs for mounting. Unsurprisingly, when the two types are thrown in and out of location lighting bags, the second fare better than the first. This issue becomes particularly important if a reflector is all that protects the flash tube and modelling lamp when the light is in transit. Better protection is provided by dedicated transit caps that lock over the head and enclose the delicate glass parts. As well as being more secure, this method also makes the lights more compact for transportation, and means, for example, that if softboxes will be used on the shoot then there will be no reason to bring reflectors. Nevertheless, the truth is that loads of spare equipment may well be taken anyway, but it can at least all be collected in separate cases that can be left in the car if genuinely not needed.

There is just one word of warning that must be noted in connection with transit caps: never fit them until the head – and the modelling lamp in particular – has fully cooled. If this caution is ignored, plastic caps may soften and deform, and may even stick to the head in extreme cases.

Reflector add-ons

Although the greatest range of different reflector add-ons is provided for flash heads on account of their general purpose designs, some accessories are also offered for continuous light units. The most common devices that are available for both types provide ways of preventing unwanted light spill by restricting the edges of the beam. The simplest form is a set of 'barn doors'. These are pairs of small metal flaps that attach to the front of the light, and are hinged to allow shadows to be cast in whatever direction the light is not needed. Although they are occasionally seen as single pairs, it is more usual to find sets of four flaps that can block the light top and bottom, left and right. One pair of opposing flaps is normally smaller than the other so that rectangular 'funnel' effects can be created to narrow and dim the light – rather like a snoot (regarding which, see below).

A fixed, uniform effect is obtained using accessories that are variously known as 'grids', 'honeycombs' and 'egg-crates'. All feature a lattice baffle that fits in front of the light to block off-axis illumination in all directions. The smaller the cell size, and the deeper the lattice, the more off-axis illumination will be blocked. Bearing in mind that a central tenet of good lighting is the avoidance of illumination where it isn't wanted, the value of light spill limitation should be obvious.

Most often, a grid or egg-crate is used in front of a sizeable light, such as a softbox or large Aurasoft reflector, whereas small

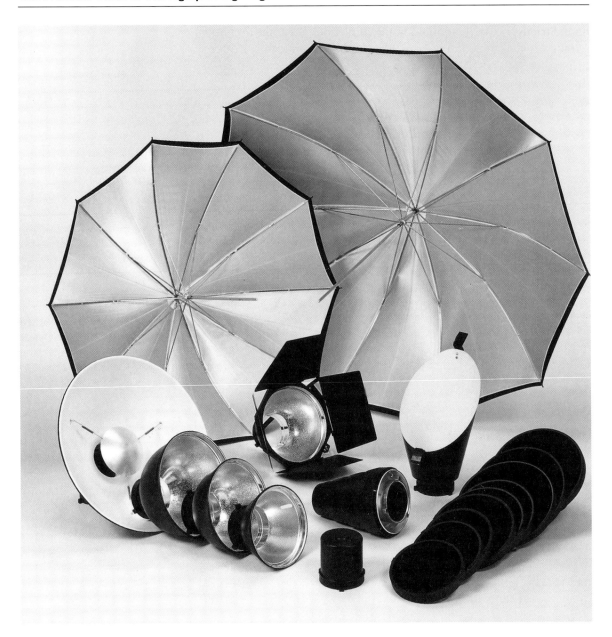

Figure 5.7 A selection of the types of reflector accessories that can typically be fitted to flash heads. Picture courtesy of Systems Imaging Ltd.

honeycombs are fitted to more modest flash reflectors to hone the light in a way that flash reflectors alone do not usually permit. The previous discussion of paraboloid reflectors (for generating parallel light beams) assumed that the light source was very compact, whereas in truth a flash tube is far from compact – and annular rather than spherical. Therefore it should be clear that even if a parabolic-profile reflector were fitted to a flash head, the result would still not be a parallel beam of light. By fitting a honeycomb, however, a usefully near-parallel effect can be achieved simply by blocking the off-axis

light. Strictly speaking, adding a honeycomb does not make the beam parallel at all, but rather gives it a narrower than normal angle of divergence. As such, honeycombs are often specified by the degree of divergence that they allow, with a highly effective design restricting the beam to a divergence of as little as 8°.

Often viewed alongside these spill prevention devices are snoots – cut-off cones that are imagined as 'funnelling' the light into a spot. Whilst snoots do indeed create a definite circular pool of light (in contrast to the softer-edged effect from a honeycomb), they also tend to add a secondary ring of light around the intended pool and have the side-effect of reducing the light's brightness. This happens because the front aperture of the snoot is smaller than the full face of the reflector to which it is fitted (or the standard reflector, if the snoot attaches directly to the head). The amount of light lost depends on the size of the snoot, but can easily amount to as much as two F-stops. Ironically, this very significant loss can sometimes be employed to advantage when using flash heads that feature rather limited output ranges. Under such circumstances, it may not be possible to turn the power low enough to give a subtle hair light when using a honeycomb, and in this case the use of a snoot instead may solve the problem.

On the subject of brightness reduction, scrims provide another way to achieve this same effect. A scrim is usually a fine wire mesh that attaches to the front of the reflector, or is mounted on a frame that is stood just in front of the light. Being made of metal, it can be used equally well with flash heads and with hot continuous lighting units. Typical reductions are from about one-third of an F-stop to a full F-stop. The mesh pattern does not normally project onto the subject because it is so fine. Equally important, the mesh can be cut to shape so that it attenuates only part of the light. Off-the-shelf 'half-scrims' are available specifically for this purpose. To a degree, it is only when partial scrims are used that the technique comes into its own, for if an overall reduction is required there are normally other means that can be used. Readers who are familiar with the original television series of *Star Trek* can observe the effect of half-scrims on some of the close-up head shots, where illumination brightness adjustments are used to focus the viewer's attention on, mostly, Captain Kirk's eyes.

If the primary purpose of a scrim is to reduce the light intensity without altering its 'hardness', then a diffuser does the exact opposite: it softens the light without (as far as possible) reducing its brightness. Diffusers are normally frosted white 'filters' that are placed in front of lights to give a more diffused lighting effect. They can be used either to break up local areas of harshness coming from a single head, or to avoid the multiple shadows that would be caused by a bank of heads arranged close together. Coloured diffusers can add a hue to

the light, and different levels of diffusion can be used to soften even the most focused of incident light beams. Effectively, therefore, the diffuser behaves as if it were a source in its own right, redefining all the properties of any light source that is placed behind it.

Soft lights

A special type of diffuser is to be found on the front panel of a softbox. Softboxes come in two types: purpose-built with their own light sources inside, and accessories that fit on general purpose lighting units. Although they are most often thought of as flash accessories, softboxes are equally at home with tungsten-halogens and other continuous lights.

Figure 5.8 Trio of different size Chimera softboxes for tungsten lights – here fitted to Lowel 1000 W DP heads. Picture courtesy of Holmes Marketing & Distribution.

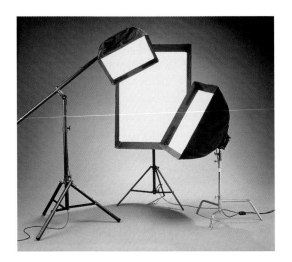

Figure 5.9 Inside a bespoke, rigid 'softbox' – in this case a Strobex Fish Fryer. The four modelling lamps and twin, folded flash tubes combine to give an accurate preview and beautifully soft flash illumination.

The usual design has a rigid or collapsible box, the inside of which is either rough-silvered or white to scatter light all around. To this is fixed either a translucent plastic or diffusing fabric front panel. Ideally, light readings taken at the centre of the softbox and at the corners should all be identical. If there is a central 'hot spot' (as is often the case with collapsible types), a small piece of semi-opaque fabric can often be positioned inside the softbox to reduce light emanating directly from the flash tube.

Provided that the softbox is properly designed, it need not reduce a flash head's output compared to use of a standard reflector. This is because all of the head's light is utilized inside the softbox, whereas standard reflectors often lose some of the light to zones outside their primary lighting area. By recovering this loss, and using a high quality diffusing fabric, the softbox can prove to be a very efficient light source. Inevitably, budget softboxes tend to be less efficient, but they can still be sensible buys if the flash heads to which they are fitted have power to spare – and provided that the intended lighting arrangements do not make severe demands on them.

The efficiency, evenness of illumination and overall lighting quality of bespoke, rigid softboxes is beyond reproach. Two examples may help to illustrate the ultimate superiority of such types. The first is provided by flaps – single halves of 'barn doors' – that can be fitted to the side of rigid softboxes not only to control spill but also to create graduated illumination that can look very effective in the background of product shots. The second is the 'cleanness' that is obtained with a rigid softbox. This becomes particularly apparent when photographing glass or other reflective bodies that show a highlight of the source itself. A collapsible softbox can easily be off-square, with wavy edges, giving a rather cheap effect to the entire picture: a rigid softbox suffers from neither of these problems and consequently produces a higher class result.

Specialized light sources

The preceding comparison between collapsible and rigid softboxes highlights a point that has already been made on several occasions: a purpose-built lighting unit is always better for its purpose than an adapted general purpose light. Predictably, there are many more specialized lights than any one photographer is ever likely to use, so the following outlines are only by way of introductions that should prompt further investigation by interested readers.

Ring lights

Lights are normally placed away from the camera axis in order to provide modelling, but sometimes a front-on effect is what is needed. This applies equally well when working very close up in

medical and nature photography, for instance, as it does when wanting to create a special effect in fashion, portrait and (to a lesser degree) glamour photography. A simple ring light can be constructed in the same manner as is used for make-up rooms, with a series of modest power tungsten lamps arranged on a frame. But instead of placing a mirror inside the frame (as would be done in a make-up room), the frame faces towards the model, and the camera lens looks through the middle. The effect is one of soft lighting that comes from all directions, reducing the visibility of skin blemishes and other facial flaws. Depending on the proximity of the background and the way in which it is lit, the ring light may also create a characteristic 'halo' shadow around the model.

It should go without saying that construction of a home-made ring light should only be attempted by people with the appropriate expertise. All others should choose off-the-shelf commercial ring lights. Foremost amongst these are ringflash heads made by manufacturers such as Hensel, Strobex, Broncolor and Bowens. All are for attachment to the manufacturers' generator packs: to date, no manufacturer has produced a monobloc ringflash (though the author is aware of one that is under development).

For smaller scale use, including some types of portrait photography, it is possible to use a battery powered ringflash of the type that is normally meant for medical and nature work. Outputs are very modest compared to those of generator pack systems, but as a means of initial experimentation battery units can be viable options when used with films of sufficient sensitivity to provide the required shooting distance and aperture range.

Projection spots

Terminologies vary, but what we are talking about here is a dedicated lighting unit that is capable of producing a focused beam of light that

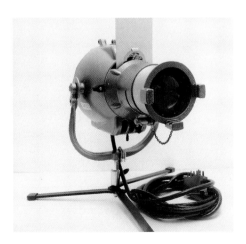

Figure 5.10 Focusing spot head for an old Courtenay Nova flash generator system, with gobo visible in half-inserted holder.

may be used to project a shadow pattern. Such lights use ellipsoid reflectors and plano-convex lenses to control the light, and are variously described as 'ellipsoidal', 'PC spot', 'profile' and 'projection spot' lights. There is always a focusing facility, and, depending on the level of sophistication, it may also be possible to alter the beam angle (the size of the spot at a given distance) using zoom optics. The ability to project a shadow pattern is what sets these lights apart from less tightly controlled focusing lights such as Fresnel spots.

Fresnel lenses, which have a series of concentric ridges on their front surface, are best reserved for focusing light sources that are not well suited to focusing in the first place. This may sound confusing, but in the early days of powerful tungsten lights the lamps were large, with big filaments, and if focused accurately would reveal an image of the filament on the subject. One way to minimize this effect is to give the Fresnel lens a textured rear surface that breaks up the image of the filament before focusing the light. The result is an acceptable pool of light with minimal imaging of the filament. This technique is particularly useful today in focusing reflector lights such as redheads and blondes, where versatility is more important than optimum performance – and where the Fresnel approach can improve usability without revealing the limitations of such designs.

Figure 5.11 Projected background created using a DHA window gobo in the Nova focusing spot flash head. A second light illuminates the model from camera left. The print was made on Agfa Multicontrast RC paper, then treated with a home-brew copper toner.

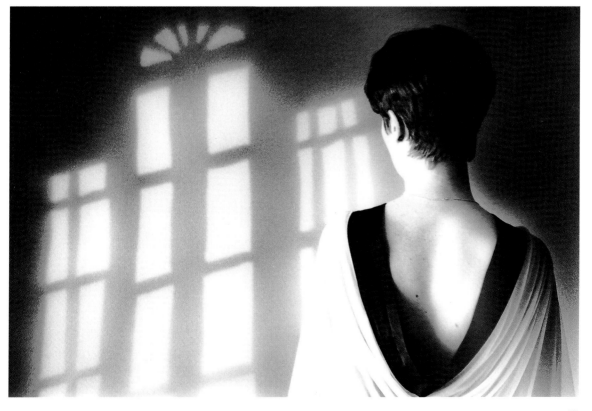

65

It should be pointed out that this approach applies principally in photographic applications: elsewhere, the considerable weight-saving offered by the Fresnel design drives most other uses. This is particularly true where massive lenses are used – such as in lighthouse beacons.

Returning to focused photographic lights, we have true projection spots that are fitted with very compact lamps featuring tiny filaments. Despite their compact sizes, these lights can produce a surprising amount of light. Furthermore, the elliptic reflector profile ensures that all of the light is usefully employed, and therefore the efficiency of such units can be extremely high. In the case of flash heads, the tubes are not annular, but rather are coiled to condense the source into as small a volume as possible. Once again, a high efficiency reflector is used. This is just as well, for as soon as a shadow mask is installed, a good deal of the light will be blocked. Shadow masks such as these are called 'gobos', though this term is also sometimes applied to any shadow effect that is created in front of a general light. Projection gobos are normally cut from thin metal sheet, but some of the more detailed types are made of mesh or etched in heat resistant glass. Thousands of patterns are

Figure 5.12 A selection of cityscape gobo designs, available from DHA Lighting. The company's extensive catalogue contains more than 900 patterns in all.

available to fit the most common theatre lights and flash heads, with prices starting at around the same cost as a low-end tungsten-halogen lamp (see Figure 5.12).

Cyclorama lights

Plain flat backgrounds are known in the theatre and film worlds as 'cycloramas', and are huge in comparison with the 3 m paper rolls that often feature in photographic studios. Lighting such a vast area is difficult, and calls for specially designed units, known, unsurprisingly, as cyclorama lights. The lamps are linear tubes, and the reflectors have a partial spiral cross-section that starts with a circular curve then progressively opens out to flatter and flatter angles (see Figure 5.13). The idea is that as much of the light as possible is directed upwards (or downwards in the case of top-mounted lights) towards the most distant parts of the background. The closest parts are lit only by direct light from the lamp, the intensity of which can be varied considerably by moving the cyclorama light away from, or nearer to, the background. The same movement has proportionately less effect on the light directed towards more distant parts of the background, and therefore provides a means of controlling the brightness distribution.

Even when a bank of cyclorama lights does not provide totally even illumination up the background wall, it does at least ensure that any light reduction is subtle and progressive, free from bright and dark bands that would otherwise draw attention to the fall-off.

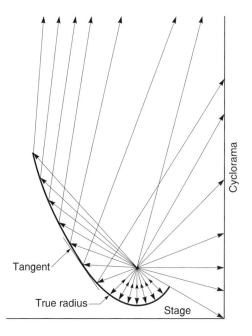

Figure 5.13 Cyclorama (background) light reflector, with varying radius that throws more light towards the most distant areas that are illuminated. Diagram reproduced courtesy of Brian Fitt and Joe Thornley, *Lighting by Design*, Focal Press 1992.

PAR lights

Best known for their use in car headlights, sealed beam PAR lamps are complete light assemblies that need nothing more than a matching plug from which to draw their power. This design contrasts strongly with other continuous light units where the lamp is only a consumable, not the entire item. PAR lamps take their name from the acronym Paraboloid Aluminium Reflector, and are specified with a number that quantifies their face diameter in eighths of an inch: the most common PAR-64 lamp therefore measures 8 inches across.

Because the lamp is fully integrated with its own reflector and lens, operational efficiency is high – at least twice that of an equivalent Fresnel. In addition, PAR lights can just as easily feature either high pressure tungsten lamps or daylight balanced discharge types (subject to the provision of an appropriate power supply). Like Fresnels, PAR lights create a pool of light – but in the latter case the pool is almost always wider than it is high. This makes sense in the context of car headlights, where the need is to light the width of the road rather than the trees above it. PAR lamps are much used in stage lighting, but are rarely employed for stills photography.

Painting and stroboscopic lights

Finally, there are two types of lights that share a common theme in that their exposures are progressive. Both are specialized in the extreme and are represented by some of the most exotic (and expensive) equipment in commercial use. However, they can both be simulated and explored using very much less expensive equipment that ought to be within the reach of every keen photographer.

First there is 'light painting'. This is a technique that has been made famous by the American photographer Aaron Jones, inventor of the Hosemaster system. In essence, the subject is set up in a fairly dimly illuminated studio, and is then lit using what can best be described as a range of torch fittings that attach to a very bright, daylight balanced light source. An external lens shutter that sits in front of the camera is opened by pressing a button on the 'torch' handle when the exposure is ready to be made.

The advantages of this technique are several. Firstly, an object can be lit from directly in front of the lens using a moving light. There is absolutely no other way in which this particular effect could be achieved. Secondly, minute areas of the subject can all be lit differently, creating either perfect or surreal results. Thirdly, it is possible to remove one item from the picture whilst lighting another, thereby avoiding shadows of one element falling on the

sides of others. Similarly, it is possible to filter or diffuse individual areas of the set – though it happens that this can also be done using conventional lighting in combination with split exposure techniques.

To explore the light painting technique using less expensive equipment, all that is needed is a totally dark room, a camera that can have its shutter locked open, and a conventional torch. By waving the torch over the set, an exposure can be built up area by area. Of course, the results are harder to duplicate than when using the Hosemaster system with its light-shaping accessories and metronome timer, but at least the flavour of the technique can be experienced relatively easily this way.

Lastly, there is stroboscopic lighting – flash lighting that pulses. The most capable dedicated commercial system that exists is the Strobex Polikon, which can fire up to eight separate flash heads of 400 J with variable timing in between. The equipment is capable of lighting part of a dance hall or an indoor athletics arena if necessary. Broncolor flash packs can also be programmed to fire in sequence with pre-set delays, but this too is expensive equipment.

To explore stroboscopic lighting on a more reasonable budget, all that is needed is one of the latest camera flashguns from manufacturers such as Nikon, Metz or Quantum. All offer stroboscopic facilities of some sort, though the flashes are of either very modest power, short bursts, or slow firing rates. Even so, it is still possible to get some interesting results – as one of the examples in Chapter 12 reveals.

6 EQUIPMENT

Up for discussion here are all things except items of lighting equipment. Specifically, this means light meters, film, filters, cameras, lenses and backgrounds. Specialized items such as flash triggering systems are covered elsewhere in the examples that follow later in this book.

Light meters

Light meters are crucial to the construction of carefully controlled lighting arrangements. It is possible to cope with many continuous lighting scenarios using in-built camera meters, but even accepting this fact a hand-held meter should be considered a high priority if for no other reason than that it puts the photographer in full control of the situation. There are separate meters for flash and continuous lighting, as well as some that work with both. Most meters also offer some combination of reflected and incident light readings. That said, there are very few meters that cover all eventualities equally well, and often it can be better to buy two or more less sophisticated meters of different types than to purchase a single all-embracing type.

The majority of low-cost flash meters measure only incident light: this is no problem because in the studio (or when using studio flash on location) it is normally easy enough to move to the subject's position to take a reading. The situation is rather different when using an on-camera flashgun. In this case, it is common either to be working very quickly or to be unable to move back and forth between the shooting position and the subject. Therefore, a reflected light flash meter is more useful at such times – and often the camera's own internal flash meter will be fine if combined with a modern flashgun.

Figure 6.1 Among the most useful items that can be added to any photographer's camera bag is a wide selection of different films. Although it is definitely best to use just one or two films mostly, there are times when something different can make a picture work much better. In this case, Kodak T-Max p3200 has been employed both on account of its sensitivity to low light levels, and its high-grain emulsion. The latter, coupled with a very narrow depth-of-field, gives this portrait a gritty and compelling feel.

Leaving this situation aside, choosing a low-cost flash meter is actually very easy. Just select one that reads to at least half F-stops and has a range of apertures that matches those you normally use with your favourite films. Almost every flash meter available will fit the bill in most cases.

It is useful to know the 'gate time' (the effective shutter speed of the meter) and for this to be adjustable to some degree. It is also useful for the meter to have a 'cordless' mode, which means that it can be used to take readings beyond the reach of a flash connection cable. Rather fewer meters provide these two functions, but even so the field is still quite wide for reasonably priced units. It is a fact of experience that different flash meters do not read the same, but this is not a problem provided that the chosen model is consistent and its performance is learnt.

If money is no obstacle, consider a flash meter that can read continuous light too. This ability can be very useful indeed when working on location, and when having to find a good balance between the flash level and the prevailing ambient lighting. Minolta and Sekonic both make excellent meters of this type. In addition, both manufacturers offer a spot metering facility for flash exposures, which is ideal for difficult situations and when working with either highlight or shadow-based film exposure ratings.

As well as a flash meter, consider buying a spot meter for continuous lighting. Purchasers of the appropriate Minolta and Sekonic models will have this feature already provided, but for

Figure 6.2 Two different types of hand-held meters. The Capital Spotmeter SP-1 is a well-priced ambient light spotmeter in the same vein as the classic Pentax V. Picture courtesy of Warner Photographic. Sekonic's L-608 Zoom Master is a sophisticated multi-mode hand-held meter of the type that is invaluable for proper evaluation of lighting and exposure.

everybody else a hand-held spot meter is a useful additional accessory to own. Pentax has long held pole position in the spot meter stakes, and the author particularly recommends the now discontinued Spotmeter V. Fortunately, a reincarnation of this classic analogue model is available in the UK from Warner's Professional.

Having obtained your meters, the keys to success are thorough initial familiarization followed by regular use. There is no point in buying a hand-held spot meter if it is consigned to the bottom of a drawer within a few months. As explained in the next chapter, the value of a spot meter lies in revealing the distribution of brightness tones within a scene, so allowing the most appropriate exposure to be chosen to match the scene precisely to the film in use. No in-camera metering system can do this with the same level of accuracy.

Polaroid 'metering'

A completely different approach to metering is provided by Polaroid instant films, which are available to fit not only medium and large format cameras, but also 35 mm SLRs too. The latter are catered for by dedicated 35 mm Polaroid instant transparency films and by specially adapted backs that clip in the place of a normal back to accept Polaroid instant print films. In all cases, the images recorded are the same size as a conventional 35 mm frame, so it should be obvious that some care is needed to get all the necessary information from the test exposure.

The pros and cons of the two 35 mm Polaroid options are as follows. In favour of adapted backs is the range of films that can be used: ISO100 and ISO400 black-and-white films, colour films with two different contrast levels, ISO64 tungsten-balanced colour film and an ISO80 black-and-white film that generates a reusable negative. Another plus point is the fact that test exposures can be made and assessed one at a time. On the other hand, Polaroid print films are not very sharp when examined at the scale of a 35 mm frame, and it is not convenient to keep clipping and unclipping the Polaroid back if using the same camera with conventional film. Because of this last point, most photographers who choose this option do so with the Polaroid back permanently attached to a spare camera body.

In favour of Polaroid instant transparency film is the fact that it is run through the usual camera as normal, and, more importantly, that it can be inspected under a loupe to reveal more detail than can be seen on a print. The disadvantages are that the film speeds and/or emulsion contrasts do not match those of conventional films, and the need to shoot at least twelve exposures

(the shortest roll length) before processing the film. Furthermore, Polaroid instant transparency film is decidedly expensive to buy and can be tricky to use.

The size disadvantage does not apply to medium format photography, where the only issue with Polaroid films is the fact that their emulsion characteristics inevitably differ from those of conventional films. That said, with experience it is possible to compensate for these differences when viewing the instant print or transparency. In any case, the major benefit of Polaroids is their ability to show the way in which all the components of the scene will be recorded relative to one another. Another bonus is the revelation of 'faults' that might otherwise have gone unnoticed – such as a reflection of the flash head in a smooth surface within the picture.

Ultimately, the decision about whether or not to use Polaroids is only finely balanced for 35 mm SLRs; in the case of medium and large format cameras, Polaroids are far more frequently used than not when shooting under controlled lighting conditions. Even at other times, such as when photographing weddings, occasional Polaroids can be used to confirm that cameras and lenses are functioning correctly. The author's suggestion is therefore to use 35 mm Polaroid instant transparency film only when it is absolutely necessary, and to work with careful metering for most 35 mm photography. But for medium and large format work, the norm should be to use Polaroids, even if only very sparingly (in order to keep costs as low as possible).

Film

It is perfectly possible to record final images on Polaroid films – particularly on 35 mm instant transparencies and on black-and-white films that generate a reusable negative (Type 665 medium format film and Types 55 and 51HC 5 × 4 inch film). Even so, it is a fact that most photographers treat Polaroids only as a proofing system, and load conventional films to capture their final pictures.

Because conventional films are constantly being improved and superseded, there seems little point in going into more than brief detail about individual products here. The crucial factors to consider when choosing a film are its ISO rating, colour/tone fidelity and exposure range. The last of these is discussed in the next

Figure 6.3 Two variations on the same subject indicating differences in film and exposure. The lighter image was captured on Kodak Advantix colour print film using a fully automatic Kodak Advantix APS compact camera. The darker image was captured on Kodak Ektachrome EPP100 using a Mamiya 7 medium format rangefinder, used in conjunction with careful manual metering.

chapter, and is often partly determined by the first. This correlation exists because lower ISO value films tend to have finer grain, and emulsions that lack larger grains tend to have restricted exposure ranges too. That is why finer grained colour transparency films in particular are often heralded alongside claims of more vibrant colour saturation. Similarly, higher speed colour negative films tend to have wider tonal ranges that give softer colours. So it follows that if a softer image quality is required, the first choice will probably not be a colour transparency film with a very low ISO rating. The opposite also holds true, and has obvious repercussions in terms of the amount of light that must be provided to accommodate the appropriate film.

When shooting in colour, a choice is offered between daylight (5500 K) and tungsten (3200 K) balanced emulsions. Normally, this distinction is thought of in terms of the designated colour balances, but it is perfectly possible to convert one type of film to match the other's lighting by using colour correction filters. This being so, other factors can come into play. Tungsten films tend to be slightly softer in colour and also slightly grainier than daylight films – and are better suited to long exposure times (in excess of a second). Daylight emulsions normally have higher contrast or colour saturation, and can therefore find filtered use under tungsten lighting for brighter results. There are also differences in the ways that the two film types react to cross-processing (a technique that is sometimes employed when special effects images are required). In short, do not make the mistake of choosing between the two types on account of their names alone!

Figure 6.4 For remote triggering of flash heads, both monoblocs and generator packs, a radio slave is ideal. One box (a small radio transmitter) fits on the camera, the other (a receiver) attaches to one of the lights. The operating range varies with the make chosen and the prevailing conditions, but will normally be sufficient for all common applications in the studio and on location.

Correction filters

Having made mention of filters for adjusting colour temperatures, it would be wrong to carry on as if this were all that needed to be said. For one thing, this brief reference has explained nothing, and may even have promoted confusion. For another, filters offer many creative possibilities that are integral to photographic lighting.

The concept of colour temperature – its origins and measurement – were discussed technically in Chapter 1. But in lighting circles there is an additional concept that needs to be addressed, and that is the idea that one type of lighting can be made to resemble another by filtration alone. In the strictest black body sense this is nonsense, for colour temperatures arise from the relative abundance of a wide variety of different radiations – visible colours comprise just a small part of those radiations. But because photographic film sees (mostly) only those hues, it is possible to convert one colour temperature into another simply by changing the relative amounts of red and blue light present.

To quantify the photographic effect, the term 'mired' (pronounced mee-red) is used, the name being a contraction of 'micro reciprocal degrees'. In other words, if the reciprocal of any colour temperature is multiplied by 1 million, the result will be the equivalent value in mired. So 5500 K daylight has an equivalent value of 182 mired, and a 3200 K tungsten colour balance corresponds to 312 mired. To convert from one source to another, simply subtract the starting mired value from the required value. So to convert daylight film (182 mired) for use with tungsten lighting (312 mired), a 130 mired shift is required. By the same token, to convert from tungsten film to daylight lighting, the shift required is −130 mired.

Initially, mired values can be confusing, and often prompt the question: why not simply stick with colour temperatures measured in kelvin? The answer lies in the way that film sees colour. When considering different lightings, the important thing is not the absolute difference in colour temperature but its value proportional to the prevailing conditions. So whereas colour transparencies look much the same whether they are shot under lighting at 5000 K or 5600 K, a very much more obvious variation would be seen if the colour temperatures were 3200 K and 3800 K (despite the fact that these two pairs feature the same absolute temperature difference). The beauty of mired values is that they too are proportional not absolute, and they therefore reflect the way that photographic film behaves.

This all starts to become especially important when partial colour corrections are employed. Suppose that a picture is to be taken indoors under bright prevailing tungsten lighting, with a

scene also visible outdoors through a window. If the picture were balanced for the indoor tungstens, the outside view would be very blue: conversely, if the picture were balanced for the exterior, the interior would be very orange. With time and the appropriate resources, the best answer would be to shoot on tungsten balanced film to match the interior lighting, and to fit a large piece of +130 mired (orange) filter onto the outside of the window frame to balance what would otherwise be a very blue exterior view. At the same time, the orange filter would also reduce the brightness of the outside scene, so lowering the overall subject brightness range as a side-effect of colour correction in this particular case.

But if time and money do not allow this approach, what then? The solution that might well spring to mind is to correct the light just partially, so that the same slight edge is taken off the warmth of the tungstens and the blueness of the daylight. The filter to use would be one that corresponds to a visual colour temperature midway between 5500 K and 3200 K. But what filter is that?

Before answering this question, think back to the statement that film sees colour hues proportional to the correct colour balance, not in absolute terms. In other words, the entire idea of choosing a colour balance of 4350 K (numerically half-way between 5500 K and 3200 K) would be completely wrong. The proper midway balance corresponds to half the mired difference: in other words, 65 mired above daylight and 65 mired below tungsten (assuming that the room lights are fitted with photographic quality

Figure 6.5 Illustrated here is the effect of a softening filter contrasted with an unfiltered image. The former (larger picture, opposite) is obviously more flattering, but also has lower contrast caused by flaring of the light into deep shadow areas.

tungsten lamps). This works out to a mired value of 247, which corresponds to a colour temperature of about 4050 K – which is 300 K below the first suggested value!

More importantly than all of these numbers, lighting filters come ready calibrated for full and partial effects. A filter that converts blue daylight for use with tungsten balanced films is called a Full CTO (colour temperature orange), while the same thing in reverse is a Full CTB (colour temperature blue). Half, quarter and one-eighth grades are also available in both cases – all with such self-evident names as Eighth CTB. The only thing to watch out for is to check precisely what colour temperatures are used as the end-points. For example, Lee's Full CTB converts from 3200 K to 5700 K, but the reverse Full CTO converts from 6500 K to 3200 K – the daylight standard being different in the two cases.

Unfortunately, matters get even more confusing when conversion is attempted between discharge lighting and films that are balanced for black body exposures (be they daylight or tungsten types). This is because discharge sources vary in the way they achieve their equivalent colour temperatures. So although HMI and CID, for example, can both be described as having a daylight colour balance, there are two different filters that convert these sources for use with tungsten films. Likewise, fluorescent tubes vary widely in their spectral outputs, and separate correction filters are required for 'white', 'cool white' and 'warm white' types.

For a comprehensive guide to colour corrective filtration, consult one of the free data sheets available from filter manufacturers such as Lee and Rosco.

Effects filters

As well as colour temperature corrections, filters also provide creative possibilities that are vastly expanded by the ability to fit coloured gels to each light source individually. This is where the two types of filtration differ; often, colour corrections can be applied equally well to the lights or to the lens, and it is frequently easier to address the lens. With effects lighting, the filters are almost always applied to the lights themselves.

Generally speaking, strong filtration is best reserved for the background of a picture, with foreground effects confined to such things as subtle warm-up filters. Coloured lighting is a good way of making a background appear brighter without losing its colour intensity, and is also useful for graduating the background to focus attention on the foreground subject. Shadow patterns can be created using gobos in projection spots, or with flags and card masks positioned in front of other lights, and can be coloured with filters – though only with an attendant loss of lighting brightness, of course.

Figure 6.6 Industrial fluorescent lighting always looks very green on daylight balanced colour film. To combat this problem, a magenta colour correction filter is used. The neutrality of the combination can be judged from the wall to the extreme right of the picture. To the left, where daylight spills in, the magenta filter has imparted its own cast to the image. Generally speaking, warm casts are more acceptable than cold, but to avoid this problem completely in this instance the simple answer would have been to close the outside door. Pictures taken on Kodak Ektachrome E200 using a Mamiya 645 Pro medium format SLR.

Allied to filters are lens softeners that reduce the sharpness of the image to give a more romantic feel to the picture. Glamorous portraits are the usual application, but moody still-life pictures and creative product shots can also benefit. A softener can be something as simple as a card frame containing a layer of fine silk stocking fabric (not thicker than 10 denier), or can be an off-the-shelf 'filter'. Amongst the commercial alternatives are DuTo types, which feature concentric annular 'ridges', and Zeiss Softars that have random lenticular patterns. Stocking softeners, and others that use a fine mesh, must be used with the lens at virtually full aperture, and even so can leave a tell-tale 'starburst' catchlight in a model's eyes, or on specular highlights in still-life images. DuTo softeners have less effect as the lens aperture is closed down, which may or may not be a good thing, whereas Softars have more or less the same effect regardless of the lens aperture – which may itself be useful in a different way. The effect of Softars does vary, however, with the distance of the filter in front of the lens, and hence is different for the same filter mounted on lenses of different brands (and sometimes even for different focal lengths of the same brand).

Before leaving the subject of filters and other front-of-lens modifiers, it should be noted that a lens hood ought to be fitted whenever possible. This is not so much to reduce flare in the lens itself as to block light from grazing the front of any accessories. The contrast reduction that can be caused by stray light scattering off a silk softening fabric is very considerable indeed, while the same light striking a flexible filter gel can create a bright streak in the final image. The best length for a lens hood is as deep as can possibly be accommodated.

Cameras and lenses

The equipment that houses the film and projects the image onto it has deliberately been placed well down this list of items. The reason is simple: cameras and lenses have little to do with lighting other than in respect of their own strengths and weaknesses. It is essential that the lighting suits the range of apertures offered by the lens, and allows whatever depth-of-field is needed or desired, but these are quantitative issues, not qualitative ones. The position of the camera is irrelevant when considering lighting exposures: it is the position of the lights relative to the subject that matters.

There is, however, an implication for the lighting in terms of where the camera will be and what angle of view will be seen by the lens. It is by no means necessary that the lights are all kept outside the field of view of the lens (provided they can be cropped out afterwards), but it obviously is essential that they do not obstruct the camera's view of the subject. A useful trick to keep in mind is

that it can be easier to avoid including background lights in a picture when the foreground subject is framed using a longer focal length lens that has a narrower angle of view. The same type of lens also allows the model (or set) to be positioned farther forward from the background without running out of width, and this in turn leaves more room for lighting units behind.

Importantly, there is no penalty to be paid in terms of lost depth-of-field when using longer lenses provided that the composition and film format remain the same. So if a head and shoulders portrait is arranged with a 50 mm lens on a 35 mm SLR, the same depth-of-field will also apply when the same framing is achieved from a more distant position using, for instance, a 135 mm lens. Things are not equal, however, in terms of image perspective. At close range, the model's face would be distorted, whereas from a more distant position it would not. The reason lies in the relative distances of each part of the model's face, and how these compare to the camera-to-subject distance overall.

There is, however, a depth-of-field issue to be considered when changing from one film format to another. This means that if pictures are being taken in the same session using a 35 mm SLR and a medium format camera, different depths-of-field will apply at the same aperture settings even when the cameras are fitted with equivalent focal length lenses. The explanation for this arises from the different reproduction ratios between real life and the film image in each case. Even allowing for the reduced linear enlargement of a bigger film format, there is still less depth-of-field. In short, it is more common to be forced to use smaller apertures with larger film formats: this in turn means more light is needed, and is a special reason to be thankful for camera movements on 5×4 inch and 8×10 inch view cameras.

Digital cameras

Separate mention needs to be made of digital cameras, the very best of which can, at the present time, only be used with continuous lighting. But since it is reasonable to assume that any photographer who can afford to spend as much on a digital camera as on a family car will also be familiar with all the intricacies of professional lighting, those models can be put to one side. Far more common, and of growing interest, are digital cameras that cost about the same as a mid-range 35 mm SLR. Admittedly, these digital cameras have fixed lenses, but they have their uses nevertheless. The important thing to keep in mind is that, as well as the lens, the 'film' is fixed within the camera. Whereas a conventional photographer can choose his or her emulsion to suit the job in hand, the digital photographer must make best use of what is provided. As with film,

the secret is to explore fully the digital system's effective speed and tonal range. In particular, do not assume that the claimed equivalent ISO rating, aperture settings and shutter speeds can be taken at face value. At the time of writing, the inaccuracy of these things is becoming something of an issue, revealed in part by the growing sophistication of such cameras, which is leading to their being used in ever more demanding situations.

Clearly, one of the main attractions of digital cameras from a commercial perspective is their saving on film and processing costs. In addition, there is also the wealth of electronic enhancement opportunities offered by image manipulation programs such as Adobe Photoshop, ArcSoft Photostudio, and JASC Paint Shop Pro. Despite the fact that these programs can be very useful in retouching images, or even removing unwanted shadows, it should be realized that the one thing they cannot easily do is simulate good lighting where it did not exist before. Proper lighting is either present in an original picture or is absent forever – whatever medium is used to capture the image.

Backgrounds

Behind every great picture is an appropriate background. Probably more pictures have been ruined by bland or unsuitable backgrounds than by anything else. On location, that is sometimes the price that must be paid for speed of working, but in the studio there is usually no such excuse.

To a large degree, good backgrounds come from planning a picture in great detail. When explaining his work, London photographer Rod Ashford often alludes to the different messages that a portrait can convey with different props and background settings. A man photographed outside a prison, for example, might be holding a suitcase because he is an inmate who has just been released, or because he is a member of staff going on holiday. There may be ambiguities, but the clues in the picture are all that allow viewers to construct their own narratives. The same holds true in a studio – except that in this case the starting point is not a prison building but a plain room that could be absolutely anywhere: it is the job of the photographer (or the stylist on a professional shoot) to set the scene by careful use of props – including an artificial background.

On location, good photographs often rely on moving things out of the background to give a cleaner look to the picture. This applies just as much to portraits of people in their own homes as it does to pictures of industrial machinery in a factory. Sometimes, if things cannot be moved, the answer is to change the camera angle a little, or to alter the lighting to make an untidy background more dimly lit – and therefore less obvious – in the final image.

Conversely, there are some types of pictures that do not require any context: such images are simple pack-shots of objects in isolation provided by either white or black backgrounds. These cases crop up amongst the examples later in this book, but for now let it be noted that one of the biggest advantages of pure black backgrounds (as provided by black velvet fabrics) is the total avoidance of shadows. This is the one and only time when, no matter where the lights are placed, there will never be any shadows visible in the background. And that, from a lighting perspective, is a very useful trick to know.

7 EXPOSURE DETERMINATION

Arriving at the appropriate exposure for a picture is a two-stage process that involves measurement and interpretation. Neither is a simple matter in its own right, let alone in combination with the other, so to master this subject it is necessary to progress slowly from an average approach to one that takes account of the specific subject, lighting, film and effect required.

The potential for confusion can be illustrated by a simple example. Suppose that you want to take portraits of two people; one is dark skinned, the other is fair. If the individual portraits are framed as tight head-and-shoulders compositions, and the pictures are taken under ambient lighting using in-camera metering, then it will be evident that different exposure conditions are recommended for the two pictures. Typically, if the dark-skinned portrait had a suggested exposure of 1/125 s at f/4, then the fairer complexion might have an indicated exposure of 1/250 s at f/5.6.

It could be argued that both exposures are correct for their given subjects – but if that is true, what would be the correct exposure for a double portrait featuring both people in the same picture? More importantly, would the exposure used for a double portrait inevitably have to be a compromise because it sought to accommodate two different skin tones in a single picture? The answer to the last question is a simple 'no' – the reasons why this is so form the basis for the rest of this chapter. By the end of the chapter, you should also realize that the first question was entirely meaningless, having been based on an erroneous initial assumption.

Figure 7.1 Although much emphasis is put on manual metering in this chapter, modern cameras are capable of handling the vast majority of situations with good success. This daffodil was intermittently lit by shafts of light in a wood, and manual metering was near impossible owing to the unpredictability of the illumination. Fortunately, the Pentax 645N auto-focus medium format camera used here performed excellently, and has recorded the scene perfectly on Fujichrome RMS colour transparency film.

Measuring light

Exposures for ambient light photography often refer to shutter speeds and apertures – as have already been used here. That system is fine as far as it goes, but it misses two points. The first is that there is no unique shutter speed and aperture combination for each exposure situation. The second is that it assumes equal importance for the shutter speed and aperture, which is not always the case. In addition, there is the huge subject of what it is that is actually being measured during metering.

The first point is easily understood. Because each (full) shutter speed step transmits to the film twice as much light as the one above it, and half as much as the one below, it follows that there should be room to vary the speed to suit the effect required. Usefully, and by very deliberate design, the double/half relationship also applies between successive lens apertures. By joining these two effects, we get photography's Exposure Reciprocity Law. This states that the film exposure is the same for a whole family of shutter speeds and apertures provided that the two are kept in the same photographic ratio. Mathematically, the numbers do not compute easily, but it is simple enough to remember that if the lens aperture is opened one stop, then the shutter time must be halved to maintain the same exposure (and vice versa)

Figure 7.2 Manual metering is important outdoors so as to match the light to the film as accurately as possible: in the left-hand picture below, automatic metering would almost certainly have given an underexposed result with unflatteringly dense shadows. Manual metering is also important in the studio, where the photographer must arrange the lights to get the desired effect. The picture below right was further enhanced during printing by the great Larry Bartlett – who was, until his death, the UK's most successful award-winning b&w printer.

The parameters that define a family of equivalent shutter speeds and apertures are the film's sensitivity to light (its ISO rating) in combination with the prevailing light level. To free the latter from the former, the exposure value (EV) scale is used. It must be admitted that very few photographers actually use the EV scale, but all who vary their exposures take its existence for granted – sometimes without even realizing the fact. Those who use Hasselblad cameras, however, may notice that some such lenses are marked with an EV scale, and via that this can be locked so that as the shutter speed is changed, so too is the lens aperture to maintain a constant exposure. This is a very useful feature that quickens changes to the lens settings when working under pressure.

Incidentally, it is worth noting in passing that the term 'shutter speed' is something of a misnomer. The speed of a focal-plane shutter's travel inside a given SLR is constant regardless of the exposure time. As was mentioned previously (in the context of flash lighting), such exposures are made by the passage of a variable-width slit across the film plane: it is the time lag between the leading and trailing edges of this slit that determine the exposure – and to which the 'shutter speed' time refers. In practice, however, this distinction is of little consequence, and the term 'shutter speed' is used throughout this book with its common meaning.

Arresting movement

Having ascertained that there is an entire family of equivalent exposures for any given film ISO (or EI – see later) and lighting EV, the issue then is how to decide on the best choice of settings. The driving considerations are movement and depth-of-field. Movement can come either from camera shake or from the subject itself. To combat the first, there is a rule of thumb which says to avoid shutter speeds that are slower (in seconds) than the reciprocal of the lens focal length (in millimetres). This rule is generally stated to the nearest full shutter speed step, so if you are using a 50 mm lens the slowest shutter speed that will reduce camera shake to an acceptable level is 1/60 s. Similarly, for a 400 mm lens set nothing slower than 1/500 s, and with a 28 mm lens kept to at least 1/30 s. Complications arise with zoom lenses, when it is best to take the longest focal length as the guide. Specifically, a 70–210 mm zoom should be used with a shutter speed of at least 1/250 s, even when set to the short end of its range.

There are three exceptions to this rule. Firstly, some people truly can hold a camera more steadily than others, and might be able to set a slower shutter speed than suggested. This is particularly true if the resulting pictures are only modestly enlarged, or are reproduced in newspapers or another relatively low quality medium.

Secondly, there are lenses (such as Canon's Image Stabilised, IS, types) that feature active optical systems to reduce camera shake. There is no doubt that such systems definitely do work for camera shake, though they can do nothing about subject movement. Thirdly, there are the demands of desperate situations. These apply mostly in press and reportage applications, where there may be insufficient light for the recommended shutter speed, so a slower setting is used with the hope that camera shake will be only modest. Generally speaking, provided that the photographer is relaxed, and there are no real give-away elements in the picture (such as small bright lights against a dark background that could reveal 'trails'), slower shutter speeds can be effective.

Whenever possible, however, the camera should be mounted on a very firm tripod. This will remove almost every hint of camera shake, and by that virtue allows much greater freedom of choice when selecting which shutter speed and aperture combination to set.

The second aspect to movement is that of the subject itself – something that a tripod can do little to arrest. Note that the operative word is 'little', for a tripod (or monopod) can prove useful in allowing smooth panning that can help to freeze the subject by transposing its movement onto the background. To pan effectively, it is necessary to swing the camera so that the subject remains in the same place within the frame as the picture is taken.

Figure 7.3 Panned picture of a classic Lancia in full flight. The blurred background adds a definite sense of speed. Taken on Fujifilm Neopan 400 using a Mamiya 7 medium format rangefinder camera.

Typical shutter speeds, even for very fast moving objects, can be as low as 1/60 s or slower. Inevitably, the subject will not be perfectly sharp in the picture, but it should be very much clearer and more accurately composed than if it had been photographed using a static camera.

There is also another way of freezing subject movement when using a slow shutter speed, and that is by adding flash to the picture. For this trick to work, either the flashgun must have plenty of power, or the subject must be relatively close to the camera. This technique is discussed in more detail later.

You will notice that no mention has been made of the appropriate shutter speed required to freeze subject movement under normal circumstances. The reason is that there is only one simple rule: always set the fastest shutter speed possible.

Depth-of-field

In theory, when any lens is focused on a subject, there is just one image plane that is totally sharp. If the subject is a square-on portrait, and the lens is focused on the model's eyes, then the ears and the nose will both be slightly out of focus. However, the degree to which this out-of-focus softness is apparent will depend on the lens aperture. When the lens is set to a wide aperture, f/2.8 for example, the softness will be more obvious than when it is set to a small aperture such as f/16. To complicate matters, the magnitude of the effect also depends on the relative size of the image on the film. So if the portrait is broadened from a head-and-shoulders composition to a full-length pose, the degree of softness seen on the ears and nose will be reduced. It also happens that if the softness is reduced enough, the ears and nose will look sharp, even though the lens was actually focused on the model's eyes.

This region of apparent sharpness is called the depth-of-field, and is exploited when photographing all real-world (three-dimensional) subjects. It therefore follows that when the picture contains important parts at different distances from the camera, a small lens aperture must be set if everything is to look sharp. Similarly, if the main subject is to be isolated against an out-of-focus background, a wide lens aperture should be set.

It is rare to find photographs in which there is great depth-of-field and also frozen movement. And when they are encountered, such pictures often seem bland. It is one of the knacks of photography to know what combination of aperture and shutter speed will produce the most interesting – as distinct from the most 'correct' – result: the only way to acquire this knack is by experimentation and having in mind a clear idea of the intended image before the picture is taken.

Camera metering

When using a fully automatic camera, shutter speeds and apertures are set without any intervention from the user. As such, the camera not only measures the light, but also decides how best to interpret the reading obtained. Users can bias the camera's choices by setting, for example, a 'sports' (high shutter speed), 'landscape' (small aperture) or 'portrait' (wide aperture) program. Sometimes it is also possible to change the way in which the light is measured, but here the options are less clearly defined.

All cameras meter the light by measuring what is reflected back from the subject towards the film. Three different methods are commonly used. The simplest type is 'centre-weighted' metering, in which the camera pays greatest attention to the light reflected by objects near the centre of the frame. Often, centre-weighted metering is also biased to the bottom part of the picture, so as to avoid the potentially confusing brightness of large expanses of sky in

Figure 7.4 Although it may not look it, this photograph was taken in failing light at the end of the couple's wedding day. Generous exposure has given a light, airy feel, with a edge-softening filter creating a dream-like effect. Picture taken on Fujifilm Neopan 400 using a tripod-mounted Mamiya RB67 Pro.

scenic pictures. By correlating the average brightness level against the film speed, the camera is able to suggest a suitable shutter speed and aperture combination taking into account any preferences expressed by the user through his or her choice of metering programme.

The second type of metering measures the reflectance of a much smaller area. Traditionally, this is known as 'spot' metering. The size of the 'spot' can vary quite widely, but only those covering between about 1° and 5° of view are true 'spots'. Anything larger than this should more properly be regarded as 'selective area' metering – and it is this type that is most common within camera bodies: true spot metering is mostly the domain of hand-held spot meters (see below).

As with centre-weighted metering, the usual method of spot assessment is to assume that the reflected area is a typical mid-tone, and to base the choice of camera settings on this premise. Some cameras, such as the Olympus OM-4Ti and OM-3Ti, allow the spot reading to be specified as a shadow or highlight area, in which case the camera shifts its programme to ensure that the measurement is exposed appropriately in accordance with the metered tone. Although it is just a short step to progress from this to the zone system of exposure, that step is not taken in this book because of the complexities that can arise. Instead, the author recommends an integrated film-and-SBR approach that will be outlined shortly.

Figure 7.5 An absolutely essential case of spot metering, without which the entire lower part of the hot air balloon would doubtless have been overexposed by in-camera metering. Picture taken on Kodak Ektachrome EPD200 using a Nikon FM 35 mm SLR.

The third and final type of in-camera metering system attempts to assess the scene as a whole, not any one part of it. By looking at the distribution of brightness values, and the overall brightness, the camera tries to match the scene to one of thousands, or tens of thousands, that are stored in its memory. With a match (or several near-matches) identified, the camera then sets what its memory tells it are the optimum shutter speed and aperture. In the vast majority of cases, this method produces accurate exposures. The problem, however, is that an accurate exposure may not have been what the photographer had in mind. In the past, the problem was with pictures that were obviously wrongly exposed: fortunately, with experience it was a relatively simple matter to identify problem situations. Nowadays, with the latest automated metering systems this is no longer the case. In short, the reliability of sophisticated modern metering systems most of the time is the very reason why their occasional failings can prove so frustrating!

Manual metering

Apart from accepting such disappointments as a price worth paying for ease of use, there are two ways around this problem. The first is to meter the light rather than the subject: the second is to match the scene to the film by careful use of a hand-held spot meter. In the studio, especially when working with flash, the first method dominates. This is for the very simple reason that it is easy for the photographer to move to the subject's position to meter the light, whereas out in the field this is not always possible (let alone practical).

Metering the light is the same thing as 'incident light' metering. It is done using a special incident light meter, or a normal meter fitted with a diffusing disk or hemisphere. To take a reading, the meter is aimed half-way between the direction of the light and that of the camera. The reading is then interpreted and transferred to the camera using the photographer's own choice of aperture and shutter speed. Of course, if the lighting is flash, the shutter speed is almost irrelevant – except that it must never be allowed to exceed the camera's synchronization speed. When measuring incident flash, the meter can sometimes be set to match the camera's synchronization speed manually: if not, it will probably have a typical 'gate time' (equivalent to the camera shutter speed) of between 1/60 s and 1/125 s. For most purposes, the exact value is unimportant.

Referring back to the hypothetical portrait situation that launched this chapter, it should be evident that incident light metering will give the same exposure conditions regardless of which person is in front of the camera. In addition, the exposure would

also be the same if the picture were a double portrait. The theory here is that it is the light intensity, not the subject, that determines the exposure. If the subject is darker in tone, then the picture will simply come out darker. That differs from the case of reflected light readings, where the camera will attempt to render all pictures with equal tonality, and where a portrait of a dark-skinned person will actually be exposed too light. The reverse situation is behind the oft-cited rule of thumb which says that fair-skinned people, like snow scenes, should be overexposed relative to what an in-camera metering system suggests. But why resort to rules of thumb? Surely these are only really necessary when the user is forced to generalize – and there should be no place for generalization when it comes to mastering photographic lighting.

Interpretation

Given that the exposure is made with the expressed intention of recording an image on the film, it should be clear that only two things really matter. These are the distribution of tones on the subject, and the film's ability to record those tones. For completeness, there is also the issue of how the photographer wants to see the tones recorded: should they be faithful to the real world, or darker, or lighter, or compressed, or expanded? All of these things can be controlled by careful choice of lighting, exposure, film and processing.

At the heart of it all is the subject brightness range (SBR) and the given film's ability to accommodate this. The essential piece of equipment that is needed to evaluate SBR is a good hand-held spot meter. It matters not whether the meter has a digital read-out or an analogue needle display – other than that any read-out that can be seen through the meter's viewfinder (rather than only on an external panel) makes life easier. It is a very simple matter to point the spot meter at a whole host of different elements within the intended picture, and to see the needle (or digital panel) display a variety of different readings. The most important readings are those corresponding with the darkest and lightest parts of the scene, together with the one taken from the principal subject. The first two give the overall brightness range of the scene, while the last one identifies the most crucial part of it.

To make use of this information, you must know the characteristics of the film you are using – and how those characteristics can be adjusted by altering the development. If this sounds rather like the zone system, then it is. The difference is that the zone system allocates nine tonal values, of which just seven carry useful picture information. This is fine if your film behaves that way, but many

high saturation colour transparency films are considerably more restricted in their tonal range. By contrast, chromogenic black-and-white films have a wider tonal range. In both cases, the zone system must be modified to take account of the film, and it is therefore the author's recommendation that readers should work backwards from their films, not forwards from subject tones.

The test that must be done, therefore, is to discover how wide a range of tones your favourite films can accept. This ability will depend on the processing regime – so that too must be fixed at the outset.

To proceed, photograph an evenly lit target, such as a plain wall or a large piece of card, using a wide range of exposures. If, for instance, your spot meter suggested that the normal tone of the wall would suit an exposure of 1/60 s at f/8, then you should run exposures right across the aperture range. Typically, this should take you from f/1.8 to f/22. In this particular instance, at the wide-open end you should also make exposures at 1/30 s and 1/15 s: at the minimum aperture end, you should make additional exposures at 1/125 s, 1/250 s and 1/500 s. In all, this amounts to thirteen frames exposed at the meter's mid-tone value and with six stops of overexposure and underexposure. Few films, when processed normally, will show different tones on each and every frame. Most likely, several of the extreme exposures will be totally black or totally clear (as appropriate); those that lie on or beyond the first black or clear frame correspond to exposures outside the tonal range of the film. It is an interesting exercise to see how processing alters the results for both black-and-white and colour transparency films. Generally speaking, colour negative films vary less dramatically, and are therefore less interesting in this context.

Personal preferences

Having obtained your strip of frames with varying tones, the final stage is to convert this into something that can be quantified and used for real-world photography – rather than pictures of evenly lit walls! The first thing to check is where the mid-tone exposure falls relative to the first black and clear frames. You know that the mid-tone exposure was the middle frame, and can therefore count how many frames there are to each side before the first ones that are totally black and totally clear. These figures give you the limits of exposure. You may find, for example, that a given black-and-white negative film has five stops of overexposure and four stops of underexposure. It may be that the range is the same to both sides of the mid-tone: a lot depends on exactly how your meter is calibrated – which is why you must do the test yourself, and not rely on published figures.

Having obtained the three values (mid-tone, maximum exposure, minimum exposure), there are two ways to proceed in terms of practical use. One is simply to set the standard film speed, and to take spot readings of the scene to ensure that its brightness range does not exceed the film's accommodation. If there is a mismatch, you must decide whether it is better to have blocked-up shadows or burned-out highlights. The choice will depend on the subject and the type of picture you want. If in doubt, bracket to capture a range of possibilities.

The second approach is to work from one of the limits of the film's range. This is exemplified in black-and-white photography by the motto 'expose for the shadows; develop for the highlights'. To use this method, set the film speed at as many stops higher as the underexposure tolerance allows, then meter from the darkest parts of the scene that are to hold detail. So if the test exposures revealed that the ISO400 film could cope with three stops of underexposure, the metering speed should be set to EI3200. If this is done, all metering must be taken only from the deepest shadows. If normal metering is used, the results will be totally unusable. In addition, be aware that any meter used for shadow measurements must be capable of reading low light values accurately – which not all are. Check the specified minimum EV level before buying a meter for this purpose.

An intermediate approach to metering – and one that works remarkably well in most situations – is to set the film speed as normal, to spot meter from the highlights and the shadows, then to use the mid-point exposure setting. So if the shadows gave 1/30 s at f/4, and the highlights gave 1/125 s at f/16, a good estimate of the best exposure to use would be 1/60 s at f/8.

Lighting effects

Bearing in mind that the subject of this book is lighting not exposure, it is worth closing this chapter by ranking these two in terms of cause and effect. For the vast majority of photography, the lighting determines the exposure. A photographer is confronted with a scene, and meters the light to make sure that the scene records as required on the film in use. But when the lighting can be controlled, whether in the studio or outdoors, one of the prime benefits is the ability to alter the exposure to produce an intended, not incidental, result. The foremost tool in this respect is the lighting ratio, which is the illumination equivalent of the subject brightness range. Much more will be said about this later. For now, it is a very useful exercise to go out with a spot meter to investigate the variety of SBRs that occurs naturally, and to discover how different scenes are recorded on film. The fact that these recordings

vary with the film used is the best argument both for sticking with one type, and also for having an armoury of alternatives that can be called upon when the usual favourite will not do. The author favours sticking with one film and using different developers (or push/pull processing of colour transparency films) to alter its effect. The fact that modern films are more versatile than their ancestors makes this a sensible tactic today, when once it would have been an extreme folly.

Figure 7.6 Two car-and-driver shots that called for very different exposure treatments. The Range Rover, shot on b&w negative film (Fujifilm Neopan 400), was exposed for the interior of the vehicle so that the driver would be clearly visible. The surroundings were then darkened selectively during printing – a fact that is betrayed by observing the scene through the car's rear window. The second image is of Bob Carlos Clarke and the Lada that he once owned, captured on Agfa Scala 200 b&w transparency film. To prevent loss of detail, metering here was taken from the white bonnet of the car: exposure was determined by this reading, accepting the fact that detail would be lost on the outside front tyre.

8 LIGHTING QUALITY

All the comments made so far have referred either to light in general or to specific items of lighting equipment – almost without any consideration of the subject being lit. The time has come now to talk about lighting in the photographic sense. This means the way in which the illumination, be it natural in origin or artificial, interacts with the subject; and how the photographer chooses to use or manipulate that interaction to obtain a particular result.

The prevailing lighting affects the way in which we react to a subject or scene. The 'warm' glow of an orange sunset, for instance, has little to do with the amount of heat the observer feels, but rather is more of a psychological reaction to the dominant hue. Other colour associations include blue for coldness or night-time, and red for danger or some types of sexual connotation. In popular parlance, green is associated with envy, but photographically it is more likely to be allied with freshness of vegetation or landscapes. Sometimes these associations are quite subtle, but even if they are not recognized consciously they are often still effective on a subliminal level.

As important as the hue of the prevailing light is its 'hardness' or 'softness'. This characteristic has already been discussed, but now needs to be considered again in relation to brightness and contrast. For daylight especially, but also for any single source in general, there is a direct relationship between the maximum brightness and the overall contrast of the lighting. The amount of light radiated by the sun is constant, but its effective local illumination on the surface of the earth varies with its angle in the sky and the amount of cloud cover. Also varying with these same things is the size and density of

Figure 8.1 A white statue against a dark background is a recipe for exposure disaster, especially when using transparency film. To avoid such problems, this scene was metered using a hand-held Pentax V spot meter. The picture was taken on Agfachrome RSX-II 100 using a Mamiya 7 medium format rangefinder.

cast shadows. If there is thick cloud, shadows are seen only under substantial objects such as motor vehicles. If the sun is clearly visible, every object will be seen to have a shadow. In mid-summer, when the sun's local illumination on the surface of the earth is greatest, shadows are at their blackest: correspondingly, during other seasons (even in full sunlight) shadows are less dense. All of these facts are directly observable.

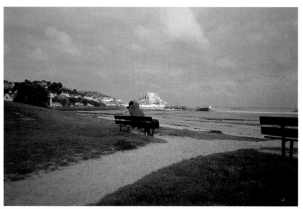

Figure 8.2 These three photographs were taken within a few minutes of each other under rapidly changing lighting conditions. The results are quite different depending on the moment when the shutter button was pressed. Pictures taken on Fujichrome RMS using a Ricoh GR-1 compact camera.

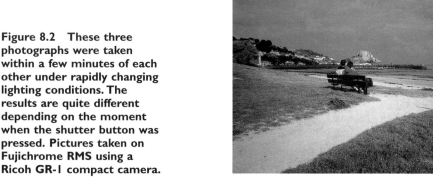

Fill-in lighting

The brightness and contrast phenomenon can be explored very simply in the studio using the extreme example of an object that is lit only from one side. When the light is switched off, the object is uniformly black, and therefore invisible. When the light is switched on, but only at a very low level, the illuminated side of the object will start to appear. Spot meter readings would reveal that the unlit side of the object still reflected no light at all, while the lit side might measure perhaps EV2 – or some similar low-level light reading. As the light's brightness increases, the reading for the lit side of the object will rise, but, in a perfect world, the unlit side will remain totally black. From this, it ought to be obvious that the overall subject brightness range is directly related to the maximum light level (provided that the minimum level always remains the same).

In the real world, there is always some level of natural fill-in lighting. This is light that cannot reach shadow areas directly from the source, but does reach them by reflection off other objects. The amount of natural fill-in depends not on the object itself but on the lighting and the local environment. So important is this fact that it should be engraved deeply into every photographer's subconscious.

Natural fill-in can go a very long way towards explaining, for example, why readers who have tried lighting methods taken from drawings in books may not have got the results they expected. To reiterate: the local environment has a major influence on the lighting effect – and it is for this reason that professional photographers often work in studios with black walls and ceilings, or arrange large black polystyrene boards around whatever is being photographed, specifically to reduce the influence of incidental fill-in light reflected back from the surroundings. That fact is rarely acknowledged and yet can, of course, greatly affect the look of any picture.

Fall-off

One of the most fundamental concepts of lighting is the inverse square law, knowledge of which has already been assumed in connection with the way in which source location contributes to exposure determination (see earlier discussion of guide numbers). Readers who are not fully familiar with the inverse square law are referred to the box panel that appears separately in this chapter. But as well as determining the overall level of illumination, the inverse square law also predicts fall-off – the way in which the brightness of illumination changes across the subject or the entire set. The change can either be rapid or more gentle, depending on the size and type

of the source, and whether it is close to the subject or further away. Larger sources placed close give a more gradual fall-off than small ones, but any light placed close gives a sharper fall-off than the same source at a greater distance.

These parameters can be restated differently in terms of their practical implications. For example, suppose that it is necessary to use a large light source quite close to the subject in order to obtain the desired primary effect, then it will be inevitable that any close-proximity background will also be lit to a significant degree. On the other hand, an object that can be lit with a smaller source will be recorded against a relatively dim background. Or viewed another way, if the subject cannot be placed far distant from a background that is to remain unlit, then the light should be as small as possible and as close as practical to the subject. In this sense, people who buy the largest softbox they can afford, for instance, may be doing themselves a disservice. Almost always it is better to buy instead the smallest softbox that will do the job. And that is why it was previously mentioned that the best source to illuminate a person is often a 'person shaped' 2 m strip light.

The same principle applies also with natural lighting: a doorway or a gap between curtains can provide a suitable full-length source, while a normal window is fine for head-and-shoulders portraits. A window is also fine for 'studio' still-life pictures that would otherwise suit a similar sized softbox positioned at the same sort of angle.

In short, the inverse square law is worth knowing, but should not be expected to apply to all photographic sources.

Individual preferences

To find out more about lighting quality, there is no better way than by using a single source. This exploration should be concerned not only with the direction and proximity of the light relative to the subject, but also the effect of every light modifying accessory under all of those conditions. It must also take into account the effect of all these things on the background, as well as on the subject itself. Mostly, the results should be predictable from the theoretical principles that have been discussed here and in previous chapters, but that likelihood is no excuse not to carry out practical tests first-hand. If nothing else, such experiments will reveal the amount of light loss suffered when using a snoot, and the efficiency of different reflectors, for example.

Tied into all of this are the films used, and the ways in which they are exposed and processed. Some photographers prefer their pictures to have a sombre feel, and expose more leanly to get darker transparencies: others prefer a brighter look, and therefore tend to

overexpose. But if overexposed pictures are not to look flat, it is necessary to have deeper shadows than normal. Similarly, if underexposed images are not to suffer from shadows that are totally without detail, it is necessary to put more illumination into the shadows initially. Therefore, to a degree at least, overexposure suits darker shadows whereas underexposure suits lighter shadows in the original scene.

As before, this principle can also be used in reverse. If you are confronted with a scene containing very dense shadows that are required to show detail, then the best technique is to give the maximum exposure possible. Outdoor portraits on a bright sunny day are a good example. Sadly, many in-camera metering systems fall short under these conditions, and all too often the final image can show 'normal' skin tones with totally black eye-sockets. This in turn commonly leads to the use of on-camera flash for fill-in. But the truth is that fill-in flash does not mix well with harsh daylight for the very simple reason that, if overdone, it can look horribly artificial. It is far better to fill in using spill from the main light itself if this is possible. For daylight, that means using a reflector panel. Much more will be discussed about working with single sources in the next chapter.

Figure 8.3 An overcast day gives the same sort of lighting quality as a giant overhead softbox – as is clearly evident here from the distribution of light and shadow on the car's body. Picture taken on Fujichrome RDP-II using a Ricoh GR-1 35 mm compact camera.

Polarized skies

Before leaving light quality, there is the sometimes vexed issue of polarized skies to be addressed. The fact that daylight is normally unpolarized, and becomes polarized by reflection, was explained in the very first chapter of this book. Light is also polarized by the scattering effect that gives the sky its blue colour. Given this fact, it is unsurprising that the polarization is greatest in areas of the sky that are 'farthest' from the sun in terms of direct illumination. In practice, this means areas of the sky that are at right angles to the sun. To locate this region, which is an arc across the sky, point your forefinger at the sun and allow your thumb to stick out at 90°: by performing a screw like action, with your finger always towards the sun, your thumb will describe the arc of maximum polarization. This arc is the area of the sky that will be darkest blue when photographed through a polarizing filter.

It should be noted that a polarizing filter has maximum effect on a clear sky, and that the colour of the sky (and its darkness of colour when polarized) varies with location in the world. That is why it is sometimes impossible to replicate locally the dramatic skies seen in some other photographers' images. In the UK, to make blue skies look darker when working in b&w, a useful trick is to use both

Figure 8.4 This picture, taken in Greece, clearly illustrates the problem of blue shadows. It is also a difficult scene to get correctly exposed owing to the natural tendency for underexposure arising from the centre area of bright white. The picture was taken on Kodak Ektachrome E200 using an Olympus OM-4Ti 35 mm SLR set to highlight/ shadow metering.

a polarizer and a red filter – but this technique obviously cannot be employed when using colour film.

Finally, the same conditions that give wonderfully deep polarized skies also cause the worst cases of blue shadows. This effect is most often seen when working with colour transparency film. The problem is that direct sunlight casts hard shadows wherever the sun is blocked from shining. But such shadows are not actually black: rather, they are illuminated by the same scattered light that makes the sky blue. This indirect light acts as a natural fill-in, but does so with a distinct blue cast. The effect is commonly seen in scenic images taken under bright Mediterranean sunlight, and often suits slight corrective filtration with a weak straw-coloured gel. Not only will such a filter 'neutralize' the blue shadows, but also it will give directly lit areas a subtle warmth that enhances the sun-drenched look of these types of pictures.

The same 'blue shadows' effect can also be seen indirectly when working in b&w. The manifestation here is of lighter than expected shadow areas caused by the fill-in effect. In b&w, however, that lightness can be lost if any warm-up filtration is used – because the filter will absorb the very hue of light that illuminates the shadows. This will increase scene contrast, as indeed it also does in colour, but in the case of b&w there is no gain in the form of corrected colour

Figure 8.5 Bright sunlight increases colour saturation provided that there is no surface glare. Also evident in this picture is a distinct variation in the blueness of the sky coinciding with increasing angle away from the sun. Picture taken on Kodak Ektachrome E200 using a Contax Aria 35 mm SLR.

Figure 8.6 Two shots of London's Millennium Dome: one taken on daylight film with a pink early morning sky, the other taken on tungsten-balanced film giving a blue look to what was actually a grey cloudy day. Photographs by Sofia Ruiz Bartolini.

balance and an overall 'glow'. Therefore, the norm is to filter lightly to correct blue shadows when using colour film, but to leave the scene uncorrected in order to make full use of the prevailing subject brightness range reduction in b&w.

Inverse square law

Much has been said about the inverse square law, but always on the assumption that readers know both its meaning and its most common failing. In case either of these assumptions is wrong, it is worth recapping the underlying principles.

The inverse square law states that the intensity of illumination falling on an object varies inversely with the square of the distance between the object and the light source. So if two identical objects are arranged in front of a light, one placed twice as far away as the other, then the intensity of illumination on the more distant object will be only one-quarter that of the nearer one. Similarly, if a single light is shone onto a particular object and gives a certain meter reading, then by moving the light forwards or backwards the brightness of the illumination can be increased or decreased respectively.

This all assumes a very small light source: for larger sources, including lights fitted with substantial dish reflectors or any softbox, the situation is different. In particular, at close range there is almost no variation in intensity with distance. As the distance increases further, and the effective size of the light diminishes (as discussed in earlier chapters), so the inverse square law starts to apply. But even when it does cut in, the inverse square law's influence is modified in the case of softboxes and large-face sources because these types of sources tend to produce substantial amounts of spill light that can be reflected back onto the subject from the local environment. Finally, when the inverse square law is obeyed, one of the most important implications is the lessening of light fall-off with increasing distance from the source. This is more easily investigated by the reader than explained in print, but by way of example it should be noted that an outdoor daylight exposure reading taken at the top of a tall building will be exactly the same as one taken on the first floor. This is because the source (the sun) is far distant relative to the height of the building. Performing the same experiment in reverse, with an artificial light source at street level, but again measuring the exposure on the first floor and at the top of the building, will produce two very different readings for reasons that should be obvious.

Figure 9.1 This picture was lit using a single overhead softbox. The sculpture was placed within a Colorama Mini Cove, and the exposure was assessed by incident light flash metering. Picture taken on Polaroid Type 51HC 5 × 4 inch sheet film using a Mamiya RB67 Pro fitted with an NPC77 adaptor.

9 SINGLE-SOURCE LIGHTING

Although studio photography almost always uses more than one light, a great deal can be accomplished with just a solitary source. This applies just as much when working freely inside the studio as it does when working under natural sunlight outdoors. In both cases, the secret lies in knowing how to control or modify the effect of the single light so as to produce a pleasing result. In the vast majority of cases, this means using panel reflectors of one sort or another. But for any reflector to be effective, it is an essential requirement that there is 'spare' illumination that the reflector can intercept without blocking light directed onto the subject. This in turn means that a single tightly focused pool of illumination is almost impossible to modify using reflectors. It therefore follows that lighting units which concentrate their illumination into small areas are often going to be used in multiple numbers – for there is no way to modify the effect of a single source of this type other than by adding more lights.

Less focused lights are different, and it is these that form the basis of this chapter. Often the lighting units concerned may be categorized as 'soft', but sometimes not. An example of the latter is bright outdoor sunlight, which is highly directional (and therefore 'hard') but also all-pervading.

The principles are the same whatever the type of illumination. To a degree, it may be thought that fill-in is more necessary for 'harder' light sources, but it is actually more correct to say that exposure becomes more critical (and the demands on the film greater) under these conditions on account of the wider subject brightness range (SBR) that is often encountered. With softer lighting, the issue is rarely one of manipulating the SBR to match the film's tonal response, and more often one of adjusting the look of the lighting for creative rather than technical reasons.

Reflector panels

Free-standing flat reflectors, as distinct from dish reflectors that mount onto the fronts of lighting units, are used to 'bounce' light

into areas of the picture that would otherwise be in shadow. Off-the-shelf products normally come in white, silver, gold and a silver/gold mixture. White reflectors give the softest effect; silver give the stronger effect; gold reflectors are similar to silver but with a warm-up look; silver/gold combinations are in between the two.

White reflectors can be compared to the action of white exterior walls, white café tables and even opened newspapers – all of which reflect light sufficiently to soften the shadows of nearby subjects that are appropriately angled relative to the source and the reflector. The effect of a 'dimpled' silver reflector is often like the slightly dappled look that comes from sunlight reflecting off water. Because they are brighter, 'metallic' reflectors can be used at more of a distance than white ones, and this in turn can be used to give a very different look to the lighting. By the same token, smooth mirror-like reflectors can create rather unnatural (or unflattering) results if used carelessly. This is especially true when working with gold warm-up reflectors, which can produce jarring lighting where the enhancement is more obvious than ever because of its warmth.

Indeed, one of the biggest problems with portable reflector panels is that they are often too small to have any useful effect except when used at short range. A good example of the problem is provided by a wedding group photograph of maybe thirty or more guests. Given that the camera will be quite distant, and that its angle of view will normally preclude any close proximity reflectors, the opportunity for bouncing light into the picture is limited. That said, a correspondingly large reflector – provided, for instance, by the white wall of a building – could be very effective. It may seem odd to suggest arranging a group portrait with the people facing a wall, but the effect can sometimes be worth exploiting. It should be obvious that the sun, in this case, will have to be behind the group in order for the front reflector to be effective across a broad group of people. The overall effect is therefore likely to be partial

Figure 9.2 This set was lit from the rear using a softbox that was large enough to cover the flat blade of the knife, but which could not match the full curve of the fork prongs. The image shown is one of the Polaroids taken to check the lighting effect.

back-lighting (giving a 'rim light' effect that helps to separate the group from the background) complemented by reflected light that brightens the front of the group.

Lighting from the rear

Exactly the same principle is also used for studio still-life work, where a softbox is placed above and slightly to the rear of the items being photographed. This arrangement can variously create a bright rim, reveal texture, or produce a clean highlight on smooth surfaces. The last of these is particularly useful when photographing cutlery, tools or other such metallic objects.

When working in this way, an important issue is the size of the softbox relative not to the object but to the camera's angle of view. Essentially, if the camera is pointed straight at the softbox, which in turn is angled square to the lens, then the light should fill the frame.

Figure 9.3 In a strong back-light situation such as here, there is high contrast between the subject and the background, but low contrast across the subject. The result can be a horrid mixture. To save the day, this negative was printed on 'hard' paper to suit the subject, and the background was then burned-in slightly to provide a hint of tone. Picture taken on Fujifilm Neopan 400 using an Olympus iS-200 35 mm SLR.

If this is so, then when the light is viewed as a reflection in any object's surface, there will be uniform white highlights. This assumes that where multiple objects are involved, all the items have flat surfaces and are arranged at the same angle relative to the camera-to-light axis. If the surfaces are flat but tilted inwards (towards the light-to-camera axis) it may be possible to use a smaller softbox than the aforementioned guideline suggests. Conversely, if the objects have curved reflective surfaces that include areas which reflect outwards in all directions, it will be virtually impossible to get a uniform surface reflection using only a back positioned source.

All-round lighting

It follows that if the object to be photographed has a surface that reflects in all directions, then the only way to lighting evenly is using an all-round source. This is most easily done by employing a diffusing 'shell', inside which is placed the object concerned and outside which is the light source. The two most common types of shell are a fabric light tent and a white translucent globe. Tents are less costly and easier to store thanks to their collapsible design: globes tend to give a more even lighting effect (though this can be a limited advantage if the globe comprises two hemispheres with an equatorial waist-band of thicker or flanged plastic).

In both cases, a single light can be directed onto the exterior of the shell from whatever angle best suits the object inside. Often, that angle will be in front of and above the camera position. Lighting from the rear can be effective when the object is semi-transparent, especially if pieces of grey or black paper are mounted inside the shell to provide edge definition. These create a sort of 'anti-reflector' effect that exaggerates the curvature of any surface. Although curvature is identified in nature by a smooth transition from light to shade, it is more common photographically to enhance that change with sharp dark (or light) bands.

In fact there are both practical and aesthetic reasons for placing dark band reflections on the object inside. Principal amongst the former is a need to hide the reflection of the camera itself. In the digital age, that end can easily be attained by electronic manipulation – though even previously it was a relatively simple retouching job on prints (but very much less so on colour transparencies). It is better still, however, to minimize the problem at the outset – and that is where the practical use for a dark band comes in.

Light tents and translucent white globes both feature apertures through which the camera lens can view the object inside. Tents employ zipped or hook-and-eye fabric fastenings that allow the aperture's position to be moved up or down to give the best angle

of view, but globes often have just a single aperture. In both cases, it is best not to let the lens protrude through the aperture, but rather to position it just outside (perhaps with a lens hood linking to the aperture) so that the light inside the shell does not fall on the front of the foremost lens element. Provided that this can be avoided, the lens area will show in any forward reflective surface as a simple dark disk. That shape readily betrays the camera, but by fixing a band of dark paper upright inside the shell, extending above and below the aperture, the give-away can be disguised.

The same technique also works on a larger scale in the studio when using twin softboxes, or light bounced off reflectors to both sides of the camera. Just one complication applies in such cases, and that is that light must be blocked from falling not only on all parts of the camera, but also on the tripod and even the photographer. For this reason, proper studio stands have matt black surfaces: similarly, many studio photographers dress in black partly for the same reason (and partly as a matter of style). A useful tip when trying to hide the reflection of a bare metal tripod in the studio is to fit black, tubular foam, water-pipe lagging over the legs.

Before leaving all-round lighting, there is one more single-source technique to mention, which is omnidirectional reflection. The idea here is that a diffused light (such as a small softbox) shines directly onto the object being photographed, and is supported by nearby reflectors placed at every other angle. The result is directional lighting with all-round fill-in. For small still-life arrangements, there are several commercial lighting systems that give this effect. For best effect, the reflective surfaces should have curved boundaries between different planes, but a good home-made system can be created using multiple small white reflectors (such as pieces of white foam-board of the type that is sometimes used for mounting pictures).

For head-and-shoulder portraits, the appropriate reflective structure can be imagined as a box. The camera looks through the front of the box, facing the person who looks in from the rear. The top of the box is removed and replaced with a softbox, leaving the sides and base to provide the reflective surfaces. When it comes to the detail, however, the box model fails because the reflectors need to be tilted backwards to direct light onto the person's face rather than just bouncing it between the softbox and the three white surfaces.

Lighting people

There are really only three ways to light people: from above, from the side and from the front. Interestingly, all three styles can be attempted with just one light – though it is more common to

Figure 9.4 This semi-surreal image was created using a single light to the left of the camera. Apparent lightening seen to the right of the model is in fact partial reversal of the image arising from the Sabattier effect: see Chapter 12 for more examples and further details. Picture taken on Polaroid Type 55 5 × 4 inch sheet film using a Mamiya RB67 Pro medium format SLR fitted with an NPC77 Polaroid adaptor. Lith print by Melvin Cambettie Davies.

supplement these main lights with others. The use of additional lights will be discussed later, but the three types of main lights are explained here.

Lighting from above with just a single source is exactly as just described for an all-round effect. If the 'box' reflector arrangement is not liked, then a single flat reflector can be used instead. It should be placed as close as possible in height to the sitter's chin – but forwards of the person, and angled slightly backwards as before. Normally, the light is placed a little further forwards still (so that it illuminates from the front), and is angled so as to light the face symmetrically. This last point is satisfied by positioning the light directly above the sitter's nose. For females in particular, this is a very flattering form of lighting as it emphasizes cheek bones and hair. When the optimum position is used, a small symmetric shadow is seen under the model's nose: the shape of the shadow is

sometimes said to resemble a butterfly in flight, and for this reason the style is known as 'butterfly lighting'. To maintain a pleasing effect, however, the shadow must stay well clear of the model's top lip. The only other thing to be wary of is a distractingly bright forehead in the absence of any fringe.

Having given an explanation for why lighting from above is best when photographing women, it must now be admitted that the biggest problem with this approach is that it can easily make faces look either fat or skeletal. These problems can only really be overcome either by adding more lights or by changing to side lighting.

In the studio, side lighting (which can come almost from the front in some cases) can be applied either using a softbox or by shining a light onto a large flat reflector. Available equipment or space may dictate which choice is made, but if both are possible then the softbox will often give a more natural look to the picture. Outside of a dedicated studio, side-lit portraits can be taken by window light, with curtains being used if necessary to alter the shape of the source. But watch out for strongly coloured curtains that can give rise to very unpleasant skin tones. Working in b&w, if this is a viable option, is the easiest way to avoid any such problems.

A reflector may be necessary opposite the light, but unlike when lighting a tightly cropped head-shot from above, the reflector will not always be essential. The controlling factor is, as always, the desired look of the final image. This in turn must take account of the tonal range of the film and the prevailing subject brightness range. It is not necessary to fit all of the latter into the former if the intended effect permits otherwise. But if the two do need to be matched, yet start unequal, then a reflector will normally be the answer. Importantly, the reflector must be of an appropriate size for the intended crop, and the framing must allow it to be placed close enough to be effective.

By having the person close to the window (or the softbox), greater illumination intensity is obtained. That may make it easier to set the desired aperture and shutter speed, but it also increases fall-off, and so makes a reflector all the more necessary. Conversely, moving the person farther away from the window (or softbox) drops the illumination, but also reduces fall-off. In addition, it

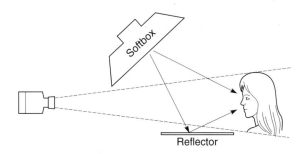

Reflector

Figure 9.5 Approximate positions of softbox and reflector for a single-light portrait arrangement. To avoid unflattering shadows, the softbox must not be too close to the sitter. The reflector acts like a mirror, and should be positioned with this fact in mind.

makes the light slightly harder too – which may not be a good thing. Predictably, there will be an optimum position that brings all of these factors into balance. Trial and error, leading to experience, is the only way to master this scenario.

That said, it is vital when working on location to have the camera mounted on a firm tripod. Only in this way can the camera settings be freed-up so that they can be chosen purely for artistic effect – without having to worry about the degrading effect of camera shake. The fact is that people usually hold quite still when posing for the camera, but very few photographers are truly capable of holding a camera steady at slow shutter speeds.

Last of the single-source portrait techniques is lighting from directly in front of the subject. One way to do this is by using copy lighting: strictly speaking this involves two equal light sources arranged symmetrically to each side of the lens-to-subject axis, but two heads are employed only for the purpose of creating a single, uniform front lighting effect. In portraiture, however, this technique produces very bland results. The second 'full frontal' possibility, which is also not generally used in practice, employs a 'light painting' wand that is drawn across the front of the model's face, directly between the person and the lens. A very static pose that can be maintained throughout the exposure is essential. Professional models are able to hold such poses, but most people are not. And that reason, as well as the expense of the bespoke equipment required, is why light painting is not generally employed for portraiture of any sort.

Light banks

The most widely used front lighting for portrait photography involves a very large light source, such as a massive softbox or bank of windows (not lit by direct sunlight). The photographer and camera are positioned between the 'light bank' and the sitter, and for

Figure 9.6 Sofa lit using a softbox that was slightly larger than the object itself. As a result of this scale of operation, there are no hard shadows on the floor. The size of the softbox is just apparent from the corner that can be seen intruding into the top of the picture; the light stand can also be seen to the left of the frame. Obviously, these elements would be cropped out of the final image, and are shown here purely for information. Picture taken using an Epson PhotoPC-850Z digital compact camera.

Figure 9.7 Two approaches to 'one-light' wedding photography. For the outdoor shot, a single 500 J Bowens Esprit monobloc was fired into a white reflective brolly to give a directional, yet natural lighting effect. For the indoor shot, a single 1500 J Systems Imaging monobloc was used in 'bare bulb' mode to give almost shadow-free illumination.

this to be possible without blocking any significant amount of illumination it should be clear just how big the light source needs to be. Indeed, few softboxes are big enough, and it is most common to use banks of windows – as are often found in dance and theatrical rehearsal studios.

Because the lighting is so all-pervading, unadulterated portraits lit this way will almost inevitably show something of the surrounding environment. If this is not wanted, the picture must either be very tightly cropped or finished off with an artificial background that is erected behind the sitter to obscure the room beyond. Nothing can be done, however, about the catchlights in the sitter's eyes, which, unless retouched, will show an outline of the photographer silhouetted against the light source. The only possible hope may be provided by small areas of wall between adjacent windows where the photographer can stand less obtrusively. As with all-round, large-scale still-life lighting, dark clothing and blackened tripod legs will also prove an asset. Unfortunately, the 'dark area' camouflage tactic (which is analogous to placing a dark panel inside a light tent) creates an unnatural and sometimes unnerving catchlight that will probably still need to be retouched. Ironically, it is often easier to retouch the irregular outline of a photographer than a solid dark rectangle.

Ringflash

Essentially, this is a similar idea to the 'big light behind the photographer' approach, but using a considerably more symmetrical source located in front of the camera. Because of the source's annular shape, the camera lens can poke through the centre of the light to view the subject without obstruction. Small ringflashes are intended for close-up photography, but can also be used in portraiture provided that

Figure 9.8 Hensel ringflash head fitted to a Mamiya RB67 Pro medium format SLR. Other manufacturers' ringflash heads are mostly similar, though some, such as the original-design Strobex model also shown here, are contained within square-section housings that can be mounted on their own stands.

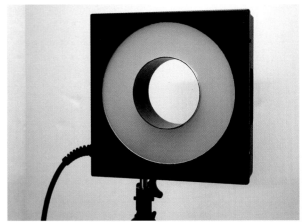

their power levels permit. There is, however, no escaping the fact that a full-size ringflash will give better portrait results. Unlike the case with single-source lighting in general, exposure is not straight-forward when using a big ringflash. The reason is that the lighting effect is so distinctive that conventional exposures tend to look flat, and it is more common to overexpose by perhaps two F-stops to get a brighter image. If colour transparency film is used, this tactic causes an attendant loss of saturation, but on negative film colours get more intense. Cross-processing a transparency film to get negative characteristics intensifies the colour still further.

Bare-bulb lighting

A single-source technique that can be used reasonably successfully for all types of photography is bare-bulb lighting. As its name suggests, the method involves a naked light source (normally a flash head) with no reflector attached. If such a light is aimed directly at the item being photographed, the illumination will be harsh – rather like direct sunlight on a clear summer's day. That effect is not very useful, but by turning the light in the reverse direction, and aiming it into one of the room's corners that is diagonally opposite the

Figure 9.9 Lit using only a Strobex ringflash, this picture reveals the black contour lines that are so characteristic of this lighting method. Picture taken on Polaroid Type 51HC 5 × 4 inch sheet film using a Mamiya RB67 Pro medium format SLR fitted with an NPC77 adaptor. Model: Marie White. Lith print by Melvin Cambettie Davies.

subject, beautifully soft lighting is obtained. Quite a lot of power is needed if the source is used inside a large room, but in a small to medium size room a flash unit rated at about 400–500 J will be sufficient. Care must be taken to check that the reflecting surfaces off which the light is bounced are not coloured (unless the picture is being taken in b&w, when colour casts are irrelevant). With that proviso, bounced bare-bulb illumination is highly recommended as an easy-to-use and very versatile technique. Metering is uncomplicated, and just a single incident light reading taken at the subject position will often suffice. That said, it is wise to check also fall-off into the background as well as the brightness of any obvious foreground features – just in case there is anything that might mar the picture.

Before leaving bare-bulb lighting, it is worth noting the reason for removing the flash head's reflector. The purpose of any dish reflector is to concentrate the light in one particular direction, whereas bare-bulb illumination works by scattering the light in all directions. The only time that a reflector would be useful is when the flash head cannot be located close to the room corner (perhaps because the stand used is too low). In this situation, a bare head might cast shadows from tall surrounding objects, whereas directing the light higher up with a reflector will help to avoid this problem. It should go without saying that the corner into which the light is aimed must have a clear 'view' of the room overall, and of the principal subject in particular.

On-camera flash

The best advice that can be given about in-built camera flashguns is to keep them turned off for as much of the time as possible. Sadly, many compact cameras power-up their flashguns as soon as they are activated, even if the flashgun is not used. If possible, it is often better to try to hold the camera steady rather than letting the flashgun fire in borderline light-level situations.

External flashguns are much more controllable, offering not only manual power adjustment but also, in some cases, a choice between early (first curtain) and late (second curtain) flash synchronization. These settings are relevant when the picture contains a mixture of flash with some amount of ambient lighting. If there are moving objects, late (second curtain) synchronization ensures that any blur due to motion is behind the sharp part of the exposure – as would naturally be expected.

The only reason why first curtain synchronization is more common is that it came first for technical reasons. In the early days of photography, disposable flashbulbs were used, and these took time to burn to peak brightness. Therefore, flashbulbs had to be

triggered a split second before the exposure was made, and that arrangement could only be guaranteed by synchronizing the flash relative to the start of the shutter timing. Cameras that are marked with an 'M' flash setting (rather than the usual 'X') can be used with flashbulbs at any speed setting of a leaf shutter: with other cameras, flashbulbs can only be used at shutter speeds below about 1/30 s.

Two relatively recent innovations in on-camera flash are 'slow-synchro' and 'red-eye reduction' modes. Slow-synchro flash is like fill-in flash, except that it is used mostly at night to ensure that some contribution is recorded in the picture from the ambient lighting. The effect is achieved by forcing the camera to set a shutter speed more appropriate to the natural light level – one that is below the maximum that provides 'normal' flash synchronization. Everything works automatically, though the fact is that many experienced photographers were regularly using this trick long before it was automated for mass convenience.

Red-eye reduction normally involves firing a high-speed sequence of low power flashes before the main flash that exposes the picture. The theory is that because dilated pupils are the cause of red-eye in pictures, a preceding bright light will cause the pupils of anybody facing the camera to contract, so reducing red-eye. In practice, success is not always guaranteed.

There is, however, another use for the red-eye reduction mode that can be more useful still. Because the pre-flashes last for a second or two, there is time to check in the viewfinder for 'hot spot' reflections of the flash in any mirror-like surfaces that happen to be in the picture. If any such reflections are seen, the camera angle can be adjusted and a further picture can be taken to avoid the problem. This trick is not really a lighting technique in its own right, but it does provide an easy means of improving the quality of pictures lit by on-camera flash – especially when using SLR cameras that undergo viewfinder black-out at the crucial moment of exposure.

Nothing more will be said about flashgun lighting specifically here, but it should be realized that almost every lighting technique outlined in this chapter can be adapted for use with a flashgun. The most important assets in this respect are manual control over the light level, and the ability to use the flashgun off-camera, connected for synchronization by either a cable or a wireless (radio or infrared) link. Most flashguns support both manual control and remote synchronization – though it may be necessary to fit a hotshoe-to-cable adaptor onto the camera if a flash PC socket is not provided as standard. After that, all that is needed is a budget flash meter to open up the world of single-source lighting. If you start this way, it probably won't be long before you yearn for a better lighting system, but at least this is a low-cost way to try out some ideas and to get a feel for how the principles work in practice.

Figure 10.1 This picture is unusual in that multiple lights have been arranged within view across the background behind the subject. These 'effects lights' are actually small white lamps normally used to decorate Christmas trees. The lens aperture was chosen to give the desired size and shape of out-of-focus highlights, with the shutter speed adjusted to give the required exposure. This picture would have been very much more difficult to create if it had been lit using flash.

10 MULTIPLE LIGHTS

In principle, it does not matter how many light sources are used; the basic method of working is always the same. The essential starting point is to have a clear idea of the desired effect. Confusion, when it arises, almost invariably stems from trying to follow a recipe rather than attempting to achieve an independently visualized result. The problem is that it is difficult to know where to start or what can be achieved when thinking about lighting. This chapter therefore outlines some of the possibilities, ranging from 'synchro-sun' fill-in flash to multi-head studio arrangements.

Two lights

The simplest example of two-head lighting is that employed as copy lighting. This has been mentioned already, and is discussed fully as an example later. Nevertheless, it is worth noting that if the two lights are initially set up equally, but one is then turned to a higher power, then the overall effect becomes one of a main light and a fill.

This scenario is where proper two-source lighting begins. The brighter 'main' light provides the modelling and determines the exposure for the picture: the dimmer 'fill' light sets the density of the shadows – and thereby the mood of the picture. If modified copy lighting is used, the fill light is at the same angle as the main light but on the opposite side of the lens-to-subject axis. It is more normal, however, either to move the fill light closer to the lens axis than the main light, or to give the fill as near as possible a non-directional position. The second option is achieved by aiming the fill light into a high corner of the room or studio in exactly the same way as was described previously for single-source bare-bulb lighting. It therefore follows that if you own a light which can be used on its own in bare-bulb mode, then that same light can also provide the fill for a simple two-source lighting arrangement.

Inevitably, the question that quickly arises is what should be the relative levels of the main and fill lights? Since the former determines the exposure, it follows that its brightness must suit the

film used and the aperture setting required. The fill must be dimmer than the main light, but that does not necessarily mean that it is set to a lower power level. Rather than considering the output setting (or lamp wattage) of the light itself, you must instead attend to the meter readings obtained from each light separately. These figures must then be reconciled with the desired effect on your chosen film. Because personal tastes and film handling methods vary, it is not really possible to generalize about the best settings other than to suggest some starting points.

When using b&w film, the meter reading for the fill light can be around three or four stops below the main light if only a subtle fill-in effect is required. So if the main light's meter reading is f/16, the fill light will be between f/5.6 and f/4. This means that if the picture were taken at f/16 with the main light switched off, nowhere in the scene would be underexposed by more than three or four stops. Given that the tonal range of most b&w films allows for around four stops of brightness above and below the main exposure, it should be clear that no area within the picture will have shadows that fall outside the tonal range of the film.

A similar exercise suggests that about the same settings should be good for colour negative film, but the reality is that colour film often benefits from rather more brightness, so three stops is normally the limit of the fill below the main light here – and two stops below is not unusual. Colour transparency films (and b&w transparency films too, whether Agfa Scala 200X or one of the 35 mm Polaroid films) tend to have narrower tonal ranges: two stops is normally the limit for the fill, and sometimes it is even set just one stop below the main light.

To make sense of all these suggestions, set up some example pictures and take a series of exposures with different lighting ratios

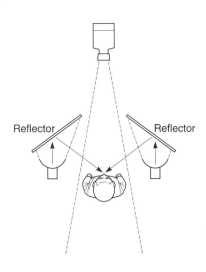

Figure 10.2 Symmetrical front lighting obtained by bouncing the illumination from two identical heads (either flash or tungsten) off reflector boards that may be either flat, as shown here, or 'L' shape.

Figure 10.3 Classic bounced front lighting from a pair of panels that are either flat (as in the diagram and used for the portrait) or 'L' shaped (as used for the cooking pot). Portrait taken on Kodak Ektachrome E100VS; cooking pot taken on Kodak Ektachrome E200. Both pictures captured using a Mamiya RB67 Pro medium format SLR.

(balances between the main and fill light). When the films are processed, look at the images to decide which are your favourites. The settings that apply in each case will probably vary with the subject, the angle of the main light and the method of applying the fill. Although this complicates matters, it does provide a straightforward way of obtaining an entire set of 'best' balances that will then form the basis for all future work.

Synchro-sun

Sometimes, however, there is not much room for adjusting the balance between the main and fill lights. Nowhere is this more true than when using a fully dedicated on-camera flashgun to tame the shadows of a bright sunny day. The technique used here is known as 'synchro-sun fill-in flash', and is provided automatically by most fully automated TTL-controlled flashguns according to pre-defined algorithms. This is very convenient, but is not good for creative lighting.

It should be mentioned that flash fill is rarely as necessary as many cameras think, and that the automatic flash burst can often kill rather than improve the atmosphere of a picture. It should also be obvious from the preceding comments about film types that any flashgun that does not take into account the exposure latitude of the film (which is indicated as part of DX coding on 35 mm film cassettes) is doomed not to give the best results.

That is not to say that TTL fill flash is bad: its convenience means that it cannot be described that way. But if a more individual result is required, the user must switch to manual power and set the output level and lens aperture accordingly. Once again, fully dedicated flashguns have systems (such as automatic film speed setting) that can actually hamper manual control, and for this reason it is strongly recommended that an all-manual flashgun is purchased specifically for synchro-sun use.

Assuming that such a unit is used, the method of operation is exactly as it would be in the studio, with the flashgun set an appropriate number of F-stops below the main exposure. This can become very confusing in the field, so there is a useful alternative tactic that is frequently employed by medium format wedding photographers. The method is to reset the film speed dial on the flashgun only, then to match the flashgun's aperture to that of the lens. For example, if the film used is rated at ISO100, and the fill flash is required at two stops below the sunlight exposure level, then an easy way to proceed is to set the flashgun's film speed indicator to ISO400. Once this is done, the flashgun's integral sensor will automatically provide fill flash that is two stops below the daylight level.

There are, however, a number of assumptions at work here. One is that the camera will not override the flashgun's settings. This can only really be ensured by using a manual flashgun with an old-fashioned (non-TTL) automatic mode that employs a sensor on the front of the flashgun itself. The second assumption is that there is freedom to choose whatever shutter setting is necessary to give the correct balance of exposures at the working aperture. Obviously, the shutter setting must not exceed the fastest time that gives proper flash synchronization – a factor that comes into play when using 35 mm cameras and medium format cameras that have focal plane shutters. Cameras with shutters in their lenses, such as most professional medium format cameras, liberate their users from all such worries.

Finally, there is the question of whether the flashgun is powerful enough for the job it is being asked to do. Typically on a bright summer's day under direct sunlight the exposure for ISO100 film could be 1/250 s at f/16. Of course, nobody in their right mind would really want to take a portrait under such bright, direct lighting conditions by choice, but if it is simply unavoidable then synchro-sun fill flash can help.

The biggest factor controlling the success of the technique is the level of fill flash used. At a distance of say 6 m (a reasonably common full-length portrait range), the f/16 light level would be matched by a flashgun with a metric guide number of 96 for ISO100. This is a very high power rating indeed, and there is not a single commonly available flashgun that would be up to this task. Fortunately, the flashgun is being asked to work two stops below this, so the effective guide number required falls to 48. This rating is still high, but several top-of-the-line flashguns of this power level are currently available.

Modest flashguns can be used under the same daylight conditions if one or more of the working parameters is/are adjusted. By opening the lens aperture one stop to f/11 (and increasing the shutter to 1/500 s at the same time), the effective flash guide number required drops to about 34. This brings many mid-range flashguns into play – provided, of course, that the higher shutter setting does not exceed the camera's maximum flash synchronization speed. Similarly, if the shooting range falls to 2.5 m (a typical maximum distance for 'happy snap' portraits), then the flash power needed is reduced again to a very modest GN14. It is no coincidence that many compact cameras which are intended for 'happy snaps' are fitted with integral flashguns with guide numbers of between 12 and 20.

Some readers may find all these figures, which are based on the guide number formula given much earlier in this book, very confusing. If that is the case, then a simple justification for being

Figure 10.4 Synchro-sun flash was used to add sparkle to Jonathan Straker's portrait. Picture taken on Kodak Ektachrome EPP100 using a Nikon FM 35 mm SLR with a Sunpak 3075G flashgun.

able to perform such calculations is that they allow the photographer to predict in advance the lighting equipment that will be best suited to any given job or situation. At the very least, this can save the frustration of having carried kit that turns out to be incapable of performing the intended purpose: at best, it can guard against purchase of the wrong piece of equipment.

In summary of the synchro-sun flash technique, a number of general points can be made.

Firstly, the wider the lens aperture, the more modest is the flashgun power required for fill lighting. As a follow-on from this, the higher the shutter speed can be set whilst retaining full flash synchronization, the lower will be the demands made on the flashgun. In this respect, it should be obvious why 35 mm camera manufacturers constantly pursue higher flash synchronization speeds with their focal plane shutters, and why photographers who make common use of the synchro-sun technique often prefer medium format cameras with leaf-shutter lenses that provide flash synchronization at all speeds.

Secondly, the flashgun-to-subject distance has a huge impact on fill lighting performance, especially at relatively close ranges.

Thirdly, anything that can be done to improve the flashgun's effectiveness at greater range (such as the provision of a 'zoom' head) will pay dividends.

Lastly, in situations where a given flashgun has insufficient power to provide the required level of fill lighting, there is nothing to be gained by using a higher or lower ISO film. All that a different film speed will do is alter the working aperture: it won't make the flashgun itself any more effective.

Independent sources

Quite apart from the various fill-in applications, there is vast potential for using multiple lights as independent sources. Some might think that this is the point at which 'real' lighting begins, but in fact when several lights are used separately the situation is no different from using one light at a time. Ultimately it is necessary to reconcile the various power levels to achieve a common exposure aperture, but this is nothing more than a purely mechanical operation.

As was stressed at the outset in this chapter, previsualization is everything in good lighting practice. Take, for example, a portrait. Imagine in your mind what sort of person you might be photographing, and how you want the image to look. If you want to do a portrait of a person against a dark background, how will you stop dark clothing or hair blending into the distance? A common answer is to reserve dark backgrounds for fair-haired people wearing light-toned clothes. In moderation, that can be a good idea, but not if it means peroxide blondes wearing bright white blouses: if such people are photographed in front of a black background, the result will be very discordant. The same is true – though to a lesser degree – when dark-suited, dark-haired people are photographed against an over-lit white background.

To make a dark subject stand apart from a dark background, all that is needed is some careful lighting. The same rim lighting effect that was explained earlier for studio still-life work is useful again here. A light is placed to one side (or above) and behind the subject. The shape of the light should reflect the profile that is to be lit: a short strip light is good for half length compositions, whereas a simple standard head will often suffice in head-and-shoulders portraits. Determining the correct brightness can be tricky. The best way is to meter the main light, then to set the rim light about two stops below this. Often, the rim light will be set similar to the fill light. The same tends to be true of hair lights.

This does not mean, however, that the rim light or hair light will act with the same subtlety as the fill. Quite the opposite in fact. Unlike the fill light, rim and hair lights are aimed roughly towards

Figure 10.5 Three-head studio lighting arrangement using a trio of Elinchrom monoblocs. The record shot shows the location of the softbox main light (left of camera) and the background effects light (far right) that creates brightness behind the glass doors and provides rim lighting on the model. The third light is a bare-bulb fill positioned behind the camera.

the camera, and their light reaches the lens not by full reflection, which causes a considerable loss of intensity, but directly – and therefore with very little loss of brightness.

Background lighting

The colour and tonal value of the background need to be known in advance of any lighting being arranged. A reasonably common tactic is to use background paper and work on the basis that it will appear on film just as it does to the naked eye. If that is indeed the intention, then the paper must be lit evenly and at an intensity that matches the meter reading taken from the main light. Suitable lighting can be provided by a pair of strip lights, one to each side of the background, both aimed towards the centre axis of the paper. Alternatively, four standard heads with good coverage can provide nearly as good a result, with one high up and one low down, left and right. Indeed, if the uniformly lit background area required is relatively small, then just two standard heads may suffice: they should be placed on the same level but on opposite sides of the area that is to be lit. Effectively, the type of lighting being created in each case is the same uniform effect as would be used for copying.

Figure 10.6 The background
here, a green colorama
paper roll, was lit by a head
positioned just out of view to
camera left. A second light
lifts the model's hair. The
main light is on the floor in
front on the model, with fill
provided by a bare-bulb head
behind the camera. Picture
taken on Fujichrome RDP-II
(Provia) using a Mamiya
RB67 Pro medium format
SLR.

Figure 10.7 As well as
lighting the model, the need
here was to light the
inflatable chair. A single flash
head has been positioned
behind the chair facing
forwards, with its power
cable hidden within the
ruffles of the floor fabric.
Picture taken on Kodak
Portra 160VC using a
Mamiya RB67 Pro medium
format SLR.

Imagine that the background area concerned is a painting or other item that is to be copied, then light it accordingly. That way, a smooth result should be obtained.

Complications arise when trying to avoid, or work with, shadows. If shadows cast by the main light are to be overcome, then it follows that the background lighting must be brighter than the intensity of the main light on that plane. That is why the point was made previously about the position of the main light relative to the subject and to the background. The problem is that if the background is to be over-lit in order to kill the shadows, then most likely the background will become a very light tone overall.

Although this book is about lighting techniques, it is worth mentioning that shadows can also be eliminated by careful lens choice. In particular, using a long focal length lens means that, for the same subject composition, there will be a smaller area of background included in the picture. And if less of the background is in view, then obviously it is much easier to avoid any shadows that have been cast. Equally obviously, to move a cast shadow away from directly behind the subject, all that need be done is to shift the light further away from the camera-to-subject axis. Another useful trick is to tilt the camera in order to obtain a very different angle. Under those circumstances, shadows that would normally be identifiable (and therefore rather obtrusive) become abstracted areas of dark tones.

Mixed lighting

Before leaving multiple source techniques, mention must be made of mixed light situations. In theory, synchro-sun fill flash is a mixed lighting technique, but more often the term is reserved for times when flash is combined with tungsten or fluorescent lamps. Here, the lighting is mixed in both duration and colour temperature. Depending on the effect required, the first step will often be to filter the continuous sources in order to equalize the colour renditions. Full colour correction may not always be necessary (or possible) – in which case, if the picture will contain a combination of sharpness and blur, the two components will also be distinguished by their different colour hues.

Exposure is tricky. The easiest way to start is to determine the exposure for the continuous sources alone, then to adjust the flash power to give the required proportions. Suppose that the continuous lights are metered as 1/30 s at f/4, and that the intention is to produce a picture where the blur is a minor part of the picture. In that case, the flash might be set about two stops higher. That means a power level which meters at f/8. The lens is then set to match the flash exposure, with the continuous lighting left to

provide a subtle blur that will be most obvious in areas that were shadowed by the flash head(s).

To reduce the continuous light effect, simply increase the shutter speed. Provided that the shutter speed never exceeds the top flash synchronization setting, the value chosen will have no effect on the flash exposure – and it is for this reason that the shutter alone is used to vary the effect of the ambient lighting in mixed source conditions. If the opposite effect is required, then the shutter speed is set lower than before: once again, there will be no effect on the flash exposure.

To reduce the flash effect, set a smaller aperture together with a correspondingly slower shutter speed to keep the continuous light exposure the same as it was before. Similarly, if the flash exposure is to be increased, the aperture is opened while at the same time the shutter is speeded up. It should be obvious from the preceding options that contributions from the ambient (continuous) and flash components in any mixed lighting exposure can be adjusted independently of each other. They can also, of course, be linked together so that the exposure can be bracketed to make the picture lighter or darker overall. This adjustment is done using the aperture alone, for the aperture (unlike the shutter setting) acts equally on the ambient and flash components.

Although these controls become obvious once mastered, they can seem confusing at first. For this reason, Table 10.1 lists a range of settings and their effect for the example conditions given above. It should be noted that because the flash component is dominant, the effect of adjusting this element is mostly one of making the

Table 10.1 Examples of mixed lighting exposures

Lighting conditions (fixed for all exposures)		
Initial tungsten meter reading	1/30 s	f/4
Flash meter reading (set to +2)	n/a	f/8
Camera settings (for different lighting effects)		
Working exposure for desired effect	1/30 s	f/8*
Bracket for lighter image overall	1/30 s	f/5.6
Bracket for darker image overall	1/30 s	f/11
Less tungsten (shorter/darker blur)	1/60 s	f/8
More tungsten (longer/lighter blur)	1/15 s	f/8
More flash (lighter/sharper image)	1/60 s	f/5.6
Less flash (darker/softer image)	1/15 s	f/11

*The assumption here is that the tungsten illumination does not add significantly to the flash illumination. In practice, the working exposure might be slightly less than indicated (maybe one-half to one-third of an F-stop smaller than f/8).

picture lighter or darker, with just a slight effect on the blur/ sharpness ratio. Conversely, the tungsten component has less effect on the overall exposure: adjustments here are revealed mostly in the extent of blurring seen in the picture.

How bright?

The need here to distinguish between illumination brightness and camera settings reiterates a very important issue that was mentioned in brief at the start of this chapter. Throughout this book, unless stated specifically to the contrary, whenever mention is made of the output settings used for different lights, all references are to metered values. These are the figures that are used to determine the camera settings – as outlined above. Crucially, the references may bear absolutely no relation to the electronic power levels of the flash or tungsten heads used.

To expand on this point: it is usually the case that the main light, which is the brightest in terms of determining the basic exposure level, rarely calls for the highest power source. Often, that status is required for the fill light – especially if it is of the all-pervading type (such as one that is aimed into a high corner of the room). If a clean white background is required, it is possible that the most power will be required here, but it is far more common for backgrounds to be only modestly lit. Rim lights, where they provide an accent effect, are often some of the lowest power sources because, as already explained, their effect is obtained directly without any loss of brightness caused by reflection.

In terms of lighting flexibility, it therefore makes sense to have a range of heads comprising one or two with high maximum power settings (for fill use as well as single-source lighting), one with modest mid-range power (for main light use in multiple source arrangements) and several heads that can be switched to very low power settings (for hair and accent lighting). Specific examples of lights in action are given in Chapter 12.

11 SPECIALIST LIGHTING

There are many forms of specialist lighting, most of which are used in specific technical applications that fall outside the remit of this book. Nevertheless, this chapter covers three types of specialist lighting that can be used ordinarily with relative ease and to good effect in everyday photography.

The areas featured are infrared, high-speed and 'intermittent capture' lighting. The last of these comprises both time-lapse photography by available light and stroboscopic effects by flash. As such, the three topics respectively cover lighting that is specialist by its spectral nature, by the mechanics of its operation and by the exposure problems that it brings. Any other area of specialist lighting that involves similar considerations ought to be approachable using the appropriate methods outlined here.

Infrared

Without doubt, the first area of specialist lighting tackled by the vast majority of photographers is infrared (IR). Note here that it is the lighting that is important, not the film: the film is simply the vehicle that is used. It is true that the effects of the various IR films available differ from one brand to another, but it is even more fundamental to observe that if there is no IR illumination, then none of the films will have any special effect whatsoever. It is easy to think that taking IR pictures is as simple as loading the right film and fitting an appropriate filter. Sadly, that is not the case. Even sadder, the IR light that is fundamental to the success of such pictures is invisible to the human eye. By way of analogy, imagine walking around with your eyes tight shut and trying to guess, perhaps from the temperature you can feel on your skin, what the correct exposure would be for a picture taken on ordinary film under the prevailing conditions. If that were indeed the scenario with which you were faced, it is highly

Figure 11.1 An example of 'light painting' using a simple domestic torch. To avoid burning out the lit areas in this semi-abstracted nude self-portrait, Cat de Rham used a torch with failing batteries. Techniques such as this tend to involve a lot of trial and error at first, but become more predictable with experience.

139

probable that a general rule of thumb would be called into play – such as f/16 at one-over-the-film speed on a bright sunny day. Significantly, that is often exactly the situation that exists when taking daylight IR pictures, and manufacturers of IR films include in each box (or provide separately) suggested exposure settings for their own particular products. In short, most people approach IR photography for the first time as a matter of trial and error.

A few words of explanation are required about filtration for IR photography. For the sake of simplicity, and also recognizing its greater popularity (even now that Kodak's colour infrared film uses the E6 process in place of E4 – which endured specifically for the previous emulsion until quite recently), all discussion here is limited to b&w IR films.

It is most helpful to think of IR films as emulsions that are just like any other, except that their red sensitivities extend into the near IR region of the spectrum. Incidentally, this is not the sort of IR radiation emitted by hot bodies: pictures taken on IR film showing heated clothes irons, for example, look much like the same images taken on conventional film. The most obvious difference is only the graininess of the picture. IR films have a larger grain size because the individual photon energy of IR radiation is lower, and therefore a larger capture (grain) surface is needed to record such images. That said, it is of course possible to choose a developer that will give either high sharpness and a coarse grain structure (Agfa Rodinal for instance), or less grain but with an inherent loss of 'bite' (any high sulphite, solvent developer).

Alongside the grain issue sits the emulsion's overall sensitivity to both visible and IR light. Frankly, the former is largely irrelevant if true IR pictures are to be taken – though it does come into play when the images are recorded using filtration that also permits a contribution from visible illumination. Before expanding on this, it is useful to identify those characteristics that define an IR image. Black skies are often the first thought, but in fact a black sky can be obtained on conventional film using a plain red filter, such as a Cokin 003 or a Kodak Wratten 25 equivalent. The visual appearance of this type of

Figure 11.2 Spectral sensitivities of selected b&w films. Black areas denote full sensitivity; grey areas denote only partial sensitivity. Diagram reproduced courtesy of Ilford Imaging UK Limited.

SPECTRAL SENSITIVITIES OF SELECTED FILMS

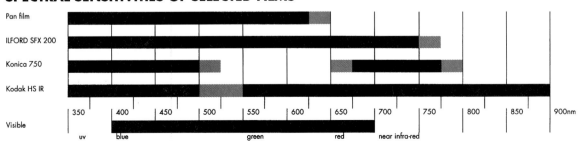

TYPICAL TRANSMISSION VALUES OF RED FILTERS

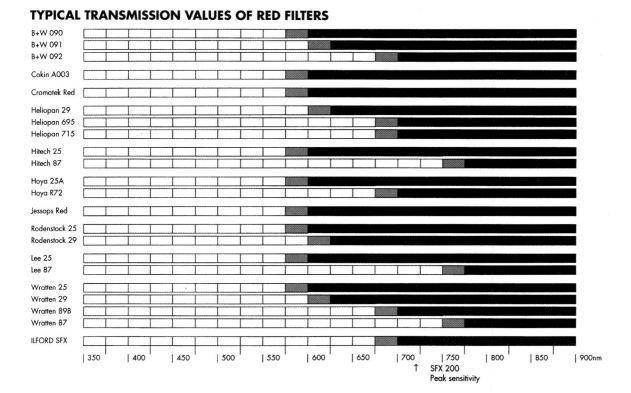

filter is in line with red stained glass, or a coloured, transparent plastic sweet wrapper. Such types are useless for IR photography because they pass too much visible light: this fact is obvious because it is easy to see right through them with the naked eye.

For proper IR photography it is necessary to use a filter that blocks virtually (or even totally) all visible light. The Kodak Wratten 87 series fit the bill perfectly; other possibilities are the Kodak Wratten 89B and various manufacturers' offerings that employ '695' or '720' glasses. The numbers are related to the maximum wavelengths of radiation that the glasses will transmit, with higher numbers corresponding to more infrared transmission. For ease of selection, such filters are often logically identified: Hoya's R72, for example, uses 720 nm glass.

The cut-off points of these filters make them almost opaque (black) to the eye. Nevertheless, they pass IR radiation and allow the taking of true IR pictures. Such images give white foliage and grass, ghostly skin tones and distorted tonal renditions of coloured fabrics. It is even possible for black fabrics to appear white in IR photographs.

As if it were not bad enough to be unable to view the scene through an IR filter (a fact that strongly counts against the use of any hand-held SLR) there is also a focusing issue that must be

Figure 11.3 Typical transmission ranges of red filters. Black areas denote full transmission; grey areas denote only partial transmission. Diagram reproduced courtesy of Ilford Imaging UK Limited.

addressed. Because the wavelength of IR 'light' is longer than that of visible light, a lens that is focused before filtration will normally need a focus correction once an IR filter is fitted. The amount of correction is normally indicated on the lens by a small red dot on the focusing scale. All that need be done to ensure sharp images is to focus as usual with visible light, then to shift the indicated focus distance from the normal focusing mark to the IR red dot before making the exposure.

Unfortunately, it is often the case that auto-focus lenses lack this feature, and under such conditions it is necessary to consider two other options. The first is to accommodate the visible/IR light mismatch using the criterion of acceptable sharpness. This is the same tactic as is employed to obtain depth-of-field over a range of camera-to-subject distances when in fact a lens can only be sharply focused on one single plane. Using the depth-of-field analogy, the aperture required to give sharp IR pictures without any adjustment to a visually focused lens is that which contains the red dot on the focusing scale. In the example shown in Figure 11.4, the aperture required is just over f/4 for one lens and slightly smaller than f/8 for

Figure 11.4 Positions of the infrared focusing indices on two lenses of different focal lengths. Clearly, the aperture that contains the indices is not a constant – something that must be kept in mind if depth-of-field is used as a way to give better sharpness when using infrared film.

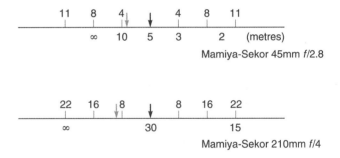

the other. Note that although the aperture required varies with the lens, it always lies beyond the point of visual focus, forcing a slight extension of the lens to what would otherwise be a closer object distance.

Importantly, however, the aperture approach will not give sharp IR pictures so much as images that are merely acceptably unsharp. To obtain better sharpness, the only other possibility is to use a lens that is better corrected than normal for red (and therefore IR) light. In passing, it may come as a surprise to some readers that lenses are not all equally corrected for different colours of visible light. The reason lies in the types of glasses used for lens elements, and the most common manifestation of this problem is slight colour fringing. Long focal length lenses show the effect worst. The solution is to use special combinations of different glasses to

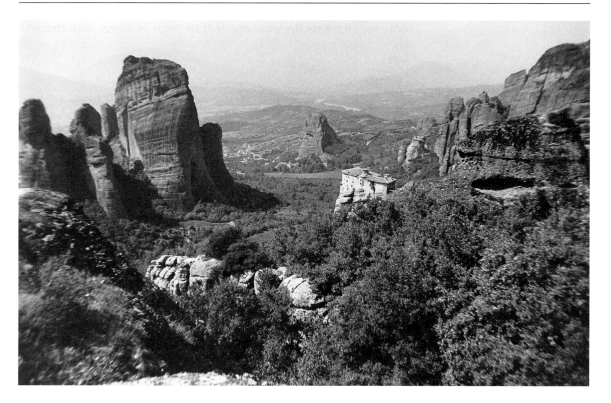

Figure 11.5 The same scene photographed on a hazy day using conventional film and appropriately filtered infrared film (Konica IR750). The infrared picture shows far superior distance detail thanks to the fact that filtration has allowed the film to 'ignore' the scattered blue light that normally turns the horizon milky.

143

produce an apochromatic effect overall. Unfortunately, although the term 'apochromatic' is quite widely applied nowadays, all such lenses are not equal, and it would therefore be unwise to rely on this label alone as proof of a lens's ability to hold focus right into the IR region. As with so much else in photography, readers are advised to perform their own tests regarding image sharpness for each lens used before fixing on a regular method of working.

IR lighting

Although the vast majority of IR photography is undertaken outdoors, often with landscapes or gardens as its theme, for proper control there is (as always) nowhere better to work than in a studio environment. Significantly, IR photography can be done using normal studio lights – either flash or tungsten. Appropriate filtration can be applied either to the camera lens or to the lights: the second possibility, which simply does not exist under landscape conditions, means that the photographer can view the composition under visible illumination yet can make the exposure using pure IR lighting. Conventional flash modelling lights are rarely appropriate for visual assessment because of their close proximity to the flash

Figure 11.6 Kodak Ektachrome Infrared film gives predominantly magenta colours if used unfiltered, but reveals a broader gamut when exposed through a yellow filter. Included here for reference is a normal colour version shot on Fujichrome RMS.

tube, which makes filtering the latter without the filters being melted by the former all but impossible. It is therefore more normal to set lights in pairs, with one in each set being filtered and the other not. In the case of tungsten lighting, powerful heads (blondes) are best used for the IR exposure – ensuring that the filters are placed far enough away to avoid overheating – with lower output heads (inky-dinks or similar) used for focusing. If the power difference is large (2000 W versus 100 W) then the exposure contribution from the focusing lights will be virtually insignificant, amounting to nothing more than a low level of fill. Be warned, however, that the exposure effect of an IR filtered light will be quite different from that of the same light used conventionally.

By far the easiest and cheapest way of experimenting with IR lighting is by using camera flashguns fitted with small Wratten gelatin filters. Provided that the flashguns can be set to a manual power level for total exposure control, this method can be very reliable indeed. As before, the flashgun's normal guide number is almost meaningless as far as IR photography is concerned. For very occasional use, simply bracket the lens apertures furiously to ensure that a good exposure is obtained. If something more reliable is needed, examine the wild bracket to determine which lens settings gave the best looking negatives, then, knowing the flashgun-to-subject distance, calculate an effective IR guide number by multiplying together the distance and the optimum aperture setting. Future exposures can then be taken with only modest bracketing using the previously determined IR guide number. Obviously, however, this calculation applies only when using the same flashgun, IR film type and IR filter as were employed initially.

High-speed pictures

This section concerns attempts to photograph events that happen very quickly. The speed concerned may refer to the reaction time or to the event time – or both. For instance, a droplet falling into a bowl of water is not a particularly quick acting event because it can be seen very easily with the naked eye, but even so it is still very difficult to take a picture at precisely the right moment. On the other hand, trying to freeze the water droplets flying off a model's hair as she tosses back her head calls for a very brief exposure at any instant within a comparatively wide time-frame.

Therefore, there are two quite separate issues to be addressed here. As far as brief exposure times are concerned, and despite advances made in faster shutter speeds, electronic flash is virtually essential. Outdoors, flash is normally used with the fastest available shutter synchronization speed. If the movement-freezing effect is to dominate, then the flash might be set at least one stop above the

Figure 11.7 Lightbox arrangement of red and infrared filters. Unfortunately, many people try to take b&w infrared pictures using visually red filters, but these are virtually useless if dramatic results are required. As illustrated here, proper infrared filters appear almost black to the naked eye (and to conventional colour film).

ambient light level. As might be guessed from previous talk about synchro-sun flash (see Chapter 10), having the flashgun as the main light means working with either a very powerful flashgun or only modest levels of ambient light. It should therefore come as no surprise to observe that many 'tossed wet hair' pictures are done in late afternoon or early evening light, or at very close range. It is also worth noting that to gain a significant flash duration advantage over the rapid shutter exposures that can be obtained with the latest 35 mm SLRs, it is often necessary to have the flashgun set to about one-quarter of maximum power, and this clearly places additional restrictions on the working conditions – or forces the use of multiple flashguns, synchronized together using remote slave sensors.

Although the shutter speed itself is of only secondary importance in terms of the exposure, the time delay between pressing the shutter button and the instant of capture can be very significant. If the picture-taking environment is illuminated by ambient light, then the shutter is essential as a means of stopping film fogging; if not, it can be dispensed with – so obviating the problem of shutter lag.

In a darkened studio, the method of working when photographing high-speed events is often as follows. The set is arranged as required, then the studio is blacked out. The camera's shutter is locked open and the exposure is made when the flash system is triggered using a system that detects the occurrence of the decisive moment. The camera shutter is then closed manually after the flash is fired, and the studio is relit so that the set can be inspected before another shot is taken.

One crucial point was glossed over in that brief overview: how, precisely, does the flash get triggered at the appropriate moment? Broadly speaking, there are two methods: mechanical contact and electronic sensors. The first method has been used since the earliest days of photography, and was the technique employed by Eadweard Muybridge in 1872 to prove that when a horse gallops there is an instant at which all four hooves are off the ground together.

On a much smaller scale, this approach can also be used to photograph a light bulb breaking as it is struck by a hammer. In principle, all that is needed is to take the flash cable that would normally link the flashgun to the camera's PC socket, and connect its two leads so that one is on the metal head of the hammer and the other is on the light bulb. But before elaborating on this suggestion, it must be made absolutely clear that readers who wish to experiment in this way do so entirely at their own risk. Any such work incurs the possibility that the photographer may get an electric shock, which could be unpleasant or even harmful. Therefore, an isolating device is

Figure 11.8 Konica IR750 b&w infrared film, exposed under studio lighting without any filtration, records a distinctly unusual set of tones (notice, for example, how dark the model's eyes appear) but still looks essentially 'normal'.

essential when working with naked flashgun contacts, and all references here assume that a suitable isolation system is being used.

It should be obvious that when the flashgun's contacts are one each on the hammer and the light bulb, the flashgun will fire at the moment of impact. If the set is arranged in a darkened room, with the hammer mounted on a hinge so that it can be swung down onto the appropriate point of contact, then the moment of impact will be visible to the eye when it is illuminated by the flash. The instant itself is too brief to be seen properly, but because there is darkness before and afterwards the brain is able to 'process' an image that would otherwise have gone unnoticed. Similarly, if the camera's shutter is locked open, the same instantaneous flash will record an image on the film. Exposure is reasonably straightforward: simply set the aperture that is appropriate to the guide number of the flashgun and its distance (not the camera's distance) from the subject. Automatic exposure control cannot normally be used, and in any case greater consistency is obtained when working manually. The only possible complication is an effect known as reciprocity failure, whereby very short exposures, such as can be given by modern flashguns at low power levels, result in underexposure of the film. Therefore, it is as well to bracket the aperture slightly. It should also go without saying that extreme care must be taken to ensure that flying glass does not cause damage to the camera, the photographer or the surrounding environment. Safety glasses must be worn by all people present, and the camera lens should be protected by a optical plastic filter (glass could shatter under impact, so must not be used). Best of all, the entire hammer and light bulb set should be contained within a sturdy rigid plastic box.

Before leaving this particular example, a final point must be made. If the flashgun contacts are fixed to the hammer and to the outside of the light bulb, and the isolating device does not introduce any significant delay before triggering the flashgun, then every picture obtained will show at best only cracks in the light bulb's glass – not the moment of shattering. This result ought to be obvious. There are two possible solutions. One is to use an isolating device that does have a delay, such as a mechanical relay switch. The other is to connect the second flashgun contact not to the glass envelope of the light bulb, but rather to the filament within (using the power contacts on the base of the bulb). The latter trick ensures that the flashgun fires only after the hammer has penetrated the envelope, and therefore guarantees an image that features glass shards in flight.

But whilst it is feasible to attach a contact to the head of a hammer, the same is not true of any sort of projectile. So if the picture required is of an arrow breaking through a ceramic tile, physical closure of electrical contacts is probably out of the question – though this is not necessarily so for a truly ingenious photographer. In any

Figure 11.9 The Mazof VIS-II is one of several high-speed flash triggering systems that can be activated by vibration, illumination or sound. Without a device such as this it is very difficult to capture high-speed events such as a crossbow bolt breaking a cigarette. Action picture by Zoran Mazof.

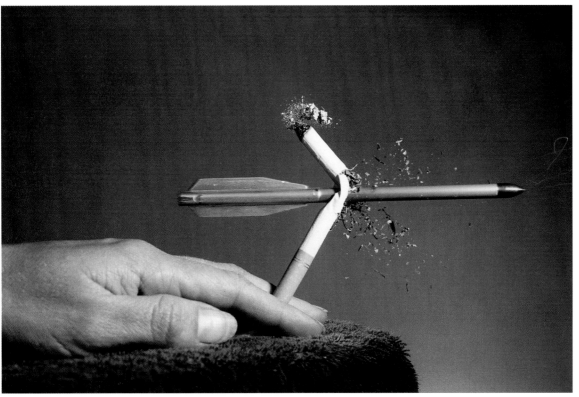

case, there is another possibility, which is to use electronic triggering based on the signal generated by a sound, light or vibration sensor. Suitable devices appear quite regularly as construction projects in electronics magazines, or can be designed by individual inventors. Alternatively, they can be purchased, and sometimes even hired, from major photographic retailers. Specifications vary, but the best designs incorporate variable sensitivity and adjustable time delays that allow pictures to be taken at various stages during a rapidly occurring event. The same safety considerations apply as before, as does the comment about reciprocity failure. Otherwise, the specifics of operation depend entirely on the device used.

Intermittent capture

In a sense, intermittent capture can be nothing more than a series of high-speed images captured on a single frame. A stroboscopic image of a golfer swinging a club, for instance, is simply a multitude of individual pictures that start at exactly the right moment. Therefore, if you wanted to take such a photograph, one consideration that would have to be addressed is timing the exposure. However, there is also the added problem of how to determine the correct aperture when recording a mass of images on one piece of film. There are two possible cases to consider: elements that are the same in every image captured, and elements that vary from one capture to another. Take the case of a snooker ball moving across the table, lit by a series of repeating flashes. The ball is in a different position each time but the cloth is fixed, therefore the exposure considerations are very different for each of these two parts of the picture.

A simple way of working is to have the moving object arranged in front of a distant black background. That way, the static part of the picture can be ignored because it will always be black. The exposure required for the moving element is the same as it would be for a single image – assuming that there is no overlap between successive images. So if a meter reading shows that the correct single-flash exposure would be f/8, then that same aperture will also be correct for stroboscopic images.

On the other hand, non-black static parts of a picture will exhibit a cumulative exposure effect, and will be recorded brighter than they would with a single flash. At first thought, the amount of 'overexposure' should be directly proportional to the number of flashes per frame of film, but in fact this is not quite right. It happens that films suffer from an intermittency effect, which is very similar to reciprocity failure. In theory, two flashes on the same

Figure 11.10 Multi-image picture lit using the Strobex Polikon, which allows multiple flash heads to be triggered in sequence with a programmed time delay. A black background has been employed to help avoid exposure problems.

piece of film should give twice the brightness of image; four flashes should be twice as bright again, and eight twice as bright still. In practice, the result obtained depends on the film used. It is often the case that two flashes work as expected, six flashes are required for the four-flash effect, and up to sixteen flashes are needed to record the brightness expected from eight flashes.

This effect can be very troublesome in still-life photography, when the available flash power is below that needed for the aperture setting that will give the necessary depth-of-field. The answer is to set the lens aperture as required, and to use 'multi-pops' to build up the image in a darkened studio with the shutter locked open. According to the guideline above, the practical limit for this technique is about two stops (six flashes).

In the case of stroboscopic imaging, the intermittency effect works in the photographer's favour. Nothing is likely to be overexposed by more than about two stops, so provided that all the static parts of the picture are dark toned, the final effect is likely to look good almost regardless of the number of flashes given. Even so, this principle cannot be exploited without limit, and it is normal, where possible, for static elements to be coloured artificially darker than normal so that they look 'right' in the finished picture.

Figure 11.11 Time-lapse image that was created by photographing the sun at exactly the same time each day for a year. The foreground was added separately. Photograph by H.J.P. Arnold.

Time lapse

A totally different type of intermittent capture is time-lapse photography. In a few cases, time-lapse pictures show a series of exposures on a single frame – much like stroboscopic images, but taken (as the name suggests) over an extended period of time. Pictures of the moon moving through the night sky are common examples of this type. But more often, time lapse photography involves a series of quite separate images captured on separate frames of film. Eadweard Muybridge's pictures of galloping horses were not only high speed but also time lapse, for the photographer needed to capture a series of pictures that would show whether or not the horse's hooves all cleared the ground at the same instant. On a smaller scale, sequential time-lapse photography can be used to reveal how a flower bends towards the light on a sunny day, or how an ice sculpture melts.

The easiest way to record a time-lapse series is using a camera with a motordrive and an intervalometer. The latter is a device that triggers the camera to take pictures at set time intervals. It can be either integral to the camera or an external item that trips the shutter mechanically (via the cable release socket) or electronically (via a remote sensor plug). Because the pictures can be taken over an extended period of time, the camera should be set for automatic exposure to give a consistent look to all of the images.

Care needs to be taken to ensure that incidental parts of the composition do not change in any dramatic way, thereby ruining the intended effect. Take, for example, the case of a responsive flower placed on a window sill with the bloom turned away from the light, facing into the room. The camera is positioned to take a series of pictures that, it is hoped, will show a progressive bending of the stem as the flower rearranges itself towards the sun. To get a good picture, an unchanging background is needed; this might be nothing more elaborate than a piece of background paper, but without it the series of images will be complicated by background variations arising from the different angle and brightness of natural sunlight at different times of the day.

Once successfully captured, an excellent way to present time-lapse images is on an enlarged contact sheet that shows the intended progression in what effectively becomes a single picture. More enterprising photographers may like to cut out the individual frames and bind them along one edge to create a 'flip book' that creates the illusion of movement when its pages are viewed in quick succession.

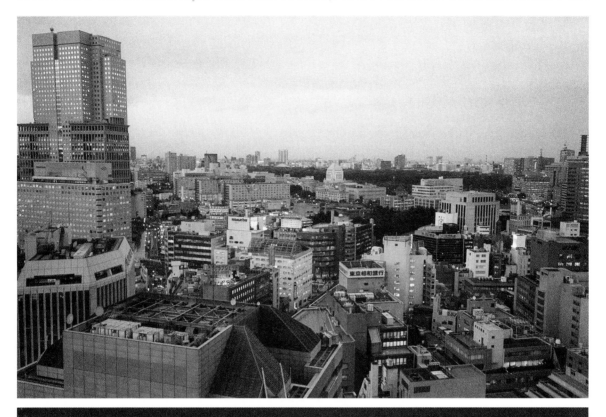

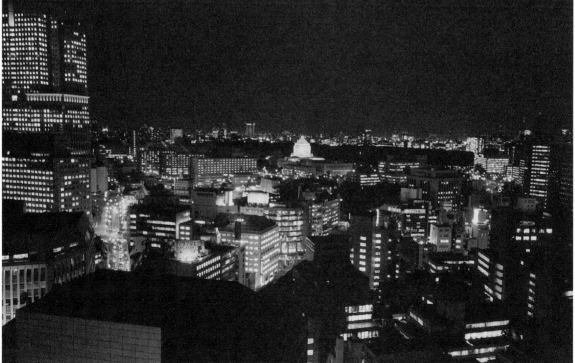

Figure 11.12 Time-lapse pictures showing sunset as it turns to dusk over the Kyoto skyline in Japan. Pictures were triggered manually every fifteen minutes, with the exposures adjusted automatically by the camera. Pictures taken on Kodak Portra 400NC using an Olympus iS-200 35 mm SLR. 155

12 LIGHTING EXAMPLES

The last section of this book is devoted to examples of lighting techniques in practice. Because the considerations differ in several important respects, the examples cover first pictures of things, then pictures of people. Inanimate objects are in many ways easier to light because they can be treated in broad types, possess infinite patience, do not move unexpectedly and can be manipulated to achieve almost whatever look is desired. The last point is the most important here. With people, even if the picture is actually a fashion image rather than a portrait, it is almost always necessary to produce a pleasing, flattering result. With objects, there are no fragile egos to be massaged, and the photographer is freer to exercise his or her own vision.

Against this big plus point there is one major limitation: because there is no spontaneous input from a live model, whose smile or twinkle in the eye can enhance an otherwise bland picture, the photographer is entirely responsible for the finished effect when shooting still-life and product pictures. The fact that such pictures are frequently taken in the studio, where all lighting is also totally deliberate, makes matters even harder still. In short, pictures of objects tend to be the hardest ones to do.

If all that sounds very off-putting, then rest assured that the purpose of this section is to show that things don't have to be difficult. The secret of successful basic product lighting is to keep everything as simple as possible. Initially at least, whenever there is an easy way of doing something that should be the method chosen. As confidence grows and skills are developed, more complex methods can be tried and adopted. That is the correct order of working: to attempt complex techniques before the basic ones have been mastered is like trying to run before being able to walk. Such desires are not so much overambitious as plain stupid.

The same considerations also apply to people photography, and the examples here cover methods that range from single-light techniques to complicated arrangements and difficult-to-meter situations. As has been stressed before, it is impossible to separate

metering from lighting: the two between them define the exposure, which can be altered by changing either component.

Although the lighting arrangements and techniques shown here have been used on a variety of different applications in each case, the details are never exactly the same from one case to another. Therefore, the explanations given are not recipes to be followed to the letter, but rather are general approaches that should provide good starting points – and in many cases will give acceptable, if not the best, pictures without very much adjustment. As to what adjustments may be necessary to turn an individual's first attempts using these guidelines into more noteworthy pictures, those things will become apparent as more and more pictures are taken, examined closely and compared with top-notch examples of similar images appearing in advertisements, magazines and exhibitions of award-winning pictures of every type.

This comment is not an attempt by the author to duck his responsibility to explain matters in full, but rather a sincere hope that, having digested the rest of this book, the reader will now be able to start making lighting decisions first-hand. Creative photography is a process of exploration. More importantly still, it is about recording a previsualized image: by contrast, following recipes is a sure-fire way to stifle individual creativity.

Figure 12.1a Lit from behind, this 'floating effect' was achieved by placing the bottle horizontally on top of the lightbox. The game is given away by the bubbles visible in the neck of the bottle.

12.1 Oil bottles

Glass is at the same time both daunting and yet easy to light on a basic level. All that need be remembered is that glass is transparent – and because of that it must be lit so that it can be seen through. It is therefore very unlikely that any sort of frontal lighting will work, because such arrangements would simply create lots of surface reflections. It could be argued that reflections are also intrinsic to glass surfaces, but in fact they are more correctly associated with mirrors: the reflections that appear in windows, for example, are generally an unwanted nuisance.

Figure 12.1b The bottle here is standing on the lightbox, which is the sole source illuminating the object. This arrangement gives a good 'glow' to the oil and shows the flavouring additives clearly, but the overall effect is not as dramatic as it is with back-lighting.

So to light any glass object, whether it is an empty, colourless vase (see later), a bottle of beer or flavoured cooking oil, the light source must be positioned other than directly in front of the object. There are three possible positions that present themselves: behind the object, to one side of the object and above or underneath the object. Examples of all three are shown here. Different readers will prefer different effects, and there is no 'right' or 'wrong' in this case. There are, however, a few tricks that can be revealed and tips that can be given for further experimentation.

Firstly, all three pictures were taken using the illumination provided by just a single A3 lightbox. A lightbox is very convenient

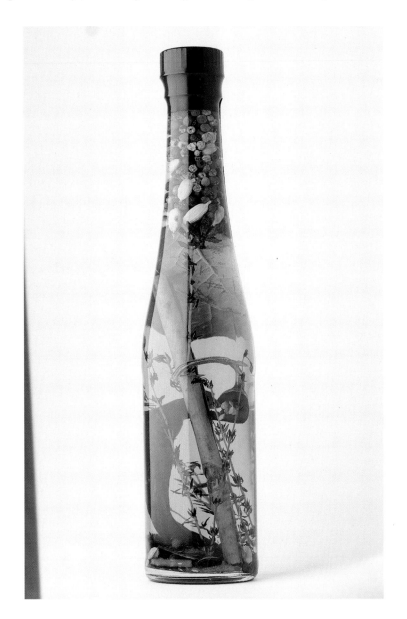

Figure 12.1c Lighting from the side is the easiest method, but also gives a less interesting result.

because it can give beautifully even illumination, but the model employed must be of the highest quality. This comment applies as much to the colour balance of the lightbox as it does to its uniformity of illumination. To check the colour balance of the source, photograph the lightbox straight onto the film that will be used for the final pictures, then check the results. Note that because the best lightboxes for this purpose are fitted with fluorescent tubes, any test must inevitably be specific to one film (see comments made earlier about bespoke fluorescent lighting). In addition, the lightbox should be tested at the same exposure level as it will appear in the finished pictures in order that a correct assessment of any necessary filtration can be obtained.

The appropriate exposure level is one at which the lightbox is clean white, but not overexposed. The precise point at which this occurs will depend on the film and the processing, and as such can only be determined properly using bracketed test exposures. That said, the bracketing, like the filtration test, should only need to be done once given that the brightness of the lightbox will be fixed for all pictures. Bracketing will only be needed above the metered level, with the best exposure probably being about three stops higher.

When lighting from the bottom of a glass object, masking off all areas of the light except for a small disk (or the appropriate shape) directly under the base will give a 'snappier' image. If the image contrast is too high, general (non-directional) fill-in lighting can be used as normal to produce the desired effect.

When lighting from behind, a 'floating in space' look can be created by placing the lightbox horizontally and positioning the object on top – either directly or using a glass sheet to separate it from the lightbox. That trick was employed here, where it can be spotted because of the air bubbles that are visible in the neck of the bottle: a slight tilt was employed to keep the bubbles at that end where they are less obtrusive than they would have been in the body of the bottle.

The film used here was Kodak EPP with a Hancocks lightbox. No filtration was needed.

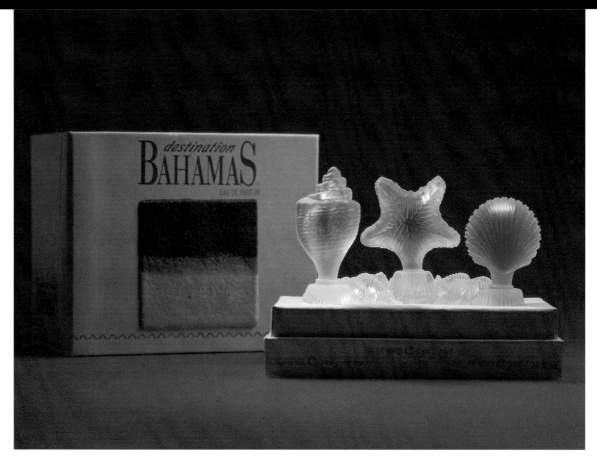

Figure 12.2a–b Flash-lit and tungsten-lit images shot on Kodak Ektachrome E100VS.

12.2 Perfume miniatures

Although perfume is contained within bottles, and therefore could be approached in the same way as the flavoured oil example, the bottles in this particular case are more sculptural. As such, they can be regarded as three-dimensional works of art, and should be lit to show form and texture as well as transparency. This is a very tough approach to take – and one that is not made any easier by the small size of the objects concerned. In professional work, such bottles for photography may be made as oversize models of the real objects, and will have been created (or selected) with an eye towards maximum perfection. Outside such assignments it is necessary to work with whatever is available, perhaps using electronic retouching to compensate for manufacturing tolerances (such as variable wall thicknesses) that appear in the image as 'defects'.

The miniature set featured here stands 7.5 cm high: the box measures approximately $8 \times 11 \times 12$ cm. It is lit using dedicated

(c)

(d)

(e)

Figure 12.2c–e Polaroid prints showing correct exposure with half a stop of underexposure and overexposure.

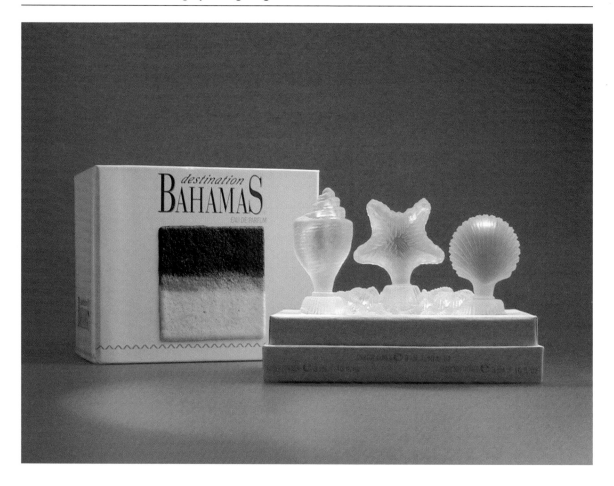

Figure 12.2f Digital image taken using a Ricoh RDC5300 digital compact camera.

small-scale Zenon lighting heads from the British manufacturer Louden Photographic. The heads feature both compact flash tubes and bright modelling lamps. The pictures here have been taken using both sources and, as is normally the case, there is a slight colour mismatch even after applying corrective filtration. This result arises from the fact that the modelling lamps have a nominal (rather than guaranteed) colour temperature. So it is that the flash-lit images show the perfume liquid to be pale blue – as it is in reality – whereas the modelling lamps render it almost colourless because they have residual warmth in the colour of their illumination. Indeed, it is obvious that the entire picture has a slight orange cast in this case.

Significantly, the orange cast might actually be preferable to an uninformed observer who did not know of the perfume's true blue tint because in general slight warmth in an image is better than slight coolness.

The lighting itself was straightforward and should be readily deducible from the finished result. Overhead lighting provides the

drama with fill, ensuring that all the appropriate details are visible. A white reflector is placed just out of view to the left of the set to throw light onto the shadow side of the box. The images featured here come from both film and digital camera files.

When working with a digital compact camera (Ricoh RDC5300 in this case), four things must always be kept in mind. All are related to the difficulty of marrying a digital camera to an external flash system. There needs to be temporal synchronization between the moment of flash illumination and the moment of image capture; the camera must have manual aperture settings that correspond with conventional lens settings; the white balance may need to be adjusted to suit the daylight balanced flash rather than the tungsten-balanced modelling lamps that will be used for focusing; finally, automatic focusing itself requires a relatively high level of illumination (higher than for 35 mm SLR film cameras). Only now are modestly priced digital compact cameras starting to be provided with all the necessary features.

12.3 Wendy Ramshaw jewellery

The creations of renowned jewellery designer Wendy Ramshaw are unusual both in their form (sets of rings, each adorned with a different protuberance) and their presentation (on pillars). From a photographic point of view, this early example contains a difficult combination of metal and transparent plastic that requires very careful lighting indeed if unsightly reflections are to be avoided.

The method used here was a rigid 'light tent' in the form of two 45 cm Deville Softlight Hemispheres. Composition and framing were restricted both by the dome's waistband and by the fixed position of the viewing port. Therefore, almost all the control that

Figure 12.3a (opposite) Shot on Agfachrome 100 with the jewellery placed inside a Deville Softlight enclosure for a virtually reflection-free result.

Figure 12.3b B&W version taken using the same lighting arrangement. For consistency of exposure behaviour and overall appearance, Agfa Scala 200 b&w transparency film was used.

167

Figure 12.3c Alternative lighting arrangement, with the main light placed overhead and black cards left and right of the jewellery. The effect is striking, but not sympathetic to the subject.

could be exercised was in respect of the lighting. Even then, the whole point of a diffusing shell is that it softens and homogenizes the light, so control actually reduced only to the ways in which the lighting effect could be modified. This meant either making major changes to the direction of the lighting, or using cards inside the dome to create a better illusion of depth and tonal variation. A totally different approach, using top-lighting with black cards to both sides of the jewellery, gave a clean plastic pillar but lost all of its roundness and left the rings rather lifeless. In addition, as can be seen in one of the supporting images here, the overhead lighting arrangement has created a distractingly bright area under the jewellery pillar.

Because the subject is almost monochromatic, the b&w pictures represent it very well. In order to keep consistent working methods, the b&w versions were shot on Agfa Scala 200 transparency film alongside Agfachrome 100 colour transparency film. As

the pictures show, the tonal ranges of these two films are very similar – a fact that allowed the same lighting to be used in both cases with just a one-stop aperture change between the two films. This consideration is of particular significance when, as in this case, the pictures are taken on a medium format camera (Mamiya RB67) where the film type can be changed back and forth on a frame-by-frame basis. Having to reset the lighting every time the film type was changed would have been most tedious!

Exposures were bracketed to get the best result, with the basic reading having been taken using an incident-light flash meter placed inside the diffusing dome. Control of image contrast, if it is required in such situations, can only really be achieved using modified processing. Colour transparency films and Agfa Scala 200 both get more contrasty with push-processing: it may therefore be advantageous to underexpose then to push the film more during development to get a snappier image. Of course, a tactic such as this cannot be anticipated by automatic, in-camera exposure systems – which is precisely the reason why a hand-held meter is virtually essential for all serious lighting work.

Figure 12.4a It is common for gobo'd sources to be comparatively low in brightness because the installed shadow mask blocks much of the light. As a result of this, and the near life-size image recorded on film, the depth-of-field here is very narrow.

12.4 Pair of silver rings

At first thought, lighting a pair of silver rings should be a task no different from the Wendy Ramshaw jewellery set already discussed. On reflection, however, that initial assumption is clearly incorrect.

(b)

(c)

Figure 12.4b–c These two pictures were shot specifically to show the effect of the main and background lights separately.

Figure 12.4d Polaroid image shot at the same ISO rating and aperture as the finished film. Although the general look is clear, the monochrome image does not reflect the colour harmony of the scene.

For one thing, there is no transparent element to be lit here; for another, the rings have no defined spatial relationship to each other whereas the set is intended to be seen in a particular way. As a result, the photographer is in this instance free to devise his or her own composition and lighting plan.

The light tent approach could still have been used, but it would have produced a more sterile image. Instead, greater interest has been created by projecting a gobo (shadow pattern) onto the background. As was emphasized in earlier chapters, such lighting effects only work when there is little spill of other illumination onto the background.

In this particular case, only one other light was used, but even so the arrangement was not entirely straightforward. Issues that had to be balanced were the camera angle and location needed to get the intended composition, together with the required quality for the main light (soft but controllable), the angle demanded by the gobo'd light (to minimize pattern distortion) and the distance from the gobo'd light to the background paper (to give the desired pattern size).

Despite its integral bellows, which are quite generous under normal conditions, the Mamiya RB67 camera had to be fitted with an extension tube to get the nearly life-size image obtained on film here. For the same reason, the front of the lens ended up close to the rings – making lighting difficult in respect of avoiding the shadow of the camera on the set. Similarly, because the background light was a fixed focal length (non-zoom) spot, the background had to be placed a fixed distance away. In a simple approach such as was used here, that means an inevitable degree to which the main light spills onto the background. This in turn fixes the maximum darkness of the background: any additional illumination can only make the background lighter. To illustrate this point, included here are b&w prints that show the effect of each light separately, as well as the two together.

If a higher contrast background pattern is desired, it is necessary to reduce the spill from the main light. This could be done by masking the light – or by masking the background. The latter is a particularly useful trick that is achieved by splitting the main light and background exposures. A sheet of black velvet fabric is placed between the subject and the background during the main light exposure. Afterwards, the main light is switched off, the velvet is removed and the background lighting pattern is double-exposed onto the same sheet of film. Any camera that allows double exposures can be used for this technique provided that it is mounted on a firm tripod or stand to ensure perfect registration between the two exposure components.

Figure 12.5a Contact print showing not only the Blow-Zone glass vase, but also the full coverage of the A3 lightbox used as a back-light. Careful examination of the vase and the lightbox reveals the movements applied to the 5 × 4 inch camera to get an otherwise impossible perspective.

12.5 Blow-Zone glass vase

A vase or similar piece of simple glassware is ideal for initial attempts at trans-illuminated (back-lit) product photography. Often such pictures look very good in b&w, so even a modest lightbox can serve as a suitable source. The only potential problem is the size of object that can be photographed in front of even an A3 lightbox. This particular vase, which stands 28 cm high, is right on the limit of what is possible.

Looking carefully at the picture, the sides of the lightbox can clearly be discerned towards the bottom of the frame. Under normal circumstances, the negative would have been cropped to hide such tell-tale signs, but here they serve two useful purposes. The first is to illustrate the fact that there may sometimes be elements recorded within the frame that have to be cropped out afterwards: the concept of full-frame, uncropped images (much loved by some documentary photographers) has no place in crafted photography where the shape of frame is far less important than the shape of image desired.

The second purpose is to reveal that the picture was taken using a large format camera with movements employed to get an otherwise impossible combination of camera angle and perspective. The significance of this applies in respect of the lens aperture, and

Figure 12.5b–c By rotating the vase slightly clockwise or anti-clockwise, different areas of lightness and darkness are created on its contoured surface. The images here were recorded on Polaroid Sepia film, which shares the same ISO400 rating as the Kodak T400-CN chromogenic b&w film used for the final image.

(b)

(c)

therefore the lighting power level required to capture the image. At least, that simple balance would be the case if the vase had been lit by flash. By using a continuous light source instead, the effect of the camera's shutter is brought into play, thereby allowing the lightbox to be used very successfully with almost any aperture setting desired – subject to selection of the appropriate shutter speed that is consistent with the film's exposure rating and reciprocity behaviour. In this particular instance, an ISO400 film (Kodak T400-CN) was used, yet there is still absolutely no grain. This result comes from the chromogenic (dye-cluster) nature of the film and the 5 × 4 inch format used: the grain-free look is important because glass needs a smooth tonal rendition to express its proper texture.

Having explained how and why this picture was taken using a lightbox back-light, it is important to review how a similar effect could be created using general purpose flash heads if required. The method is to treat the background as the subject, and light it specifically in a manner that will give the desired distribution of brightness tones. So if the vase is required with a 'hot spot' behind it and a darker 'halo' beyond (rather like a visibly burned-in print), then the lighting should be set that way and the vase simply placed in front. On the other hand, if a uniform effect is required – like that obtained using the lightbox – then the lighting should be set as evenly as possible. As has been mentioned previously, the best way to get that effect is by using copy lighting – which is the subject of the next example image.

12.6 Copying artwork

Two-dimensional works of art vary hugely in their size and surface texture. The former influences the overall approach in terms of such things as choice of lens and close-up accessories: the latter has a direct impact on the nature of the lighting.

The painting copied here measures 120 cm square and possesses a distinctly irregular surface owing to the medium used

Figure 12.6a This picture has much wider framing than was used for the final image overleaf. The composition here shows both the balanced shadows beyond each edge of the painting, and also includes a 5 × 4 inch Polaroid print (bottom left) for scale.

Figure 12.6b Final copy of an original painting by Charlotte Gill.

(oil paints, coarsely applied). Traditional copy lighting would call for equal and even illumination from each side of the camera-to-subject axis, but that was not really possible here. Initial difficulties arose from the size of the painting, which made it hard to light the entire surface evenly. The light-to-subject distance required was considerable, and given the angles needed the lights were finally placed right back against the studio walls. It is very improbable that the painting could have been lit in this way anywhere other than in a dedicated studio space. The second problem concerned local 'hot spot' reflections on the surface of the painting. In theory, double polarization (one polarizer over the lights and another on the camera lens) could have solved this problem, but the quantity of polarizing sheet necessary made that approach prohibitively expensive here.

Both problems were solved by using indirect lighting. Multiple flash heads were aimed onto the white ceiling so that their light was scattered all around to provide soft illumination. White reflector

Figure 12.6c A much smaller original, in this case a b&w contact print from the 1940s, can sometimes be copied reasonably successfully using only natural window light. That said, this Polaroid proof print clearly reveals a slight variation in illumination brightness across the image, which is why the original was subsequently re-lit with artificial lighting before final copying.

boards were then placed to the sides of the painting, and a similar white board was laid on the floor. The effect created was close to that found inside a light tent. The picture was taken on both 5×4 inch and 6×7 cm film.

If the artwork had been smaller, with a flat or matt surface, then simple copy lighting would have been the standard choice. In this method, two general purpose heads, or pairs of heads, are arranged one to each side of the camera-to-subject axis. The lights are directed onto the artwork at about 45° so as to give even illumination. This condition is confirmed by taking incident light readings across the full area of the painting: any lighting arrangement that gives less than a 0.3 EV variation is likely to be acceptable – though zero variation is the ideal.

A useful trick that can be employed when copying, regardless of the lighting method used, is the 'pencil test'. Assuming that the artwork is laid flat horizontally, a pencil or similar pole-like object is placed in the centre, and the direction, length and intensity of shadows cast are then observed. For proper copy lighting, the directions should be symmetric, the lengths should all be the same and the intensities should be equal. Importantly, however, this test alone is not enough as it only ensures homogeneity at the centre of the painting. It takes no account of brightness variations between the centre and the edges – something that can only really be checked using a light meter, as described above.

12.7 Trade magazine cover

The styles of pictures used on the covers of publications vary widely. In this case, the brief was to show the machinery and its owner, and to leave room for the mast-head (magazine title) and other cover text. In addition, it is common for industrial pictures such as this to be shot in a slightly quirky way – with a tilted camera angle, a shorter focal length lens than normal, or coloured lighting. The reason for such tactics is that trade magazines often carry many pictures of similar looking items of equipment, and different photographic techniques are a good way of relieving the visual monotony. This picture was taken on location where the printing press was installed and used. In such cases, it is necessary to be able to work within the environment. Battery-powered lighting is a big advantage because it dispenses with the need to put lights close to power points, or to bring long extension cables that might need to

Figure 12.7a This version is similar to the cover image but with slightly more ambient fill for a lighter feel overall.

Figure 12.7b Dramatic lighting was used to give definite areas of light and shade so that the magazine's title and cover text would stand out clearly. Cover reproduced courtesy of *QuickPrinter* magazine, now known as *print now!*

Figure 12.7c With the light coming from the side rather than the front, the picture becomes a more conventional operator-and-machine kind of image.

be disguised within the picture area. In any case, industrial locations do not always have conventional power sockets – nor even, sometimes, any free sockets at all.

There are several brands of battery-powered professional flash systems (as opposed to mere flashguns). Amongst the names to look for are Norman, Lumedyne, Hensel Porty, Balçar Concept and Broncolor Mobil. The system used here was a Lumedyne 400 J pack with one head. The head has a modest modelling lamp, use of which must be kept to a minimum to avoid excessive battery drain. Because only a single head was employed, fill lighting was provided by the ambient illumination.

Using ambient light for fill when working in colour, and especially as here when using transparency film (Kodak Ektachrome 200), is a decision that must be taken only after careful consideration of the environment. In this particular instance, a visibly green

Figure 12.7d The Polaroid print shows the edge of the shoot-through brolly to the extreme left. The creases in the picture are where the print has been folded to check the composition as it will appear finally – with the brolly and other distracting elements cropped out.

overhead fluorescent tube had to be switched off. The residual mixed lighting was then insufficiently strong, in either colour or intensity, to cause any serious problems.

Interestingly, the cover shot was not the 'standard' picture for this type of assignment. Not least, it fails to show the equipment's name plate. Therefore, a second picture was taken at the same time. Freed from the constraints of the cover, this image is more typical of the genre.

In both cases, the flash head was fired through a white translucent brolly to give a softer feel to the lighting. The only other point worth making is that the cover image needed careful posing to avoid large white reflections of the brolly in the owner's glasses. The modelling lamp's modest brightness was not sufficient for this purpose, and Polaroids were therefore essential to the final result.

12.8 Rock crystal pendant

Unlike the Tae Kwan Do martial artist example of stroboscopic lighting that features in Chapter 11, this quartz crystal pendant was lit using nothing more complicated than a camera flashgun arranged to the left of the subject (linked to the camera by cable). Fill was provided by a white reflector to the right of the set.

Like the Nikon Speedlite used here, many of today's professional flashguns have stroboscopic facilities built in. Unsurprisingly, there is a direct trade-off between the frequency of the flashes, their intensity and the length of burst that can be sustained. These factors in turn dictate the kinds of subjects that can be photographed. A picture such as the Tae Kwan Do exponent would be impossible with a camera flashgun – not only because of the power level required but also because in that case of the successive flashes needed to light different areas. Things are very different, however,

Figure 12.8a Uncropped early attempt that shows the pendant starting far right, swinging to the left then back again. The neat symmetry and double images both weaken the effect here.

Figure 12.8b Cropped to show just the pendant itself, the image is exactly as conceived – but it took three rolls of film to get this composition!

on a smaller scale. The picture here was taken in a dimmed studio, with an assistant holding the pendant; a black velvet drape provided the background. To ensure that the quartz crystal remained in the focused plane, the assistant rested her arm on a support that guaranteed the correct position.

To determine the correct firing rate for the strobe, the time taken for the pendant to swing back and forth was measured by timing a number of consecutive swings, then dividing down to get the single-swing time. Because the time taken is dependent on the length of chain on which the pendant is allowed to hang, the assistant had always to hold the chain at the same point. To get the appropriate firing rate, the number of images required on the film was divided into the time for one swing from far left to far right. If, for example, the swing took 0.4 s and it was intended to get four images during the swing, the firing interval would have been 0.1 s between each flash. The firing frequency comes from calculating 1/interval. In the case of a 0.1 s interval, the frequency is 10 Hz. In reality these figures turned out only to be approximations, but they did at least provide a good starting point.

Whichever brand of flashgun is used, once the frequency and number of flashes required has been set the flashgun will signal the maximum power level available. There may then need to be some juggling with film choice and exposure rating in order to convert the power level into an appropriate aperture setting. Different brands of flashguns pose different specific restrictions.

In theory, the depth-of-field required for a picture such as this is small, but the relatively high reproduction ratio arising from the small object size in this instance (about 3 cm) meant that there would be little depth-of-field even with a small lens aperture. As mentioned above, it was therefore especially important that the assistant's hand remained in the same place throughout the picture-taking process.

The exposures were triggered conventionally using the shutter release button but anticipating the best moment to allow for the slight lag that every shutter mechanism incurs. Thanks to the dimmed studio, the position of the pendant when each flash fired could be seen with the naked eye. This point is important because Polaroids here would be a liability since they would only show when the perfect image had been recorded on instant film – not when it was captured on transparency.

Figure 12.9a Correctly timed exposure, with talcum powder inside the bursting balloon for a more dramatic result.

12.9 Bursting balloons

As was the case for the pendant picture, this is another photograph where there are parallel aesthetic and technical considerations that must be addressed. Shown here are images from three different shoots, each of which set out to achieve its own result. The green balloon is the most straightforward – and is the type of image that most people might expect to take during early attempts at such pictures. The yellow balloon image goes further with the placement of a small amount of talcum powder inside, so that when the balloon bursts there is something interesting happening between the 'peeling' sides of the balloon's surface. Finally, the red balloon (apparently burst using a sprig of holly) was shot as a Christmas card: the flash duration here was longer to give a softer, more abstract feel to the picture.

Figure 12.9b Uncropped image showing both the balloon's support collar and the assistant's hand holding the pin.

Figure 12.9c–d Polaroid showing the location of the lights on an exposure when the trigger was set off by the initial contact with the balloon, before the balloon actually burst (12.9c). The colour image shows the desired effect before final retouching to remove the pin that initiated the burst (12.9d).

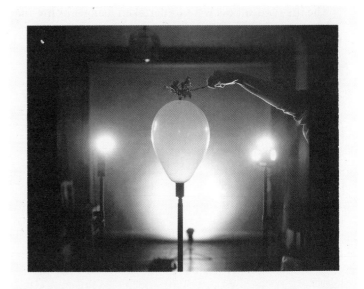

(c)

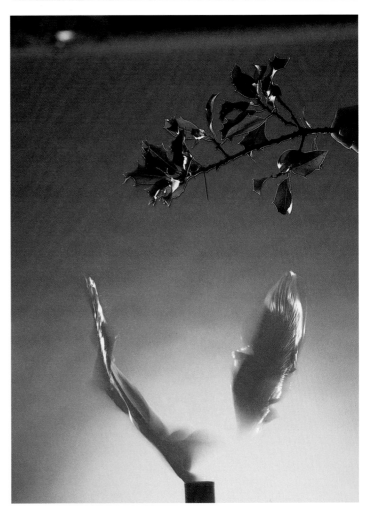

(d)

The first two shoots were undertaken using a home-made flash trigger. Although this device was designed by the author, similar designs are published from time to time in electronic hobbyists' magazines and project books. The third shoot employed a more versatile off-the-shelf commercial trigger system from Mazof Electronics. Sadly, these excellent triggers are no longer available – but others do still endure. Any major professional retailer should be able to provide such a unit.

The method of shooting is to work in a blacked-out studio with the camera shutter locked open and the lens already focused. Flashguns, or studio flash units with very short flash durations, are required for the lighting. To get the best effect, two flashguns are placed one to each side of the balloon, lighting it from the rear. A third flashgun is needed for the background if this is to be anything other than black. One of the flashguns must be connected to the sound-activated trigger: the others are tripped using light-sensitive slave cells. If the triggering system permits, controlled delays can be introduced between the 'bang' of the burst and the firing of the flashguns. Such delays allow the rubber of the balloon to 'peel' in different amounts, so freezing the event at different stages for different pictures.

Care must be taken in respect of coloured LEDs that may adorn the flashguns, for these can record as tell-tale coloured specks in the photograph. Care must also be taken regarding the exposure, especially if very brief flash durations are employed. If problems arise (the actual likelihood being dependent on the film and flashgun/power setting used), they will show themselves as under-exposure. Polaroids are useless here, for they have different reciprocity characteristics from those of wet-process films. The only answer is to make notes and learn from the results produced. If in doubt, bracket the exposures – though this will probably only be necessary towards the overexposure side of the 'correct' aperture setting.

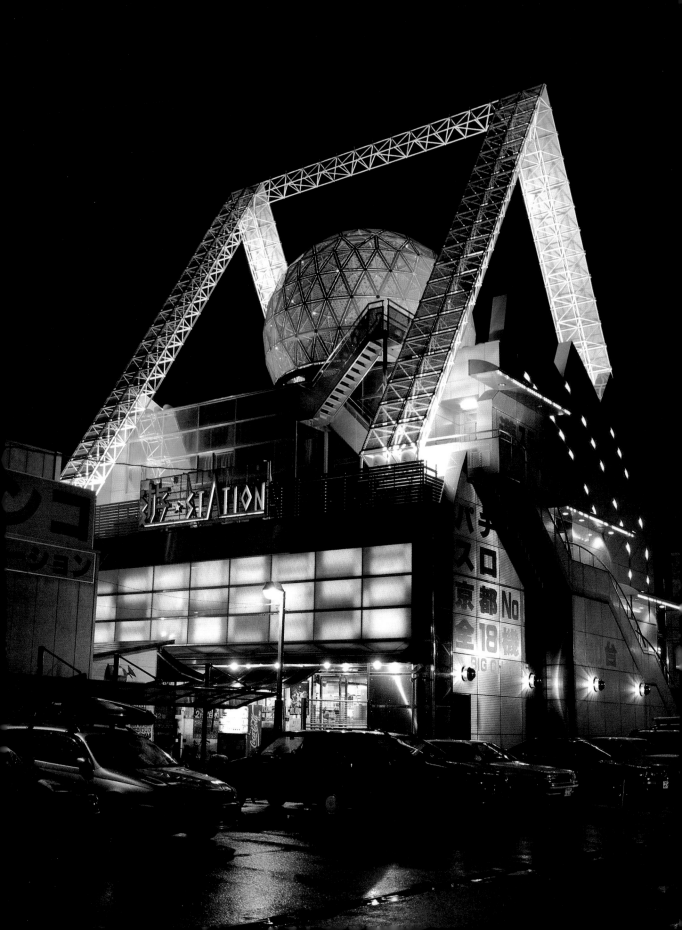

12.10 Floodlit building

On one level, pictures such as this owe absolutely nothing to the lighting abilities of the photographer. Rather, it is the designer of the building (or at least its floodlighting) who must take the credit for the effect shown. Nevertheless, there is a very definite art in recording something like this on film. For one thing, this sort of image is harder to capture than one taken in the studio for the very reason that the photographer has no control over the lighting. Therefore it is essential that the photographer must be able to control everything else – and that starts with the time of day when the picture is taken.

Most floodlit buildings look good with a deep blue sky behind. There is a general rule of thumb which says that floodlit buildings will photograph best when the sky exposure is 16 s at f/16 for ISO100 film. Experience shows that this rule is a good one, but only when the sky is indeed blue. If the day has been cloudy, and the sun sets in relative greyness, it is better to wait until there is almost full blackness. In the case of the picture here, rain had recently fallen and the surroundings were quite wet. That was a great help, for wet surfaces act as reflectors that throw illumination into shadow parts of night scenes, and so stop those areas from disappearing into total blackness.

Principal difficulties arose in this picture from the wide subject brightness range and the considerable proportion of shadow regions. Together, these two aspects meant that the exposure given had to be exactly right. Often when working at night, the temptation is to push the film as far as possible and then to expose meanly. That tactic will almost certainly produce dark areas that are totally devoid of detail, but which look as if they should hold detail. This last point is key, for there is nothing wrong with the sky being black if detail exists everywhere else.

The choice often boils down to pushing the film modestly and giving a medium exposure, or pushing more so that it is possible to expose more generously as well. In extreme cases, the two things may balance out, leaving the photographer to decide which is the best way to go. To be safe, it is normally best not to push the film to its limit, because that leaves no room for manoeuvre if the test clip (a short length of film snipped from the end of the roll and processed in advance of the rest) shows that the images have still been underexposed despite all your best efforts to the contrary.

To achieve the precise exposure mentioned earlier, a spot meter (Sekonic L-508) was used to meter the brightest highlights and the

Figure 12.10a Taken on Fujichrome RMS at the film's maximum rating (EI1000). The picture was shot on a grey day immediately after dusk, when the sky had just about turned to black.

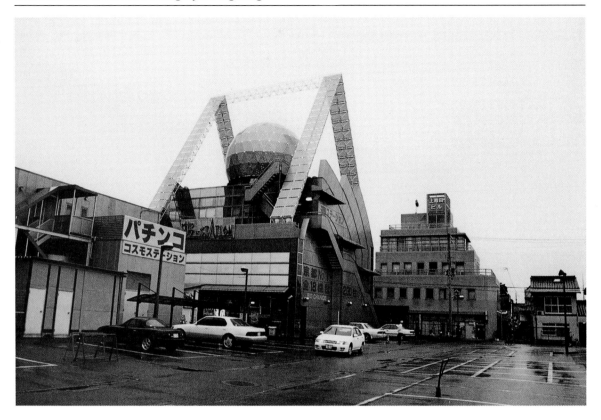

Figure 12.10b The same building in daylight. Although it is shown here in b&w, the building is in fact almost totally devoid of colour without its night-time illuminations.

important mid-tones. The latter determine the standard exposure, but the former influence the final setting. Specifically, it is permissible for in-frame light sources to be burned-out in the picture, but not for the same thing to apply to genuine highlights and lighter mid-tones. An average (centre-weighted) meter reading is likely to cause problems in this respect – and that is why carefully considered spot readings are better. Even so, a picture like this should always be bracketed during exposure to ensure that something usable is obtained.

Figure 12.11 Two separate images, both originally shot in b&w, were combined digitally to produce the result seen here. The foreground picture required a high-speed technique; the portrait was lit using just a single softbox.

12.11 Impact

Figure 12.11 (on the previous page) is a 'conceptual' picture in that it was intended to convey an impression rather than portray any one particular thing. The original idea was to combine the portrait with a broken pane of glass, but somehow to make the image more dynamic than such pictures normally are. To do this, it was decided that the glass should be in the process of shattering, rather than simply already fractured. The image is intended to intrigue and disturb the viewer through its unfamiliarity.

There are two separate elements in the picture. One is the portrait of the model, lit from one side by a softbox without any fill: the other is a picture of breaking glass. Capturing the second image was a case similar to the bursting balloons. The camera was set with its shutter locked open and the flash head was fired using a sound activated Mazof trigger. Extreme caution had to be exercised to ensure that the camera was protected (behind a sheet of clear acetate plastic) from possible damage caused by flying glass. To get the desired breaking pattern, the glass was shattered by the impact of a ball-bearing, which was fired from a modified sling-shot that could be aimed and secured with reasonable accuracy. Only three attempts were made to photograph the breaking glass on account of the risks involved.

Both component images were shot on b&w film (Fuji Neopan 400). The original intention had been to copy the negative images onto separate sheets of colour slide film using filtered illumination. The two slides would then be double-exposed onto a single transparency with appropriate masking to minimize colour mixing where the two components overlapped. This is not a difficult process, but it is very time-consuming.

By coincidence, the opportunity arose at the same time to have some sample images processed digitally using a very powerful Crosfield Mamba electronic retouching desk. This professional system is far more potent than any Mac or Windows desktop machine – and is also very much more expensive, of course.

The two components were amalgamated almost exactly as envisaged, except for the fact that the colouring and compositing were done digitally using scans taken from the two original 6 × 7 cm negatives. The retouching route scores more highly both in terms of the immediate feedback that it provides, and its ability to 'brush through' progressively from one layer of the image to the other. Masking could have achieved a similar result, but not as easily. That said, the skills needed to perform high-end electronic retouching are every bit as demanding as those needed for darkroom compositing. In addition, the file sizes required for top quality output (in this case onto 5 × 4 inch transparency film) are huge, and even today the cost

of computer systems capable of handling such files at speed is very high. It is a common mistake to imagine that a desktop PC, scanner and inkjet printer can in any way compete with the quality offered by the best high-end equipment. Conversely, a Hasselblad costs the same, and is capable of producing the same quality results, regardless of whether it is bought by an amateur photographer or a professional.

Figure 12.12a Portrait of actor Len Gregory, who was standing very close to a shaded window. The close proximity is indicated by the darkness of the room beyond, which arises from the substantial illumination fall-off that occurs with greater distance.

12.12 Window-light portraits

The main portrait here, of actor Len Gregory, is the sort of picture that anybody could take. The lighting comes from a medium size window to one side, and the exposure was evaluated using a hand-held meter to avoid possible overexposure caused by the large areas of blackness.

The supporting portrait, of photographer Roger Bamber, was also lit by window light – though in this case the window was a large bay directly behind the photographer, and the exposure was determined in-camera. Here, however, the film had to be uprated to get a more manageable exposure in the failing afternoon light. Specifically, the Fujifilm Neopan 400 was rated at EI1600: it was developed in Fotospeed FD30 push-process chemistry that is excellent for controlling grain and contrast.

Figure 12.12b In this portrait of photographer Roger Bamber, the sitter is more distant from a substantial bay window (which lies behind the photographer). As a result, more of the room is visible because the fall-off is now occurring less rapidly. By the same token, the overall illumination level is lower, and the film had to be uprated to get usable shutter speed even with the lens set wide open.

The thing that makes pictures such as these work is a good rapport between the photographer and the sitter. One of the things that helps this rapport is simple lighting, which speeds up the photographic process and ensures a high chance of success without any need for Polaroids or intricate metering. Fortunately, window light is a viable option inside most buildings, whether they are homes or offices. This means that the technique can be employed equally well for everything from executive portraits to pictures of a bride at home before she leaves to go to the church. The secret is simply to get the camera between the sitter and the window – though it is not necessary for the photographer to be directly between the two. Sometimes, very effective pictures can be obtained by standing just to one side of the window, but very close to the wall, and looking across and slightly backwards towards the sitter. This technique is particularly good for bridal portraits because the woman's close proximity to the window allows generous exposure. That in turn ensures that the interior of the room beyond is recorded quite dimly, which can be useful as a way of hiding clutter.

One thing to watch out for, however, is the influence of artificial lighting within the room. A warm orange glow from domestic tungsten lamps is not too bad, but a green glow from office fluorescents is definitely to be avoided. To be safe, always switch off fluorescent room lights when working by window daylight.

It can be useful to place a reflector between the sitter and the window to throw extra light onto his or her face. The reflector can be particularly effective when it is placed flat on a table with the person seated beyond. This arrangement is a good way of giving a 'glow' to the sitter's face, and can be observed naturally on people who are seated outdoors at white café tables. A side-placed reflector can also be useful, but only if the person is looking across the window rather than directly towards it. The arrangement is effectively one where the window becomes a large softbox arranged to one side at the front, with the reflector placed on the other side of the camera-to-subject axis. This is a more moody look than that obtained when the photographer is directly in front of the window, and is also one that requires more careful metering. Therefore, front-on window lighting is the system to stick with when speed and confidence of success are paramount. In all cases, fill flash is to be avoided when working at a window because its rather hard quality conflicts with the relative softness of the natural light.

Figure 12.12c Candid picture of a bride being prepared for her wedding. Blur on the hairdresser's arm betrays the slow shutter speed required to make the exposure.

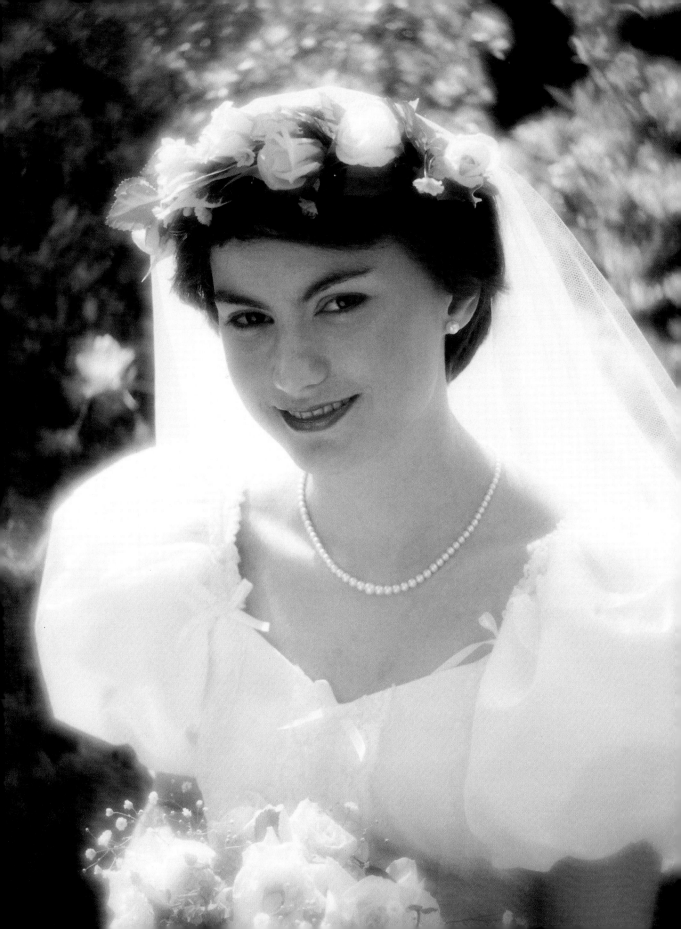

12.13 Wedding photography

An entire book could be written about wedding photography, but having mentioned bridal portraits in the previous example it seems appropriate to develop the topic in a little more detail here.

When working outdoors, the most useful rule is to seek out attractive areas of shade. In the case of large or formal groups, shade can be created by posing the people with the sun behind them: in the case of smaller groups or individuals the shade of a tree can be very effective. Contrary to common snapshot advice, one of the worst things you can do is have the sun over your own shoulder. Although this tactic can be effective when taking holiday snapshots on the beach, the high subject contrast arising from a bride's white dress in combination with dark suits worn by groom and male guests makes direct lighting inadvisable for wedding photography.

Normally, fill-in flash is used in wedding photography only when it is not possible to control the pose relative to the direction of the sunlight, and the latter comes from a forward angle. Most often, problems arise when the bride gets out of the car: there is a traditional picture of her stepping from the car, and another of the bride and father gathering themselves to walk from the car to the church. The lighting for both of these pictures is determined by

Figure 12.13a (opposite) Portrait taken on a very bright day, using the shade of a tree with a white reflector held in front to give catchlights in the eyes.

Figure 12.13b Flash was used here, but is quite subtle thanks to the fact that its illumination comes via reflection off a white ceiling. The interior lighting has been successfully balanced against the outdoor brightness: only a reflection seen in one pair of spectacles gives the game away.

Figure 12.13c Careful positioning has placed the bride and groom in a well-lit patch of grass, with a darker background behind. The groom's face is lit by the sunlight, which also gives an ethereal glow to the bride's dress thanks to the use of a Zeiss Softar filter.

Figure 12.13d Sometimes the weather is so dark and wet that conventional pictures are impossible. Here, rain has forced the bride and groom to take refuge under a tree. Unusually for wedding photography, flash is the dominant light source in this instance.

where the car parks. The same issue of a fixed direction relative to the sun also arises as the bride and groom pose on the steps of the church after the ceremony.

The other common problem area is inside the church, where flash is often forbidden. Fortunately, long exposures (made during the hymns to hide the sound of the shutter) are viable if the camera is mounted on a secure tripod. This is because people tend to stand quite still inside a church, and all of the building is totally static of course. Therefore, provided that there is no camera movement it is normally possible to make exposures of 1/4 s or so without much blur being evident in the final print. The person who is most likely to move is the priest – and action in that quarter is quite acceptable.

Flash is allowed, and often essential, in the vestry when the register is being signed. To avoid an extremely harsh look, it is best to set a medium slow shutter speed so that the ambient light provides a degree of fill for the flash. Care must be taken, however, regarding the nature of the available light. If it is daylight from a small stained-glass window, or artificial light from tungsten lamps, then the flash might only be one stop higher than the ambient reading. On the other hand, if the available light is fluorescent, the flash needs comfortably to overwhelm it with maybe a three-stop exposure advantage.

The usual way to proceed is to check the ambient light exposure, which might be 1/30 s at f/2.8, and to convert this to a more meaningful flash aperture of perhaps f/8. The corresponding ambient light shutter speed would then be 1/4 s. This would give equal exposure contributions from the flashgun and the ambient lighting. To get the required lighting difference, the shutter speed is increased by the appropriate number of F-stops. So for a daylight fill situation, the corresponding exposure would be 1/8 s at f/8, whereas for a fluorescent fill situation it would be 1/30 s at f/8. The slow shutter speeds are potentially misleading in terms of sharpness because the core image will be frozen by the brief burst of flash, though there may be slightly soft edges around anybody who moves during the full exposure – so wherever possible ask people to hold totally still for the entire duration, and not to start moving as soon as the flash has fired.

That said, although several comments have been made regarding uprated film elsewhere in this book, it is often a better tactic to put the camera on a firm tripod and shoot with a slower shutter speed to accommodate a lower speed film. There are of course limits to this, but those boundaries are often very much farther than many people imagine.

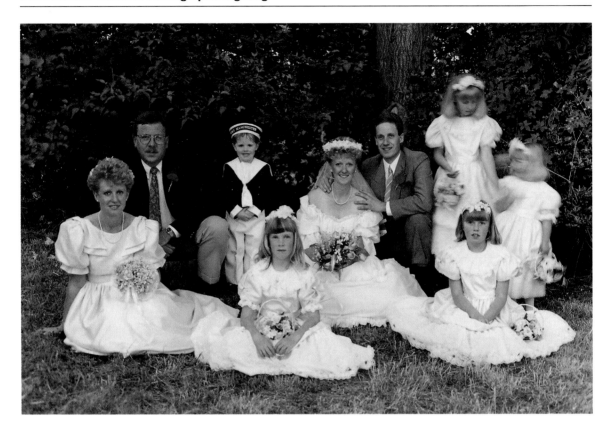

Figure 12.13e

The family group out-take picture also shown here (Figure 12.13e), for example, looks perfectly normal except for the blur caused by the little girls moving as the picture was taken. Without that blur, it would be easy to assume that this were a conventional picture taken at 1/125 s or some other routine shutter speed. Once the blur is seen, it is obvious that the shutter must have been closer to 1/4 s. The successful portrait of this group, taken on the next frame of film, is back to looking as if it was taken at a 'normal' shutter speed. The point has been made before, but will be stressed again now: a sturdy tripod or other camera support is one of the most useful items of equipment that can be owned (and used) by any photographer who is determined to improve his or her lighting skills.

12.14 Sabattier-effect body parts

It is common for professional photographers to indulge in personal work in order to stay sane and fresh through the cut-and-thrust of paid, but sometimes rather boring, commissions. Ideally, that personal work should have a positive potential benefit for future assignments. Often, it is only by developing and showing personal work that photographers are able to move their careers in new directions. The pictures here are from one such project. Appropriate lighting is intrinsic to the entire effect, which uses a Sabattier technique to create semi-abstract images of parts of the human body. In the Sabattier technique, an image is exposed as normal but is then interrupted during its processing and flashed with white light. This causes partial reversal of the picture, and also puts a distinct line between areas that have reversed and those that have not. Most commonly, this method is associated with the work of Man Ray, where it is referred to as 'solarization': in fact, it was Armand Sabattier who first noted the effect (in 1862). In any case, true solarization is a different effect entirely.

To employ the Sabattier method whilst taking pictures, rather than afterwards in the darkroom, Polaroid Pos/Neg film is used. The medium format version is called Type 665; the two 5 × 4 inch

Figure 12.14a–b Readily identifiable parts of the body given the Sabattier effect treatment. All pictures shot on Polaroid Type 665 film.

(a)

(b)

'versions are Type 55 and Type 51HC. To obtain the effect, the picture is exposed conventionally, pulled through the processing rollers but then 'peeled apart' after only about 10 s. A medium power flashgun is then fired directly at the negative, which is subsequently left for the remaining processing time before being 'cleared' and washed as usual.

The basic method is easy to master, but getting ideal pictures is rather harder – mostly because the lighting has to be adjusted specifically to suit the Sabattier effect. Because reversal involves lightening dark tones, there must be plenty of shadows in the picture. In addition, reversal involves a gain in shadow speed on the negative: this means that areas that would show as solid black and devoid of all detail in normal pictures suddenly start to reveal texture. The result is a mid-grey tone that displays information not previously visible. To get a smooth tone, the black shadows must be totally black.

By the same token, there must also be areas that are very well lit, for the mid-tone areas (which are often the most important ones in conventional photography) tend to lose impact alongside reversed shadows. The overall need, therefore, is for a very wide subject brightness range that comes from contrasty lighting. For ease of working, tungsten heads are often better than flash. Something as modest as a single 800 W redhead can be sufficient. Indeed, all of the example pictures here were taken using just such a light: the reversal exposure was made using a flashgun of GN32 power rating, set to about 1/4 power and held just far enough away from the Polaroid to ensure even illumination.

Figure 12.14c Totally abstracted picture created by taking an extreme view looking up the model's neck towards her jaw line.

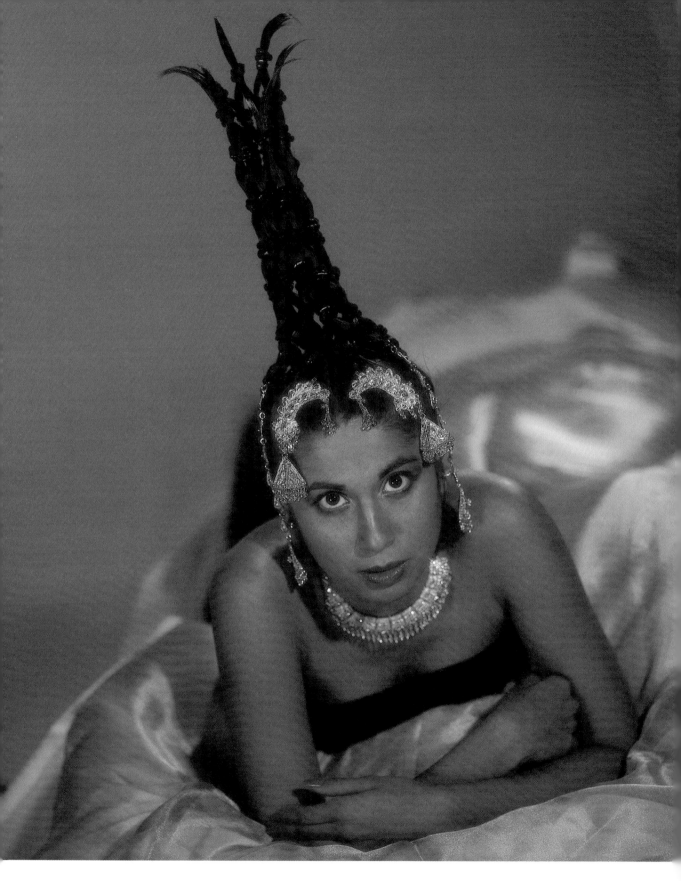

Figure 12.15a Striking hair and stunning gold jewellery combine to make this an eye-catching image.

12.15 Hair shoot

In theory, hair (and fashion) pictures are portraits of sorts. In practice, it is the hair (or clothes) that must look good: except at the highest levels of fame, the model is almost incidental.

This picture was one of a series done for a hairdresser who was trying out new styles. In the context of the previous example, this is the hairdresser's equivalent of a photographer's personal work. Because the hairdresser needed to see how the shoot was progressing, and because there was insufficient budget for anything more than initial Polaroids, the decision was taken to light with tungsten heads – the effect of which can assessed reasonably well by eye. In addition, a digital camera was used alongside the film camera as a means of taking electronic 'Polaroids' as the shoot progressed.

As the record picture shows (Figure 12.15b), the main light was an old 2 kW Fresnel spot light that was softened with a diffusing gel supported in a frame some way in front of the light to avoid heat damage. Fill-in lighting came from a diffused 1 kW flood placed on

(b)

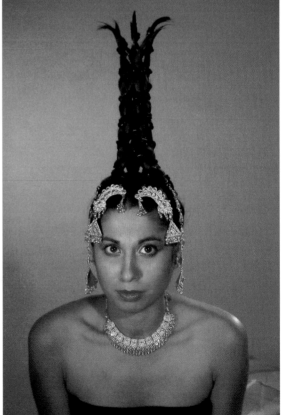

(c)

Figure 12.15b–c Record picture, taken using a Ricoh RDC5300 digital camera, showing the location of the lights and the extreme height of the camera to get the required angle of view. Also captured digitally, using the same camera, is one of the try-out compositions (12.15c).

Figure 12.15d–f Try-out poses captured on b&w Polaroid film (which develops faster than colour film). In one case, the background lighting clearly overpowers the model (12.15f) – something that was corrected before the final transparencies were shot.

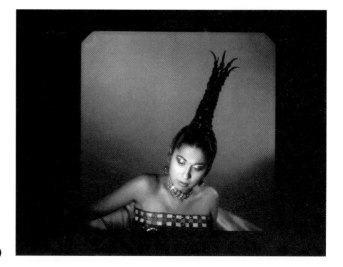

(d)

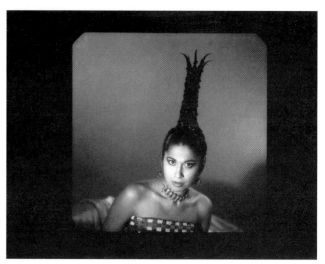

(e)

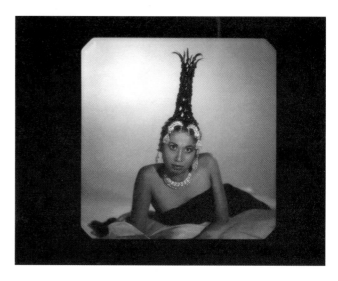

(f)

the other side of the camera-to-subject axis. Depending on how the model was posed, the main and fill lights were sometimes transposed to give a better balance of light and shadow. The background paper had a strong orange colour, chosen to impart a warm feel to the picture, and was lit with a 2 kW Photon Beard blonde. As was mentioned in Chapter 3, these particular lights feature linear tubes rather than more compact types, and their areas of illumination are more oval than round. Sometimes that fact can be an inconvenience, but here it was used to give a slightly unexpected fall-off pattern that makes the edges of the pictures look as if they have been 'burned-in' in the darkroom. Hair lighting was provided by an 800 W redhead that was fitted with a snoot. The snoot was used not to restrict the light's area of coverage, but rather to dim the light's brightness slightly. This use was discussed in Chapter 5.

The film images were shot on Fujichrome RTP-II (ISO64): the exposure was f/4.5 at 1/60 s. Digital images were captured with the Ricoh RDC5300 set to automatic in respect of both exposure and white balance.

The record picture shows how high the camera sometimes had to be placed in order to get the desired angle. It is a common mistake to shoot everything at either eye-level or waist height. Low angles as well as high ones can be very effective. A useful trick is to shoot from anywhere between knee and ankle height in order to make a model's legs look longer. Beware, however, that you must use a long focal length lens if the 'falling backwards' look is to be avoided. Also, take care when shooting from extreme angles as it is easy for lights (or power cables) to creep into the frame. It should go without saying that the lighting will almost certainly have to be adjusted, or possibly even reset entirely, with each change of camera angle.

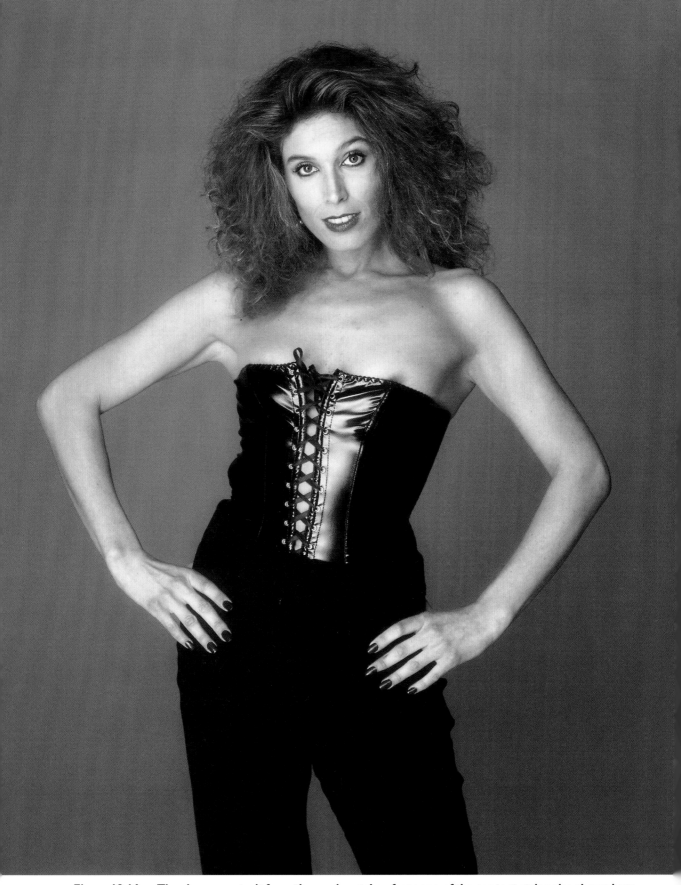

Figure 12.16a The chosen portrait from the session, taken from one of the contact strips also shown here.

12.16 Helen Levien

These pictures of interior designer and television presenter Helen Levien were shot for publicity purposes. A wide range of poses and ideas were tried, some of a more traditional nature and some using pots of paint and brushes as props.

Because the poses were to vary so much, and because there would not be a huge amount of time to relight, the arrangement used was one that offered good flexibility. The main light was a strip softbox; fill came from a single head fired into a ceiling corner. Black panels were placed left and right of the shooting area, and a plain green background paper was used behind. All of these components were chosen for their suitability for both colour and b&w photography, recognizing that both types of pictures would be shot during the session.

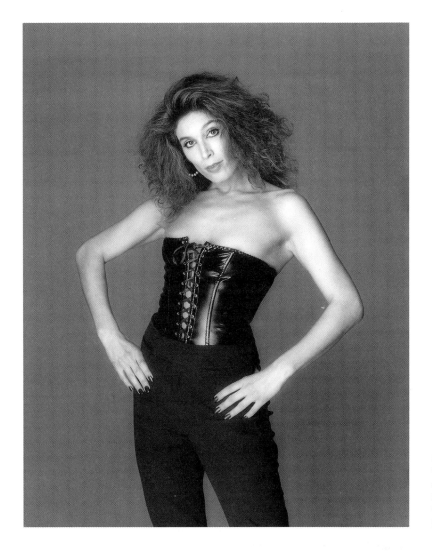

Figure 12.16b Variant on the chosen image, but in this case captured on Ilford SFX200 film: no filtration was used, so the portrait looks 'normal'.

215

(c)

(d)

(e)

Figure 12.16c–e Extracts from some of the contact sheets from the shoot, showing a few of the poses tried. The lighting remained principally the same throughout the shoot.

The danger of any versatile lighting arrangement is that it will also be somewhat bland. In particular, the lighting tends to be rather flat, with only subtle shadows cast. This result is obvious, for were it otherwise the well-defined areas of light and shadow would restrict the range of posing options – and even film choice.

It was specifically to guard against flat lighting that black 'reflector' boards were used. These are not reflectors in the sense of reflecting light, but rather reflect themselves in anything stood nearby. The effect is obvious when shooting still-life arrangements, and is sometimes very clearly visible in pictures of glassware and metallic objects. In portraiture and fashion photography the effect is more subtle, giving a black edge to areas of skin and light-coloured clothing that are nearest to the black boards. No exposure adjustment is needed.

The lighting arrangement here ensured consistent illumination over a floor area that was about 1 m square. The controlling factor in achieving this result is the location of the softbox: if it is very close to the model, there will be a definite fall-off with increasing

distance. On the other hand, if the softbox is too far away its illumination will be rather dim. Therefore it should be clear that the ideal position is one that is as close as possible to the subject whilst at the same time maintaining even illumination throughout the required working space.

If the background is to be lit separately, then a considerable distance will be needed between it and the working space. That in turn calls for a very large studio. The alternative is to light the background with spill from the main light. This is fine, but it does mean using a significantly off-axis lighting angle to minimize shadows of the subject on the background. In all probability, the off-axis lighting position will not pose any problems, but care must be taken if the main light is moved further around to the front during the session as this could introduce the very shadows that off-axis lighting is often used to avoid.

The large strip-light employed here makes all shadows soft: coupled with a close ratio between the main light and the fill, this means that even if shadows of the subject were cast on the background they would only be faint and rather indistinct. Small light sources are very much harder to work with in this respect, so a good suggestion for anybody having trouble with background shadows in a small studio at home is to fit softboxes onto the lights. Of course, this will modify not only the background but also the entire lighting effect – but this is one of those trade-offs that come into play in any small studio.

Figure 12.17a Print made on Kentmere Bromoil paper from a Sabattier-effect Polaroid negative to get an almost charcoal-drawn image.

12.17 Athlete

The main picture here is an example of the Polaroid Sabattier effect at work. The subject, swimmer Marie Atkinson, was photographed partly for her portfolio and partly to test an improved version of Agfa's Scala b&w transparency film: in the latter context, one of the images obtained was used by Agfa to launch Scala 200X in the UK.

The basic lighting approach was very similar to that used for the previous example. As before, the need was to create a useful working space within which the model could be posed without a need constantly to be moving the lights. Having said that, a hair light was employed for some of the pictures, and this clearly did need adjusting whenever the pose was changed.

For the 'ordinary' pictures, the background was a mid-grey tone, but for the Scala and Sabattier pictures a black background was used instead. As should be immediately apparent from the

Figure 12.17b Contact sheet showing conventional and Sabattier versions of the final image, plus two Sabattier variants of a different pose.

Figure 12.17c–d Conventional pictures taken during the same session.

(c) (d)

images shown, the lighting was also changed. This was done both to show off the swimmer's muscles, and also to introduce more symmetry into the picture. The main light was therefore shifted from the side to overhead. The position of the overhead light was at a very high angle indeed, so that the illumination 'grazed' the muscles to cast distinct areas of shadow. This effect is analogous to the dramatic shadows that a low sun creates on a freshly ploughed field, or even on rippled sand.

It is a general principle that acute lighting from any direction tends to emphasize texture on whatever subject is lit. If the subject is naturally smooth, such as glass, then grazing light will reveal every speck of dust sitting on it. By the same token, frontal lighting tends to reduce surface textures, but gives good colour saturation (provided there is no glare on the surface). Intermediate positions are best for revealing shape and form.

A change that could have been made to the overhead lighting would have been to work with a bare head rather than a softbox.

This would have given more sharply defined shadows that might have suited some photographers' visions. Here, however, the intention was to show the swimmer's muscles and overall build, yet still to keep the picture looking feminine. The long hair goes some way towards that, but is by no means a sure indicator these days: a slightly soft light source is another helping factor.

The colour and b&w portrait pictures were printed as normal, but for the Sabattier effect image a specialist b&w printing paper was chosen. The paper used was Kentmere Bromoil, which has a natural paper texture rather than the regular finish associated with more routine papers. The overall result is one that suggests a pencil or charcoal quality – though some of that effect may be lost in the book publishing process.

12.18 Designer coat

Once again, this shoot started off with a safe lighting arrangement that allowed plenty of working space. As in the last two examples, the initial arrangement centred on an Elinchrom softbox strip to one side with a second Elinchrom head fired into the ceiling for fill. The two heads were both 500 J units, with the fill head set to maximum power and the main light to minimum. As was explained in Chapter 10, this pattern of power distribution is quite normal.

Figure 12.18a The as-shot version, which includes the edge of the softbox and has creases in the background paper.

Figure 12.18b Instruction print, made by copying the original 35 mm transparency onto 8 × 10 inch Polaroid film. This was given to the retoucher as a means of identifying the work that needed to be done.

Figure 12.18c Digital
C-Type print created from
the retouched picture file.

The fill light, despite providing a lower level of illumination, is often set to a high power level – especially when it is employed in all-pervading, 'bare bulb' fashion.

This picture is interesting because it illustrates well the part that electronic retouching tends to play in professional photography. The image was posed and lit essentially as required: retouching was used only to 'clean up' the image. As shown on the b&w proof print, cleaning consisted mostly of removing blemishes and creases on the background paper, and tidying the model's hair. In this instance, the nail varnish colour was also changed from one that was initially viewed as striking but was later thought distracting. Retouching was undertaken professionally, and the final image was output using a digital C-Type printer (Kodak Pegasus). In general, there are four options for handling digitally retouched pictures. The first, and apparently the neatest, is to keep the picture in electronic form, passing it around on a CD or other high capacity disk. This is fine, except for the fact that there is no visual reference against which to

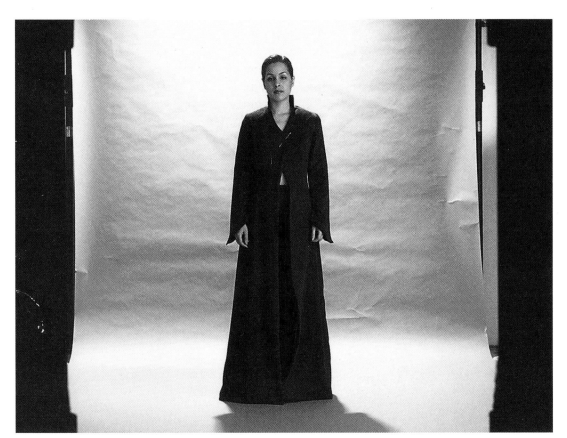

(d)

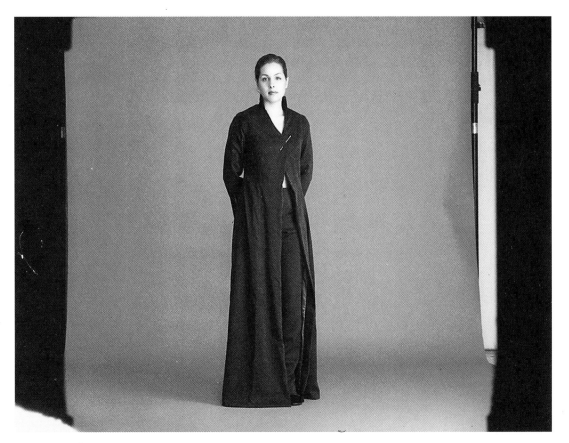

(e)

check the image if any uncertainties arise. The second is to write the file to film. Not only does this allow multiple print copies to be made at leisure later, but also it provides an immediate visual assessment of the image. The twin disadvantages of this option are the file size needed and the high cost of this service. It is cheaper to write the electronic file onto C-Type paper, as here, but if lots of copies are needed the price escalates rapidly.

Finally, there is today the possibility of using a desktop inkjet printer to output the image. The best machines of this type are now very good, but it should always be remembered that inkjet technology was initially intended for proofing – not for durable prints that might compete with traditional silver halide media. Although the technology is improving all the time, the current best recommendation is to keep inkjets for proofing and to have the same files written out as C-Type prints once the image has been finalized. Conveniently, these two technologies require roughly the same size files to create the same size prints.

If this short diversion into digital output technologies seems far wide of the main topic of this book, then let it be repeated here that the one thing electronic retouching cannot easily do is change the nature of the lighting in an image. Therefore, no matter how sophisticated digital imaging may become, good lighting technique will always be an essential part of good photography.

Figure 12.18d–e Polaroids that were shot specifically to show the effect of changing from top (12.18d) to side lighting (12.18e) when the background paper is already well used.

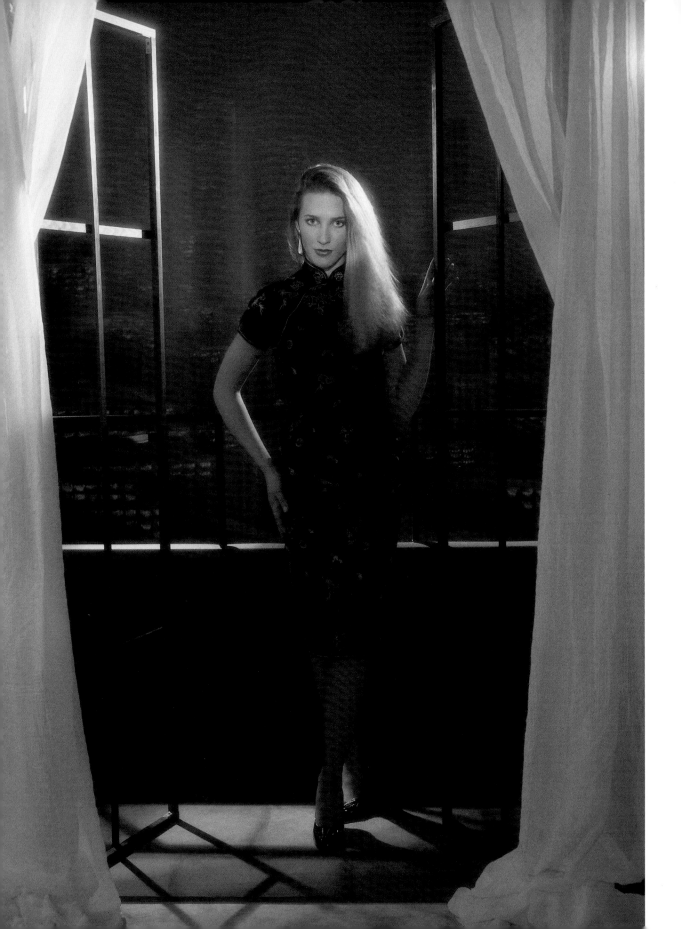

12.19 Balcony scene

If the lighting here has worked as intended, then the main picture should look as if it was taken in an apartment, looking out onto a balcony and the city beyond. In fact, as the b&w print shows, it was taken in a studio using a constructed set.

The background was hand-painted by specialist company Fantasy Backgrounds, and was intended to look out-of-focus even when recorded sharply on film. This was so as to obtain a greater differentiation between foreground and background than could be achieved by aperture control alone. Background lighting was even, from a pair of floods arranged one to each side from low down in order to suggest the fall-off that is seen when looking upwards into a city night sky. The heads are hidden from view by the balcony 'wall', which is in fact thin plywood covered in textured wallpaper and painted mid-grey.

Figure 12.19a (opposite) If the lighting has worked as intended, this shot should look as if it really were taken looking out onto an apartment balcony, with a nocturnal city in the distance.

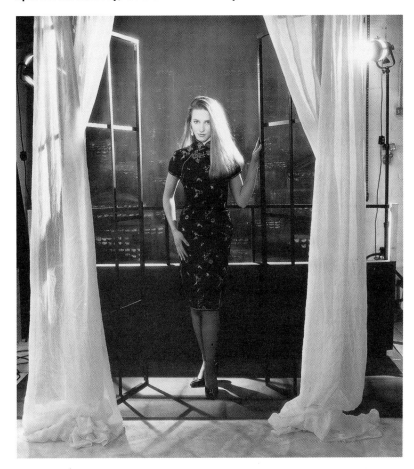

Figure 12.19b The full frame area shows where two of the lights were located.

Figure 12.19c Taken during
a previous attempt with the
set: owing to poorly balanced
lighting, this picture reveals
rather too readily the
spotlight that was used to
brighten the model's face.

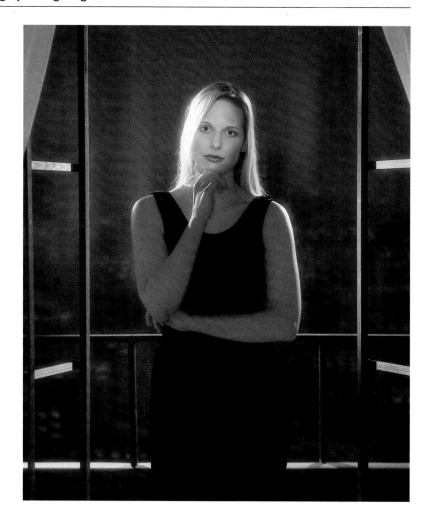

Two forward-facing lights cast shadows from the patio doors
on the floor, with one also lighting the model's hair. The model
herself is lit with a dim fill-in light and a bright spotlight that
illuminates only her face. Accurate aiming of the spotlight is crucial
to the success of the picture, and for that reason the model used had
to be capable of holding a fixed pose while at the same time looking
natural and relaxed.

The film used was ISO200 Kodak EPD. Because tungsten
lighting was used in combination with flash, the shutter speed
employed had to be quite slow and the lens was set wide open
(f/4.5). To add to the soft look desired in the picture, a diffusing
filter was used on the lens. This also had the added advantage of
excusing slight softness due to subject movement or minor focusing
inaccuracies. Kodak's replacement for EPD, Ektachrome E200, has a
much better push-processing behaviour, and if the picture were
reshot today it would have been possible to get a higher proportion
of pictures with the required level of sharpness.

12.20 Theatre production

Photography for the stage is most definitely not confined to the stage alone. The pictures here, for Sarah Le Brocq's production of *Flying Ashes* from a few years back, go from cast pictures (overleaf) through rehearsal to performance. The lighting and the film were different at each stage, and two separate camera systems were also used in order to get access to the required film stocks.

The cast pictures were taken in the studio against a plain white background using flash lighting, Kodak PXP (Plus-X) film and a medium format Mamiya RB67 camera. The main light was a single Bowens head placed on the floor to create an eye-catching effect. No fill lighting was used as it was felt that solid shadows would add to the drama of the image. Exposure was determined using an incident flash meter.

The rehearsal pictures were taken on location in a large hall using the painted brick walls as a natural background. Again the camera was a Mamiya RB67, but this time the lighting came from a location flash pack and the film was Kodak TXP (Tri-X). Originally, the plan had been to use tungsten heads in order to simulate the look of stage lighting, but the shutter speeds and apertures required precluded the taking of action pictures. The move to Tri-X was partly an attempt to get a slightly more 'raw' look in comparison with the studio pictures. As before, exposures were based on incident flash meter readings.

The theatre pictures, taken of the actual performance (during the final dress rehearsal), were shot under available lighting using

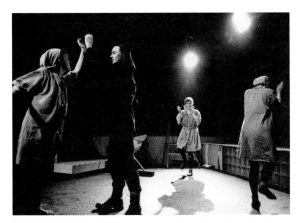

Figure 12.20a Taken under stage lighting during the dress rehearsal, for front-of-house use.

Figure 12.20b Emotional image that was shot off-stage in a rehearsal studio – hence the tight composition.

Figure 12.20c (opposite) Cast picture posed in the studio for eye-catching effect.

Figure 12.20d Alternative cast picture that was shot upright but was reproduced in one national newspaper horizontally.

Kodak T-Max p3200. Because this film is available only in 35 mm format, the cameras used were Nikon FMs (with a variety of different lenses). Today, the existence of Ilford 3200 Delta in roll-film means that a medium format camera could be used instead if desired, though a 645 body would be a far more likely choice than either a 6×6 cm or a 6×7 cm camera. Exposures were evaluated using a hand-held spotmeter (Pentax V). The large areas of

Figure 12.20e Although the fast film used here (Kodak T-Max p3200) allowed reasonable depth-of-field under stage lighting, the lens was deliberately set wide open to give a sense of isolation.

blackness and local bright spots caused by lights included within the frame mean that it would have been very difficult to get accurate exposures by any other method.

Grain is clearly evident in the performance pictures, but this is not normally a problem as far as stage photography is concerned. Even so, Ilford 3200 Delta is significantly less grainy than Kodak T-Max p3200, and would therefore often be preferred when working in small or medium size venues that do not have the illumination capability found in larger theatres. If the lighting is very modest, production pictures are best done after the dress rehearsal, not during it. This allows the lights to be set to maximum brightness (rather than their working settings – which are often more moody). It also means that the actors can be posed to a degree, so permitting slower shutter speeds than can be employed during the running show. The one thing to guard against, however, is extreme push-processing of the film: extended development raises image contrast, and stage contrasts are already quite high enough!

12.21 Single-light portrait

Having progressed from simple lighting set-ups to complicated arrangements and demanding situations, it is nice to finish with a single-light portrait technique.

The method involves placing one light on a high stand or boom arm at a height slightly above the model's eye level. A medium size square softbox is fitted to the head. Below the sitter's chin is placed a white panel reflector that throws light back up to reduce the densities of shadows cast by the main light.

A variation on the technique is to use a curved reflector formed from a piece of white background paper. Another variation employs a hinged three-part reflector (Lastolite Tri-Flector) that can be used to make a box that has the softbox on the top, with the reflector panels making sloping slides opposite each other and a flat base. For optimum effect all reflecting surfaces should be angled slightly backwards.

It is quite possible to shoot like this, with just a single light, because as well as acting as the main light the softbox also creates a good highlight on the model's hair and gives enough soft spill to illuminate the background without casting obvious shadows.

Figure 12.21a Record picture, taken on another occasion, showing the same basic arrangement as was employed for the main picture overleaf.

Figure 12.21b Simple but very effective portrait lit using a single softbox main light with fill from a white reflector: the variation in background tonality was added in the darkroom.

Negative film is the best choice for such pictures. This is partly because there is little control over the lighting contrast (which might turn out a little high for flattering portraits on transparency film), and partly because the subsequent printing stage allows the background to be burned-down to create a vignette effect.

As outlined previously, this 'butterfly lighting' arrangement is best suited to people with narrow rather than broad or round faces. For fairly obvious reasons, it should not be used on people with high foreheads or very deep-set eyes. The style does, however, flatter people – especially women – who want to be seen with strong cheekbones.

In the absence of a studio flash head, this lighting can be simulated using a camera flashgun and a 'shoot-through' diffuser panel of the type made by Photoflex and Lastolite, amongst others. The flashgun is normally set to manual and positioned on the far side of the diffuser screen, which acts like the front surface of a softbox. Under these conditions, exposure must be assessed using a hand-held meter. Non-TTL automatic modes must not be used as the flashgun sensor will be confused by the white diffusing screen. Flashguns that allow off-camera TTL exposure control can, however, be used in dedicated automatic mode. The white diffusing screen must not be omitted as that would make the resulting light quality very hard and unflattering. If studio heads are used, a large open reflector with a centre baffle that prevents direct illumination can be employed in place of the softbox.

Outdoors, a variation on this method uses the sun as the light source, angled from a medium height in front of the model. The white diffusing panel and white reflector panel are both put in place as when using a camera flashgun indoors. This system gives soft lighting on the model, with natural lighting beyond in the background. Normally, the background comes out slightly over-exposed relative to the portrait part of the picture – a fact that helps to isolate the person from the surroundings.

13 EPILOGUE

This book is far more than one person's effort: many people have contributed to it, either directly or through discussions that have provided ideas. Therefore, and with apologies to anybody who is left out, the author would like to acknowledge assistance and support provided by the following: Tim Cecil at Strobex, Mike Devorchik at KJP Calumet, Chris Whittle at The Flash Centre, David Morphy at Cirro Lite, Simon Larn of Larn Lighting, Tim Haskell and Barry Parker of Optex, John Allwright of Systems Imaging, Mark Langley of Johnsons Photopia, Hardy Hasse of Hasselblad, Sean Henry of Lastolite, Kevin Aylott of Fantasy Backgrounds, Alec Harris of Colorama Photodisplay, Mike Gristwood of Ilford, Martin Wood of Kodak, Neil Ward of Fujifilm. Mary McNaulty of Epson, Ed Davis at Optima Studios, Trevor Spiro at Assassin model agency, Chris Snode at The Sports Workshop, Adrian Fanning of PRF Associates, Mike Sherry of Sky Photographic, Sandra and Greg Forte of Joe's Basement, and b&w master printer Melvin Cambettie Davies. Thanks are also extended to all the photographers who have openly discussed their lighting techniques with the author over the years – particularly Sean Ellis, Jonathan Knowles, Douglas Arnold, Cat de Rham, Sofia Ruiz Bartolini and Michelle Sadgrove, all of whom have kindly allowed their pictures to be used here. Thanks, too, to the various models who posed for the pictures, either specifically for this book or as part of equipment test sessions initially shot for magazine reviews. Marie White appears in several pictures within this book, as does Helen Levien – who has been a frequent and willing participant in various photographic projects over a number of years.

Final thanks go to the patient staff at Focal Press who endured a longer than anticipated gestation period for this book. But the biggest thank you is to my wife Lin, who has probably heard more talk about lighting over the last fifteen months than any normal person could stand. She is also the individual referred to as 'assistant' in several of the example pictures.

Figure 13.1 Very early morning architectural image, taken on 5 × 4 inch colour print film. Photograph by Michelle Sadgrove.

Of course, in photography – and lighting especially – you never stop learning. The end of this book is therefore simply the start of learning more things, another step on the ladder of photographic development. It is ironic that after 50 000 of my own words, I cannot conclude with anything better than a comment recorded during an interview with Michelle Sadgrove:

'Photography is all about capturing light. It's not about the tools you use, it's about what you see as a photographer.'

Appendix
SCIENTIFIC LANDMARKS IN THE HISTORY OF LIGHT

Modern science requires light to be considered as both a continuous wave and a series of discrete particles. But this is not a new idea, for the wave–particle duality of light existed in debates long ago, right back to the times of Ancient Greece. Pythagoras maintained that light must be particulate, while Aristotle argued for waves in an all-pervading medium that he called the pellucid. In 300 BC, Euclid announced that light always travels in straight lines – a suggestion that was subsequently generalized by Hero who said that light always journeys by the shortest path between two points.

Although there were other investigations along the way, in particular Ptolemy's systematic characterizations of the ability of substances to bend (refract) light to different degrees, the next milestone came in 1675 when Newton dispersed white light into a rainbow of colours using a glass prism. Newton was also the first person to appreciate that curved lenses (which had started to find use in telescopes and microscopes earlier in the same century) would inevitably cause coloured fringes in their images because they could be considered as pairs of curved-surface triangular prisms joined base to base. That is why Newton set about building a telescope that used a curved polished metal mirror rather than glass lenses – an idea first suggested by James Gregory in 1663.

In 1678, Huygens proposed a detailed mechanism for the longitudinal transmission of light waves – a mechanism that could be observed and explored using waves on water. One such demonstration involved creating waves in a shallow tray and sending them towards a barrier with a small aperture in the middle. On the other side of the barrier, the previously straight waves are seen to have become curved, radiating out with the aperture at their centre. This phenomenon is known as diffraction. In terms of light, it explains why a back-illuminated pinhole can be seen from a range of angles on the other side of the barrier. Without diffraction, an observer might assume that the pinhole would create a thin beam of light that would be visible only in the dead-ahead direction.

Crucially, however, Huygens suggested that light waves travel not in a perfect fluid (idealized water), but by transmitting energy to adjacent light

particles that are all-pervading. The easiest analogy here is to imagine a line of snooker balls all touching each other: if a moving snooker ball impacts squarely on the end of the line, it comes to a halt and passes all of its energy through the line to the ball at the far end, which is immediately set in motion. The intervening balls that remain motionless, but pass energy nevertheless, are the equivalent of all-pervading light particles.

Putting to one side the need for this all-pervading medium, other workers progressed the theory of light in other ways, including the development of compact lenses (Fresnel) and maximum resolution models (Rayleigh). Unfortunately, each new development brought greater complications to the existing model of light, and it fell to James Clerk-Maxwell to simplify matters by suggesting that light is not a mechanical thing at all. As such, light can never be explained fully by mechanical models, and can only be described mathematically as a general electromagnetic wave.

The final milestone to date was laid by Albert Einstein, whose work on the photo-electric effect (not his Theory of Relatively) won him the Nobel Prize in 1921. It had been known for some time that when light is shone onto certain substances, electrons can be emitted and a current established: the puzzling aspect was that there seemed to be no correlation between the brightness of the light and the strength of the current. This is totally contradictory to any wave-on-water type model where the strength (amplitude) of the wave is directly related to its ability to do work – to break through a sea wall, for example. Einstein discovered that the amount of light shone on a photo-electric substance is less important than the colour of the light, and formalized an equation that defines the energy of a single light particle (photon) as being directly related to its frequency.

In visual terms, the energy is related to the colour, not the brightness, of the light. A common illustration of this fact is the glow that can be seen when a starched white shirt is subjected to UV light: no matter how bright any non-UV light is, it will never cause the same eerie glow.

Two years after Einstein won his Nobel Prize for formalizing the particle nature of light, Louis-Victor de Broglie suggested that the reverse is also true, and that all particles – including macroscopic objects the sizes of cricket balls (or even planets) – can also be considered as 'waves'. In 1927, de Broglie was proved right in respect of sub-atomic particles through experiments conducted independently by Clinton Davisson and George Paget Thomson. Louise de Broglie was rewarded with the 1929 Nobel Prize: Davisson and Thomson shared the Prize in 1937.

Experimentation prompted by dualism allowed the development of lasers, which in turn led to Dennis Gabor's discovery of holography, for which he was awarded the 1971 Nobel Prize.

Today, the wave-versus-particle debate has ceased to have meaning because light, like everything else in the universe, can now be considered whichever way best suits the phenomenon being observed. To cynical observers, this represents the ultimate scientific 'fudge', but until some better concept comes along, it is the best model available for defining that most common yet intangible thing we call 'light'.

INDEX